TT
900
.H6
L43
2002

CLEARI

Chicago Public Library

006517149
The complete idiot's guide to holiday cr

THE COMPLETE IDIOT'S GUIDE® TO

W9-BCN-089

OCT 1 6 2004

Holiday Crafts

by Marilee LeBon

ALPHA

A Pearson Education Company

Copyright © 2002 by Marilee LeBon

All rights reserved. No part of this book shall be reproduced, stored in a retrieval system, or transmitted by any means, electronic, mechanical, photocopying, recording, or otherwise, without written permission from the publisher. No patent liability is assumed with respect to the use of the information contained herein. Although every precaution has been taken in the preparation of this book, the publisher and author assume no responsibility for errors or omissions. Neither is any liability assumed for damages resulting from the use of information contained herein. For information, address Alpha Books, 201 West 103rd Street, Indianapolis, IN 46290.

THE COMPLETE IDIOT'S GUIDE TO and Design are registered trademarks of Pearson Education, Inc.

International Standard Book Number: 0-02-864200-7
Library of Congress Catalog Card Number: 2001093551

04 03 02 8 7 6 5 4 3 2 1

Interpretation of the printing code: The rightmost number of the first series of numbers is the year of the book's printing; the rightmost number of the second series of numbers is the number of the book's printing. For example, a printing code of 02-1 shows that the first printing occurred in 2002.

Printed in the United States of America

Note: This publication contains the opinions and ideas of its author. It is intended to provide helpful and informative material on the subject matter covered. It is sold with the understanding that the author and publisher are not engaged in rendering professional services in the book. If the reader requires personal assistance or advice, a competent professional should be consulted.

The author and publisher specifically disclaim any responsibility for any liability, loss, or risk, personal or otherwise, which is incurred as a consequence, directly or indirectly, of the use and application of any of the contents of this book.

Publisher
Marie Butler-Knight

Product Manager
Phil Kitchel

Managing Editor
Jennifer Chisholm

Acquisitions Editor
Randy Ladenheim-Gil

Development Editor
Amy Gordon

Senior Production Editor
Christy Wagner

Copy Editor
Jan Zunkel

Illustrator
Jody Schaeffer

Cover Designers
Mike Freeland
Kevin Spear

Book Designers
Scott Cook and Amy Adams of DesignLab

Indexer
Tonya Heard

Layout/Proofreading
Svetlana Dominguez
Nancy Wagner

Contents at a Glance

R0176517149

Chicago Public Library
Clearing Branch
6423 West 63rd Place
Chicago, Illinois 60638-5005

Contents

Foreword

As the style editor for *Home Magazine,* I'm fortunate to have easy access to trends and information about the newest and greatest ready-made products for every room in the house. But like many of you, when it comes to receiving gifts, I'm often the most touched and impressed by handmade offerings. For example, on my first wedding anniversary a mysterious box arrived in the mail. I was moved to tears to find it contained a beautiful album quilt created by my longtime friends Heather and Stacey. The dynamic duo had invited wedding guests to sign and decorate quilt squares. Then they integrated the decorated pieces with fabric from my bridesmaids' dresses. I was amazed at the hours of organization, along with the handiwork, the project must have required. Upon closer inspection, I was dazzled by the variety of artistic efforts represented in the quilt. Some wedding guests had drawn stick figures or lettered loving messages in permanent marker. Others stitched their good wishes in colorful embroidery floss. And a talented few brightened the mix with appliquéd designs and detailed paintings on fabric. The common thread: Everyone involved, from the most talented adult artists and crafters to children barely old enough to wield a crayon, had contributed a creative piece of themselves to a work of folk art, a treasured memento of a happy event, and a future family heirloom.

Enriching the memories of holiday events—and making them all the more memorable with the time and talents we contribute—is just what Marilee LeBon's newest book, *The Complete Idiot's Guide to Holiday Crafts,* inspires us to do. Happily, the author has provided practical ways to make holiday crafting easy and entertaining. And thanks to the inspired recipes she's tailored for each season, the projects can turn into a delicious way to bond with family and friends.

The informative sections on organizing and stocking your craft area will get you started on the right track, and you'll feel your confidence and knowledge grow as you peruse the step-by-step instructions you need to create innovative crafts. Even better, many of the skills you'll learn along the way, such as making a papier-mâché piñata, can be applied to other projects, including whipping up attractive, handmade paper for an Earth Day celebration. You'll also find yourself turning frequently throughout the year to the comprehensive glossary of terms and techniques, along with the craft resources, in the back of the book.

Finally, and perhaps best of all, with this book in your home library, the next time you see a finished craft project and feel the urge to say "I could do that," you can—and will!

Laura Dye Lang
Style Editor, *Home Magazine*

Laura Dye Lang is the Style Editor of *Home Magazine.* Over the past 15 years, she has written, edited, and produced articles and features on home furnishings and decorating for consumer publications, including *Texas Monthly, Traditional Home, House Beautiful* Special Interest Publications, and *Bridal Guide.*

Introduction

I can still remember staying up with my sisters late into the night on Christmas Eve, trying to catch a peek at Santa Claus. The house was beautifully decorated as a result of our family's combined creative efforts. We spent our time off from school making ornaments for the tree, cutting out snowflakes for the windows, making Christmas decorations, and baking enough cookies to feed an army. Of course we knew that Santa wouldn't be happy if he didn't have a variety of cookies to choose from on Christmas Eve. And, we wouldn't want him to be disappointed enough to cross items off our wish list!

Now that I'm older and wiser, I realize how important holiday traditions are to the family. The ritual of making decorations and exchanging gifts during the holidays brings an element of creativity and loving care to these seasons. I'll always remember as a child painstakingly wrapping up a can of hairspray for my sister, Carol, in a large box so that she wouldn't guess what it was. (Hey, what do you expect on a $2 budget?) Somehow I equated her perfectly teased hair (which was the current fad) with a burning desire to own cans and cans of hairspray. She got me a troll doll that I really wanted—but then again, she was older and had a bigger budget. On Christmas Eve we were allowed to open one gift, and much to my delight she chose mine, knowing full well it was just a can of hairspray. Her generous spirit helped to make that Christmas a memorable event.

As a parent, my favorite gifts from my kids have always been their homemade crafts. They'd spend hours creating the perfect card for special occasions and painting murals for our pleasure (occasionally on their bedroom walls, but who am I to staunch the creative process?). When my daughter was little, she drew a picture of our new dog relieving himself on our lawn. We happened to be paper-training him at the time, which was a process she found very interesting. She punched holes all around the edges of the paper and threaded them with yarn, tying a bow in the end. She then wrote "Joe" on the top and gave it to her dad for Father's Day. Now that she's illustrating this book for me, I like to pull it out occasionally to keep her humble. The point, however, is that she gave Joe the best gift of all—a homemade gift of her time, talents, and thoughtfulness.

That's really what this book is all about—enhancing your holiday celebrations by exercising your creative talents and sharing these precious moments with friends and family.

What's in This Book?

In this book you'll find out how to celebrate the holidays by making unique craft projects, creating handcrafted gifts, and preparing special holiday meals for friends and family. You have to admit—you can't beat a home-cooked meal or a present crafted with love. This book is organized into the following five parts:

Part 1, **"Holiday Helpers,"** explains the process of setting yourself up for successful crafting sessions. You'll find out how to organize your work area and craft supplies, and how to use new crafting techniques. You'll also discover some tips on how to make time for crafts in your busy schedule, and how to deal with the stress that can occur during the holiday seasons.

Part 2, **"Curing the Winter Doldrums,"** contains ideas for making special crafts for Christmas, Hanukkah, Kwanzaa, and New Year's. You'll also find tips here for keeping the kids busy during their school break and for making traditional holiday foods to grace your dinner table.

Part 3, **"Time-Honored Holidays,"** celebrates the less hectic holidays of St. Valentine's Day and St. Patrick's Day. Seasonal crafts, family activities, and dinner menus are presented to the reader to inspire and entertain.

Part 4, **"Spring Ahead,"** urges the reader to do just that—spring ahead to the traditional celebrations of Earth Day, Passover, Easter, and Mother's and Father's Day. Once again, seasonal crafts, kids' activities, and delicious foods are detailed.

Part 5, **"Super Summers and Fall Favorites,"** delves into the celebration of the summer holidays such as Memorial Day, Fourth of July, and Labor Day, while incorporating a patriotic theme. It also deals with the two fall holidays, Halloween and Thanksgiving, and lists craft projects, activities, and party foods to celebrate these holidays in style.

Bonus Bits of Information

If you thumb through this book, you'll find interesting tidbits of information in the sidebars that describe holiday traditions, define the lingo, warn about crafting pitfalls, and explain how to further enhance a holiday project.

Festive Facts

These are additional bits of information that pertain to the subject being discussed. You'll find out things like what questions are asked at a Seder dinner, why Kwanzaa is celebrated, and how the Christmas-tree tradition got started.

Seasonal Sense

These are further definitions of the tools and materials that you'll be using in your crafting sessions. Look here to find useful information, such as when to use a **crimper,** how to replace stitches with **fusible webbing,** and what to do with a **spouncer.**

Holiday Hints

These tips contain ideas for adding to or transforming a holiday craft. You'll find out how to change the theme of a craft, use various crafting mediums, and substitute materials in your crafts if desired.

Holiday Hassles

These notes of caution are warnings about any pitfalls or dangers associated with the crafting process. For example, you'll find out when to wear protective clothing or eyewear and when to keep an eye on a heated project (such as melting wax for candles) so that it doesn't catch fire.

Acknowledgments

The success of this book was dependent upon the combined efforts of many people. First of all, I'd like to acknowledge my deceased father who helped to make our family's holidays fun and memorable when we were growing up. My mother, who has been a constant source of information to me during this writing process, has shared her many creative talents with me over the years. She played the unofficial role of "technical advisor" on this project. Thanks also to my sisters Carol and Lisa who allowed me to tap their own abundant sources of creativity.

I'd also like to thank my husband, Joe, who exercised his Journalism degree by helping me to edit my copy and who pitched in even more than usual to keep the household running during my deadlines. My daughter Melissa supplied her considerable creative talent to enhance the craft projects. She also painstakingly detailed the steps to making the crafts in the book with her precise illustrations. A pat on the back and encouragement from my son Ryan was what every mom needs to succeed.

I'd also like to thank the talented individuals at Alpha Books who made this project come alive. My acquisitions editor, Randy Ladenheim-Gil, encouraged my efforts and gave the book life and direction. Amy Gordon (development editor) helped to organize and keep the book on track, along with providing helpful ideas and guidelines. Copy editor Jan Zunkel ensured grammatical accuracy, and senior production editor Christy Wagner gave me valuable information and advice on the technical aspects of this project. Thank you one and all!

Trademarks

All terms mentioned in this book that are known to be or are suspected of being trademarks or service marks have been appropriately capitalized. Alpha Books and Pearson Education, Inc., cannot attest to the accuracy of this information. Use of a term in this book should not be regarded as affecting the validity of any trademark or service mark.

Part 1

Holiday Helpers

Getting organized is the key to successful crafting sessions. Without it, the following is too often a common occurrence: You find a clever craft idea in a magazine and decide to try your hand at making it. However, you don't have the right materials on hand so you clip out the article and set it aside. Somehow you remember to stop at the craft store on your way home from work. Once home, you look for the clipping (probably in a pile of bills by the refrigerator), only to realize you forgot to get something. Or even worse, you can't find the article. By this time, you're no longer interested in the project.

If this scenario is familiar to you, you'll want to check out the chapters in this part before you delve into the art of crafting. You can avoid hassles by incorporating these valuable shortcuts and tips into your experience. You'll learn the basics of successful crafting, including how to set up a work station, shop for, and store craft supplies, and how to make time in your busy schedule to enjoy the art of making crafts. You'll also find out how to streamline your holiday traditions to help make spending time with your family and friends the center of your celebrations.

Don't miss another opportunity to express your creative talents. Take the time to read these helpful hints to set yourself up for success.

Setting Up
for Success

In This Chapter

➤ Maximizing your creative potential by preparing your work area

➤ Learning where to find craft ideas and how to file them away for future reference

➤ Finding out what you'll need for successful crafting and where to buy it

➤ Reaping special rewards by involving your family in your crafting adventures

Making crafts is much like any other creative process—the hardest part is getting started. You may have plenty of ideas, but getting them organized and executed doesn't always happen as planned. Or you may have the basic crafting talent but not enough ideas to keep you happy in the process. Whether you just want to dabble in the creative arts or are committed to devoting serious time to your hobby, you'll want to consider a few details. In order to get started, you have to decide what you want to make, who you want to make it for, what craft medium you prefer to use, what materials you'll need, and how to put all these factors together into the perfect craft. If that's enough to make your head spin, keep on reading to learn how to get organized for crafting success.

This chapter will attempt to outline the basic concepts of crafting and teach you what tools, materials, and equipment you'll need to accomplish your goal—a handcrafted project that you can be proud of. You'll also learn where to shop for these items and how to make the most of your crafting experience.

The Planning Process

There's an important element of success connected to having all the necessary ingredients on hand to start and finish a project without interruption. To be able to do this, you only need to plan ahead and become the slightest bit organized. You could either accomplish this on an individual basis—buying the ingredients you'll need one project at a time—or you can stock up your craft corner and forgo the trip to the store for every crafting session. I've found the second method works best for me.

Holiday Hints

You might want to keep a disposable or instant camera handy to take pictures of possible craft projects as you come across them. Develop the pictures and arrange them in a photo album to refresh your memory when the time comes to create.

Besides the craft materials themselves, you might want to purchase a few basic pieces of equipment, furniture, and storage units for your work area. I'd recommend setting up shop in a corner of your home. I created a workspace in my family room because I enjoy having company when I craft. However, an attic space, basement, or spare room is also a great place to do crafts, and you'll be able to spread out and be a little messier. Wherever you set up, you'll need a table, a comfortable chair, some storage bins, a filing system, a trashcan, and, of course, your craft supplies. Good lighting, a pleasant sound system, and a fan or space heater can also help create a comfortable work environment.

Collecting and Organizing Project Ideas

Now that you've dug out a corner of your house and set up a workstation, it's time to organize your project ideas. Where do you find ideas for crafts? Books like this one are a great resource, of course. If you find yourself really getting into one specific craft, you could check some books out at the library or spend some time in the reading room of a bookstore to find the perfect book. There are craft magazines that you could subscribe to (see Appendix A, "Resources and Supplies"), and classes at craft stores or community colleges that you could attend. You also might want to visit craft shows or check out the free craft ideas offered on the Internet. I've also included a list of my favorite Internet craft sites in the resource section of this book.

Holiday Hints

The next time someone asks you what you'd like for a special occasion, tell him or her a gift certificate to your local craft store!

Once you've obtained your craft ideas, there are two filing systems that you could use depending upon how serious you are about collecting project ideas. You

could set up a scrapbook, or you can buy a small filing cabinet to arrange your ideas alphabetically or by season. This is a book about holiday crafts, but there are many craft ideas that don't have a season. I'd suggest keeping an alphabetical file, which includes all the seasons and holidays, and then putting other craft ideas into a miscellaneous file. I know this sounds like work, but you'll appreciate the effort when you decide to make that cute Halloween witch you saw in a magazine last year and can pull it out without a moment's thought. If you use the scrapbook technique, buy one with magnetized pages so that you can easily add articles and photos as you find them. Use binder dividers to keep the items categorized.

A Multitude of Mediums

There are so many different ways to make crafts that it's hard to keep them all straight. For example, if you like to paint, there are many mediums and techniques you can use. You could try your hand at sponge painting, stenciling, fabric painting, painting with special effect paints (such as rust or crackle paint), stamping, and so on. This section will attempt to list various craft mediums and the tools and materials that you'll need to accomplish a finished project.

➤ **Candle making:** beeswax sheets, wax pieces, paraffin, or gel wax; candle wicks; molds; candle scent; candle dye; decorative pieces (optional)

➤ **Clay beads:** *Sculpy* or *Fimo clay;* plastic knife for sculpting; toothpick for making holes in the beads; cord, wire, or elastic for stringing them; jewelry closures (optional)

➤ **Glass etching:** glass piece to etch, glass-etching stencils, masking tape, Popsicle stick, protective eyewear and clothing, etching solution, window cleaner

Seasonal Sense

Sculpy and **Fimo clay** are trademark brands of sculpting clay that can be molded into a project and baked in an oven until hardened. The clay is perfect for making many projects, such as molding sculptures, creating clay beads, or rolling and cutting out cookie-cutter ornaments. The clay projects should be baked in a 275°F oven for 15 to 30 minutes, depending upon the thickness of the items.

➤ **Homemade modeling dough:** 2 cups flour, 1 cup salt, 1 cup water, mixing bowl, rolling pin, and cookie cutters (optional)

➤ **Mosaics:** plastic molds; grout, plaster, or cement; decorative pieces such as tiles, marbles, or polished glass; tile cutting tool (optional); mosaic adhesive; sponge; mosaic sealant

➤ **Painting on fabric:** T-shirt or other fabric product, fabric paints (I prefer the kind that come in squeeze bottles), or acrylic paints and textile medium, iron-on transfers (optional)

➤ **Papier-mâché:** newspapers, bowl, flour, water, acrylic paints, clear acrylic finish spray

➤ **Scrapbooking:** Scrapbook, pages, decals, stickers, glue, markers, textured paper, decorative-edge scissors

➤ **Soap making:** block of clear glycerin; soap chips; soap dye; soap molds; soap scent; decorative pieces such as herbs, flowers, or plastic pieces

➤ **Sponge painting:** acrylic paints, sponges with varied textures

➤ **Stenciling:** stencil designs, tape, stencil paint, stencil brush or spouncer

Seasonal Sense

Crackle paint is a spray paint that you can use to create an antique finish on projects. You'll need two cans of different colored spray paint for this effect—a base coat and a finish coat. When the paint dries, the finish cracks as if it has been weathered. **Stone finish paint** also comes in a spray can and creates a cement-like finish on projects with one application. **Stained-glass paints** are translucent and can be sprayed on glass to create a stained-glass effect.

Individual Ingredients

Besides the tools and ingredients needed for special crafting techniques, there are many basic craft supplies that you'll want to have on hand to create your projects. It's a good idea to buy the larger (more economical sizes) of the materials you'll use over and over again (such as acrylic paints, glue, and papers). It's also best to buy quality tools, such as paintbrushes, glue guns, and scissors, that will hold up through a

multitude of projects. You may want to buy certain tools that are specific to the project materials you are using. For example, I have a pair of sharp scissors I use only for fabric because other materials would dull them.

One tip for organizing your supplies is to buy and label special bins for groupings of items you'll use together. For example, you can keep all your paints, paintbrushes, cleaners, foam trays, and so on, in one bin, and your paper goods such as construction paper, foam sheets, and copy paper in another bin. Wooden pieces such as Popsicle sticks, clothespins, craft sticks, and such, can also be kept in a separate bin or drawer; and so can yarns, threads, needles, ribbons, and so on. In other words, try to store your ingredients in groupings however it best suits you to remember where they are.

Now that you have an idea of how to organize them, let's take a look at the basic ingredients you should have on hand to become a crafting wizard. This may appear to be a long list, but you don't have to buy everything at once; you can assemble it over time as you create beautiful craft projects.

Paints, Brushes, Markers, and Finishes

➤ Acrylic or craft paints

➤ Stencil paints

➤ Nontoxic tempera paints (for working with kids)

➤ Special-effect paints such as *crackle paint, stone finish paint,* and *stained-glass paints* (You may want to buy these as needed for a project.)

➤ Fabric paints

➤ *Textile medium*

➤ Assortment of different shapes and sizes of paintbrushes

➤ Stencil paintbrushes and/or spouncers

➤ Sponges for sponge painting

➤ Stamps/stamp pads

➤ Set of permanent magic markers (I'd recommend ones with a thin point on one end and a thick point on the other end.)

➤ Basic colors of painter markers (These are optional, but they make painting small projects a snap.)

➤ Clear acrylic finish spray

➤ Wood stain

➤ Varnish

➤ Decoupage finish

➤ Paint, peel, and stick squeeze paints (These are also optional, but kids love working with this medium.)

➤ Plastic template for paint, peel, and stick paints

Seasonal Sense

Textile medium is a liquid helper that transforms acrylic paints into washable fabric paints. The advantage of this medium is that you don't have to spend a fortune on fabric paints that you wouldn't ordinarily use (for example, colors for a one-time project). However, fabric paints in squeeze bottles are easy to use and handy to have if you intend to do a lot of painting on fabric. If using textile medium, be sure to follow the directions on the bottle for preparing your fabric and making the painted area permanent.

Holiday Hassles

You should exercise caution when using a glue gun. If you have a high-heat glue gun, even a small drop of hot glue can cause a serious burn. I'd recommend buying and using a low-heat glue gun, especially if you'll be working with kids. You can buy colored and sparkle glue sticks that can be used to decorate projects such as wood, fabric, and metal.

Papers and Cutting Tools

➤ Pack of construction paper

➤ Pack of *foam sheets*

➤ Packs of foam-sheet cut-outs

➤ Tissue and crepe paper

➤ Textured papers

➤ Card stock

➤ Copy paper

➤ Tracing paper

➤ Transfer or copy paper

➤ Scissors

➤ Decorative edge scissors

➤ Exacto knife

Seasonal Sense

Foam sheets can be used in craft projects to replace construction paper. They are made of a foam composite material that can be cut, glued, and stapled like paper. However, foam sheets are more versatile and more permanent than construction paper. You can buy these sheets with a sticky backing for covering projects. You can also buy bags of foam cut-outs at craft stores that include seasonal shapes, letters and numbers, and fun designs. These foam sheets and cut-outs are great for making wreaths, calendars, costumes, puppets, and so on.

Fabrics, Trims, and Sewing Aids

➤ Assorted colors of felt
➤ Material remnants
➤ Trims such as lace, rickrack, and ribbon
➤ Yarn
➤ Thread
➤ Elastic
➤ Cord
➤ Embroidery thread
➤ Needles
➤ Fabric glue
➤ Fusible webbing
➤ Iron-on transfers
➤ Cotton T-shirts, carryalls, aprons, and so on (to paint)
➤ Feathers
➤ Pom-poms
➤ Buttons
➤ Polyester fill
➤ Sewing machine (optional)

Festive Facts

The early history of the sewing machine dates back to 1834, when Walter Hunt built a machine to sew a short seam. Elias Howe created a prototype in 1846 in Massachusetts, which was improved upon by Isaac Merritt Singer. Singer figured out how to mass-market the expensive invention by introducing the world to installment buying. Some experts argue that a Frenchman named Barthelemy Thimonnier created the first sewing machine, which he patented in 1930. This was a continuous-thread machine that was capable of replacing hand sewing.

Glues and Other Adhesives

➤ Low-heat glue gun

➤ Clear and colored glue sticks

➤ White and/or clear glue

➤ Tacky glue

➤ Fabric glue

➤ Mosaic adhesive

➤ Spray mount

Construction Materials

➤ Assorted wooden shapes

➤ Wooden picture frames

➤ Wooden plaques

➤ Popsicle sticks

➤ *Craft sticks*

➤ Clothespins (spring-loaded and peg)

➤ Wooden candleholders

➤ Wooden bead heads

➤ Wooden knobs

➤ Wooden heads that fit over clothespins

➤ Wooden and/or cardboard boxes

➤ Chalkboards in wooden frames

➤ Clay pots (assorted sizes)

➤ Sculpting clay

➤ Pipe cleaners

➤ Beads/bead wire or cord

➤ Ceramic objects (to paint on)

➤ Glass objects (to paint on)

➤ Plaster

➤ Cement

➤ Decorative glass pieces and/or marbles

➤ Styrofoam balls and wreaths

➤ Grapevine wreaths and forms

Seasonal Sense

You can find **craft sticks** in bags in craft or discount stores. They are wooden sticks (colored or plain) that have notched edges for assembling them in projects. They also can be snapped apart at the notches to form smaller sticks. You can use these sticks in many projects including building toys, decorating frames, making ornaments, and so on.

Decorative Items

➤ Dried and/or silk flowers

➤ Glitter

➤ Stickers

➤ Rub-on transfers

➤ Flocking kits

➤ Foil transfers

➤ Spanish moss

➤ Basket filler

Trash to Treasure

Two good sources of craft materials that won't break your budget are items recycled from the trash bin or collected at garage sales. You might want to make a list of the following recyclable ingredients and place it on your refrigerator to have family members save them for you. You could place a recycle bin in front of the trashcan to hold

these items until you're ready to store them. You might also want to attend local garage sales to find a variety of objects that can be used in your projects. Remember, one person's junk is another person's treasure.

➤ Glass jars: Mason jars, jelly jars, baby-food jars

➤ Tin cans

➤ Newspapers

➤ Foam meat trays (disinfect and use for paint palettes)

➤ Foam cups

➤ Toilet paper and paper-towel cardboard tubes

➤ Buttons from discarded clothing

➤ Cardboard boxes

➤ Cookie tins

➤ Sponges

➤ Shopping bags

➤ Paper bags

➤ Berry baskets

➤ Plastic milk cartons

➤ Plastic soda bottles

➤ Magazines

➤ Cardboard boxes that hold cases of drinks (These are good to use for spraying small items with paint.)

➤ Fabric scraps

Holiday Hints

You should check in the back or corners of craft stores for items that are placed on clearance. Even if they're from another season, they can be stored until you're ready to use them, and you'll get a good buy on supplies for future projects.

Shopping Suggestions

If you haven't bought craft supplies before, you may be wondering where to find all these ingredients. The first place you might try looking is your local craft store. There are several big craft store chains (such as Michaels, AC Moore, and JoAnn Fabrics) that have aisles and aisles of craft materials interspersed with craft project ideas. You could take a cart through these stores and buy just about everything you need to get started. There are also discount stores (such as Wal-Mart and K-Mart) that have craft sections that sell these items. You won't find the variety of items that you'd find in a craft store, but you may get a better price on some materials.

You can also get a variety of craft supplies, tools, and equipment on the Internet or from craft catalogs. However, you have to be careful that you don't get stuck with a large shipping bill. Many of the companies will waive the shipping fee if you buy a

certain amount of merchandise at a time. I feel that the prices on the Internet sites and in catalogs are comparable to craft store prices, although you can sometimes get a good deal on certain Internet items if you buy them in bulk. I've included a list of my favorite Internet sites and catalogs in Appendix A.

Why Bother?

Now that you know where to shop, what to buy, and how to organize it, you might need some incentive as to why you should go to all the trouble in the first place. Why make your own homemade crafts when you could purchase these at a craft show or gift shop? The answer to that question depends on your own personality. I know a lot of people who aren't interested in crafts or just don't have the time to spend on them. They do, however, enjoy getting something handcrafted on occasion. Of course, you won't want to give away all of your designs. There's also something rewarding about creating a work of art. Whether you hang a handmade wreath on your wall, make your own candles or soaps for your bathroom, or etch a pair of glasses with your initials, you'll derive a sense of satisfaction in a job well done.

Kids, friends, grandparents, and siblings can all get involved in the creative process. Making crafts with your kids or an older parent who is living with you can be a rewarding, bonding experience. I was fortunate to have my daughter around to help me make some of the crafts in this book. Melissa and I spent several creative crafting sessions together talking about what's going on in our lives. I found out things about her goals and ambitions that I would never have known if we didn't have this special time together. When my young nieces and nephews come to visit, they never fail to have a good time making "neat" crafts for their rooms or gifts for their friends and parents. It's a good way to get to know the people you love and to have fun doing it. You also have the added bonus of having a special memento of your time spent together.

Each chapter in this book contains a section of crafts and activities that are perfect for children. Grab the kids away from the TV and spend that next rainy day crafting lasting memories.

Necessity Is the Mother of Invention

You have your supplies; you have your incentive; now all you need is the talent, right? Not really. Talent is relative. Maybe you can't draw a straight line—so what—that's why they invented rulers. There are lots of little tricks and techniques to crafting that can turn you into a creative genius. For example, you can make almost any painted effect on a project simply and perfectly by using stencils or stamps and some paint. If you have trouble drawing faces, they make face transfers that can be rubbed onto your project instantly. Don't be afraid to try a project in this book just because you haven't been formally taught the techniques. Just follow the step-by-step simple

instructions under each project and you'll be successful. Just to give you an idea of how easy crafting has become, here are some craft substitutions that will make people think you graduated from art school.

➤ **Drawing flowers on a project:** Cut flowers from a magazine or remnant wallpaper borders and glue them onto the project. Cover the project with decoupage finish for a professional look.

➤ **Sewing a project with a sewing machine:** Use iron-on fusible webbing or fabric glue to hold fabric materials together.

➤ **Hand-lettering projects:** Use letter stickers, rub-on letters, or stenciled letters in place of calligraphy. Draw a faint pencil line to guide the placement of the letters on the project.

➤ **Painting a landscape on slate or a wooden plaque:** Paint the slate or wood with antique-white paint and use a colored rub-on transfer of a country scene to complete your project.

➤ **Decorating with seasonal shapes:** Buy bags of cut-out foam shapes, buttons, or decals.

➤ **Quilting:** Buy pre-quilted squares or sections of material in a fabric store and add some binding or finishing touches (such as sewn-on buttons and ribbons) to make them into a work of art.

➤ **Creating an antique effect:** Color the project with a base coat of paint. Mix some white paint with water (about two parts paint to one part water) to make a wash and spread this over the base color. You can rub it off in spots with a sponge or sand it off in some places when it's dry to give it a worn effect.

➤ **Painting on T-shirts or aprons:** Use an iron-on transfer to give you the basic design, and color it in with fabric paints.

➤ **Transferring a design to a project:** Copy the design using tracing paper. Tape a piece of carbon or transfer paper over the project and then tape the traced design over this. Trace over the design again to transfer it onto the project.

Now that you've gotten the basic supplies and information you need to craft the projects in this book, it's time to move onto Chapter 2, "The ABCs of Crafting," to learn some specific techniques that will help turn your projects into works of art.

The Least You Need to Know

➤ Getting your workspace and craft supplies organized will ensure success in your crafting sessions.

➤ There are certain craft supplies that are specific to the medium you use and others that are basic to the crafting process.

➤ Craft stores, Internet sites, books, catalogs, and magazines are handy sources for craft ideas and supplies.

➤ Getting your family and friends interested in your hobby makes your time spent crafting even more rewarding.

The ABCs of Crafting

In This Chapter

➤ Crafting basics to apply to your favorite projects

➤ Tricks of the trade to save you time and energy

➤ Traceable patterns to enhance your craft projects

One of the most difficult aspects of making crafts is figuring out how to use the mediums and tools. Fortunately, once you learn the techniques for crafting, you can use them over and over again. This chapter will attempt to show you the basic skills necessary to make the projects in this book. We'll explore the various crafting processes (such as painting, candle making, stenciling, and lettering), and learn the step-by-step methods used to create beautiful handmade crafts.

As you encounter these techniques used in projects throughout this book, you might want to refer back to this chapter for tips, shortcuts, and any necessary warnings. Specific crafting mediums will be presented in alphabetical order to help you access them quickly. Illustrations and sample artwork will appear under some headings, which will help you turn an ordinary craft project into a masterpiece.

Creating Candles

You can use several types of mediums to make beautiful candles from scratch. Basically, you can craft molded candles from melted wax pieces or melted gel wax,

or you can roll candles from sheets of beeswax. There are many types of decorative pieces that you can add to make your candles unique. You can also use liquid scent and dyes for a professional touch. The following are the basic steps to making beautiful candles.

Poured Wax Candles

Don't be afraid to try your hand at these lovely molded candles. They're a lot easier to make than you might think, and they create a romantic atmosphere when lit for dinner.

Prepare your mold by taping a wick with a metal tab onto the bottom of the mold. If you use a waxed wick (which is stiff), it should stand up in the middle of the mold. If you don't have a stiff wick, tape the other end of the wick to a pencil and lay it over the mold to keep the wick in the center.

Place the wax pieces (either colored wax pieces or chunks of paraffin) in a tin can such as a coffee can. Fill a frying pan half full of water and bring it to a boil. Place the tin can in the boiling water. Continue boiling the water until the wax is melted. Add candle dye and/or liquid scent and stir well.

Use an oven mitt to remove the can from the boiling water. Pour the wax into the mold, being careful not to disturb the wick. Poke any bubbles that may occur in the candle with a toothpick and refill the holes with more melted wax.

Holiday Hints

If you have broken crayons hanging around the house that you aren't using, you can peel them and add them to the wax pieces to color the candles. You can also remove the wicks from old or broken candles and re-melt them to make new candles. If you don't have a candle mold, try cutting the bottom off of a quart milk carton, washing it out, and using it for a mold. You can peel the carton off when the wax is hardened.

Gel Candles

Making gel candles is a new trend that is creative and fun to do. There are many options to consider when choosing a container for a gel candle. For example, you can

make candles in cocktail glasses as decorations for an adult party (see Chapter 7, "In with the New," for directions), or you can make a whimsical fish bowl candle for a unique mother's day gift (see Chapter 13, "Parent Perfect," for directions).

Prepare the candle container by gluing or taping the end of a wick to the bottom of it. If the wick is not stiff (waxed), tape the other end of the wick to a pencil and lay it across the top of the container.

Place any decorative pieces that you wish to sink to the bottom inside the container (such as marbles and decorative glass), being careful not to disturb the wick.

Spoon out about $\frac{1}{3}$ of the gel wax into a small saucepan. You might have to use a knife to cut around the edges of the gel to facilitate an easy removal. Melt the wax on low heat for 5 to 10 minutes or until it turns to liquid. Add a couple drops of dye to the gel if desired. Place a candy thermometer in the gel when melting it and do not exceed 260°F.

Carefully pour the wax into the prepared container, keeping the wick straight up and down in the center. Allow the wax to cool for about 10 minutes. Using tweezers, insert any decorative pieces that you would like to appear to be floating in the candle into the gel on the side of the container, away from the wick. Allow the candle to cool thoroughly (several hours) before handling.

Holiday Hassles

When making homemade candles, be especially careful that the wax doesn't boil over or spill onto a burner. Wax is highly flammable and will catch fire instantly. Have some sand on hand to put out any accidental fires that could occur. (If you're careful and keep your eye on the melting wax, then you shouldn't have a problem.) Don't throw unused wax down a drain or a clog will occur when it hardens. Gel wax should never be melted in a microwave oven.

Rolled Beeswax Candles

Beeswax candles can be rolled or molded into unique shapes according to your preference. They burn clean and clear and give off a pleasant natural essence.

Place the beeswax sheet on a cutting board. Using a ruler and an Exacto knife, cut the wax to the desired height and width. Allow at least 6 inches of beeswax as the width to make sure you have enough to roll around the wick.

Cut a piece of candle wicking 1 inch longer than the height of the candle. Place the wick on one end of the beeswax and begin to roll the beeswax tightly around the wick. Apply some pressure to the candle when rolling it, and mold the ends together to keep the wick in place. The tighter you roll the candle, the better it will burn. If necessary, use a hair dryer to heat the beeswax to make it more pliable for rolling into candles.

Drawing Designs

Many books and pamphlets in libraries, bookstores, and craft stores show you how to draw objects such as faces, animals, designs, and flowers. If you decide to make your own patterns on projects, I'd suggest investing in a few how-to books. The sample designs I give you here will help get you started on an artistic path. If you would prefer to trace these illustrated designs onto your craft project, you should refer to the technique described in the "Transferring Tricks" section later in this chapter.

Some steps to drawing your own designs.

(© Melissa LeBon)

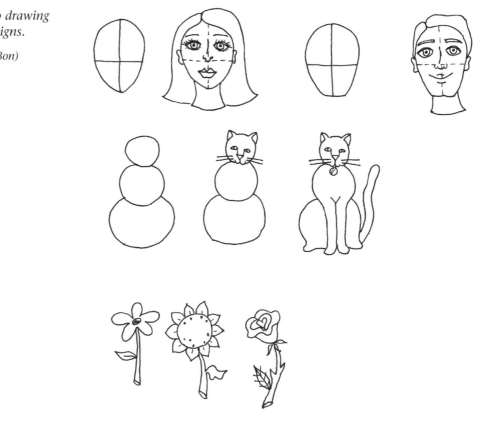

Etching Glass

Glass etching is a little involved, but once you get the hang of it, you'll be able to customize glasses, vases, tabletops, and just about anything that's made of glass. The following are the basic steps to using a glass etching kit:

Clean and dry your glass object with water and a paper towel.

Select a stencil design and position it on the glass, securing it with masking tape on the edges.

Rub the stencil with a Popsicle stick to transfer it to the glass, being careful not to gouge the stencil. The stencil will become cloudy when transferred. Remove the top sheet of the stencil by peeling it back.

Apply a border of masking tape around the stencil, overlapping it by $1/8$ inch to prevent etching cream from etching unwanted areas.

Shake the etching cream thoroughly. Don protective eyewear, clothing, and gloves. Using a paintbrush, apply a thick layer of etching cream over the stencil. Allow this to remain on the stencil for one minute only, then wash it off under warm water.

Remove the tape and stencil, and clean the glass with window cleaner.

Holiday Hassles

Be sure to wear protective eye-wear and clothing and gloves when using etching cream. Glass etching solution is an acid that can burn exposed skin. You should keep this product and other toxic craft products in a locked cabinet, out of the reach of children and pets.

Marvelous Mosaics

There are several mediums that create unique mosaic effects. You can use decorative pieces embedded in plaster, cement, or grout. Or you could use adhesives to glue colorful plastic pieces onto a glass object to make a stained-glass effect.

Plaster Mosaics

Plaster is inexpensive, easy to work with, and creates a clean, smooth background for mosaic pieces. Check out the hardware store for an economical bag of plaster to use in this project.

Pour the powder plaster into a mold to about $2/3$ full. Add water according to the manufacturer's directions (approximately three parts plaster to one part water). Mix the water into the plaster with a putty knife. The plaster mix should be the consistency of thick pancake batter. Burst any bubbles with a toothpick and smooth the top with a trowel or Popsicle stick.

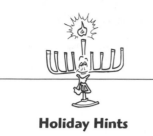

Holiday Hints

You can make many unique craft projects using mosaic techniques. You could make a stepping-stone for your garden (see Chapter 13), coasters for your coffee table, a trivet for your kitchen, or a stained glass votive light using a small glass fishbowl. (See *The Complete Idiot's Guide to Making Great Gifts* for directions for mosaic coasters, trivets, and votive lights.)

Add the decorative pieces and allow this to harden for about 15 minutes. Wipe the mosaic with a wet sponge to remove any excess plaster. Do not move the mold until it has hardened overnight. Spray the finished product with clear acrylic finish spray.

Cement Mosaics

You can make cement mosaics using decorative pieces and/or add a pair of handprints or paw prints to the wet cement and give it as a gift to a grandparent.

Pour the cement powder into an old bucket. Mix this with water according to the manufacturer's directions on the bag or box. Pour the mixed cement into the mold.

Add the decorative pieces on top and allow this to dry about 15 minutes. Wipe the mosaic with a wet sponge to remove any excess cement. Do not move the mold until it has hardened overnight.

Paint the hardened mold with mosaic sealant and allow this to dry overnight before using it.

Stained-Glass Mosaics

Light up their lives by making your friends a stained-glass votive holder. You can also make a stained glass votive by painting a design on it with stained-glass paints and simulated lead and eliminating the grout.

Buy bags of plastic stained-glass pieces at a craft store. Glue these onto a glass object (such as a vase) using mosaic adhesive. Allow this to set overnight.

Mix a bag of grout according to the manufacturer's directions. Apply the grout to the plastic pieces with a Popsicle stick, filling in the cracks. Allow this to set for about 10 minutes, then wipe it lightly with a damp sponge to remove excess grout from the top of the plastic pieces. Allow the grout to dry overnight. Spray the finished project with clear acrylic finish spray.

Practicing Painting

You can use stamps, sponges, stencils, stickers, decals, transfers, and so on, to make lovely designs on projects. If, however, you'd like to try your hand at painting your own professional design, you might want to try out these techniques presented by artist Colleen Wilcox of Mountaintop, Pennsylvania.

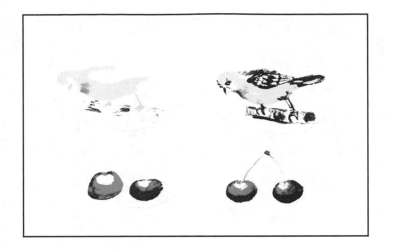

Steps to painting a bird and cherry.

(© Colleen Wilcox)

Cheery Cherry

Show off your creative talent by painting this lovely cherry on a clay pot for the kitchen.

Using acrylic paints, start with a darker red and a lighter red paint. Paint the darker red along the outline of the cherry and leave a small white patch in one corner (could be top center). Fill in the cherry with the lighter red paint being careful not to paint over the white patch.

Mix your red with white to make pink paint, and paint that around the edge of the white patch. You can add a touch of yellow in a spot around the white. Paint the stem with a light green color. Add some brown and darker green to the tips and edges of the stem.

Basic Birds

If you think painting is for the birds, you haven't tried making this beautiful yellow bird that would look lovely painted on a garden sign or a bird house.

Sketch the basic outline of the bird. Using acrylic paints, paint the bird a yellow base color. Paint a darker orange patch on the head and chest.

Fill in the edge of the beak and legs with gray paint. Shade the underside of the bird with brownish-yellow streaks. Add a darker gray or brown to the forehead, back, and underside of the neck and above the legs.

Add black on the wings, tail, and legs.

Tips to painting a lovely seashell.

(© Colleen Wilcox)

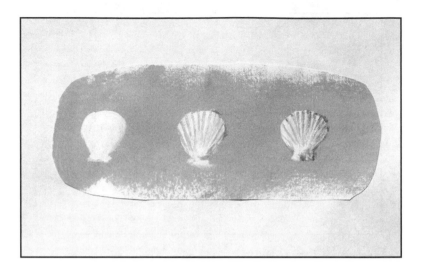

She Sells Seashells ...

You'll reminisce about the shore every time you see this shell motif painted onto a plaque or decorative item. Try this design on a welcome sign for a beach home.

Sketch the basic shell shape. Using acrylic paints, paint the shell white, mixed with a touch of yellow. Add gray lines to create a shell texture. Add a touch more of yellow to the shell along the gray lines.

Darken the tops of the lines with a darker gray. Also, use this color to outline one side of the shell. You can add a touch of brown or orange at the bottom for variety.

Steps to painting a flower design.

(© Colleen Wilcox)

Flower Power

Flowers are a versatile décor and are easy to design yourself. Try painting this flower in several different colors on a wooden serving tray to use for summer refreshments.

Using acrylic paints, paint a basic petal shape in a solid color. (You can sketch it in first, if desired.) Add a darker version of that color in streaks near the ends of the petals.

Paint some more quick streaks of a shade that is lighter than the first base color on the inside of the petals. Finish up with a dot or streak of white on top of the lighter streaks. Outline the flower in black and, if desired, add some darker flowers in the background or nearby.

Papier–Mâché

The basic ingredients for papier-mâché are flour, water, and newspapers, but you can substitute other materials and/or fibers for the newspaper to make different effects. Follow this recipe for best results:

In a bowl, mix $3/_4$ cup flour with $1/_2$ cup water. You could also mix about $1/_3$ cup white glue with 3 tablespoons water instead to make a more translucent paste.

Cover the project with the paste and add layers of torn up strips of paper. You could use newspaper, tissue paper, crepe paper, brown paper bags, or experiment with other scrap papers. Allow this to dry until hardened (usually overnight).

The following are some ideas for projects made from this medium:

➤ **Papier-mâché masks:** Cover a large balloon with papier-mâché, allow it to dry, pop the balloon, and cut the ball in half. Paint the mask with acrylic paints (see Chapter 15, "Halloween How-To's," for directions).

➤ **Piñata:** Cover a large balloon with papier-mâché. Leave an opening at the knot to insert candies or treats when it's dry. Paint the piñata with acrylic paints and add features with tissue paper or foam sheets. You could also use smaller balloons to make Easter eggs or Thanksgiving gourds.

➤ **Papier-mâché boxes:** Cover a gift box with papier-mâché strips and allow it to dry. Paint the box with acrylic paints and varnish or spray it with clear acrylic finish spray.

Printing

You don't have to be an expert at calligraphy to be able to make professional-looking lettering on your craft projects. These simple illustrated tips will help you make the

most out of your lettering prospects. If you're really serious about doing your own printing, you might want to invest in a good calligraphy pen or marker and take a class in the art. This would be particularly helpful if you like to do scrapbooking or to design your own stationery.

Tips to making professional letters.

(© Melissa LeBon)

Sculpting

You can mold various forms of sculpting materials into craft designs. Two of my favorites are store-bought and homemade types of clay or dough that you can roll and cut out or model into shapes. Projects made from both of these dough mediums can be baked in an oven to harden and make them permanent. You can paint the shapes with acrylic paints and varnish them to make a finished product.

Sculpy or Fimo Clay Beads

Make your own jewelry for your next holiday bash using this easy-to-work-with clay medium.

Knead the clay with your fingers to soften it. Roll the clay into snakes and then cut them into beads to make jewelry. Roll two or three colors of clay together to form a twisted color effect. You can also roll several colors of clay together and form a contrasting color of clay into a flat piece to cover the roll. When you cut the beads, there will be an outline color on the outside.

Be sure to make holes in the beads with a toothpick or sharp instrument before baking them. Bake the beads in a 275°F oven for about 15 to 20 minutes or until the clay is hardened. Varnish the cooled beads and allow them to dry.

This clay can also be rolled out onto a flat surface with a rolling pin and cut out with cookie cutters. These clay designs make nice ornaments, gift tags, or dough shapes for decorating craft projects (such as picture frames, wreaths, and plaques).

Holiday Hints

You can make dough ornaments out of an aromatic apple/cinnamon concoction that has a delightful holiday smell. Simply mix 1 cup ground cinnamon, $^2/_3$ cup applesauce, and 1 tablespoon white glue in a mixing bowl. Mix well and roll out onto a flat surface with a rolling pin. Cut out shapes with cookie cutters and bake in a 350°F oven for 8 to 15 minutes, or until the dough turns golden brown on the edges.

Homemade Clay or Dough

Save yourself a trip to the craft store and some of your own dough by making this pliable puffy salt dough.

In a mixing bowl, combine 2 cups flour, 1 cup salt, and 1 cup water. Work out any lumps that may occur. If the mixture is too dry, add a small amount of water. If it's too wet (sticky), add more flour.

To make ornaments, roll the dough onto a floured flat surface with a rolling pin. Cut shapes out of the dough with cookie cutters and bake them on a cookie sheet in a 350°F oven for approximately 8 to 15 minutes, or until the edges are golden brown.

You could also sculpt your own shapes out of this dough and bake them as you would the cut-outs. You may need to add to the baking time depending upon the thickness of your project. If desired, paint your sculptures with acrylic paints and coat them with a layer of varnish.

Seasonal Sense

A **spouncer** is a special paint–brush with a rounded foam end. This tool is used for dabbing paints onto projects. It is especially helpful when working with stencils to get full coverage of paint on your design area.

Holiday Hints

If you own one, you could use a projector to enlarge designs and transfer them to projects. This is especially helpful when painting large designs on walls.

Stenciling

Stenciling is a fairly easy craft medium that produces great results. If you're not into painting, you could substitute stenciled effects for hand-painted designs in your projects. There is a vast array of stencils and paints on the market, including many holiday designs. You can find almost any stencil pattern to fit your project.

To prepare your project for stenciling, cut out the stencil of choice and tape it on your project. Use special stencil paints and apply them to the stencil area with a stencil brush or *spouncer*.

To create a unique stencil effect, dab the paints onto the project, making some areas lighter or darker in places as desired. Be careful not to move the stencils when painting them to avoid smearing the paints. Remove the stencil and allow it to dry. Spray the project with clear acrylic finish spray if desired.

Transferring Tricks

You can transfer the designs shown here, or other printed designs, to a project in minutes following these simple steps:

Place tracing paper (or thin copy paper) over the illustrated design. Trace this with a pen.

Tape a piece of carbon or transfer paper on top of your project surface. Tape the tracing paper on top of this and retrace it with a pen. The design will be transferred to your project.

Some sample designs to transfer onto your projects.

(© Melissa LeBon)

Scent-Sational Soaps

Making homemade soaps is a simple project that is both fun and rewarding. You can add decorative pieces and natural fibers to your soaps to make them even more appealing.

Using a knife, cut off two squares of a clear glycerin block and place them in a microwave-safe cup. Cook on high in the microwave for 40 seconds or until melted.

Stir two drops of soap dye or food coloring and one or two drops of liquid soap scent into the mixture. Add any decorative pieces such as soap chips or fibers to the melted glycerin.

Pour the mixture into soap molds. Allow them to harden overnight before popping them out of the molds.

The Least You Need to Know

➤ There are basic techniques that you can learn once and then use over and over again when making crafts.

➤ You can give your craft projects a professional touch by following the simple painting and drawing methods outlined in this chapter.

➤ You don't have to have an art degree to create skillfully executed crafts that will win rave reviews.

Stress-Free Holidays

> ### In This Chapter
>
> ➤ Decorating your home and crafting holiday gifts at the same time
>
> ➤ Speeding up pre- and post-party cleanups
>
> ➤ Planning and executing holiday menus
>
> ➤ Avoiding the stress that accompanies a holiday season

Holidays should make you feel happy and relaxed. They should also be fun times that you share with your family, outside of your usual routine. Unfortunately, sometimes they become a time of competition to see who can put up the most decorations, make the largest batch of cookies, or buy the most presents. If you feel like the Grizwald family in the movie *Christmas Vacation,* you owe it to yourself to slow down! Catch your breath and avoid doing anything that stresses you out to the point of no return.

What will *you* do when the next holiday pops up on your calendar? You could either panic at the sights and sounds of the approaching season, or you could spend a little advanced preparation and turn your holiday into a refreshing break from the old grind. Spend the holidays with your family and friends having fun together instead of obsessing over the things that need to be done. Check out the relaxing holiday crafts and activities in this book, and devote yourself to sharing rewarding time together with your family. Remember, chores and errands will always be there, but time spent with your family is precious.

You may be wondering how you'll find time to create holiday crafts during these hectic days. That's where this chapter will come in handy. Hopefully, if you incorporate these tips and shortcuts into your holiday routine, you'll find you still have time left over for the fun stuff.

This chapter will take you step-by-step through holiday activities and help you find time in your schedule that you can use to exercise your creative energy. Gather your family around you and make a list of do's and don'ts for the holidays. Spread the chores out and remember that "Many hands make for light work."

De-Stressing Holiday Shopping

If you literally shop until you drop, you might want to rethink your holiday buying habits. Take a look at what's stressing you out about this activity and reassign or revise the holiday plan. For instance, maybe you like to shop but hate to wrap presents. You can either assign this task to older children or a spouse or use the store's gift-wrapping service. Try shopping ahead of time so you can get things finished before the terrible lines begin to form. I like to pick up little things like stocking stuffers throughout the year and wrapping them as I go along.

You might want to consider giving gift certificates to stores, movie theatres, restaurants, and so on, for the long-distance or hard-to-buy-for people on your gift list. You'll save yourself the hassle of shopping for, wrapping, and shipping presents.

Other options for Christmas shopping include shopping over the Internet and shopping from catalogs. If you live in a rural area, you'll find more variety in gift ideas using these options. Make sure you check out shipping costs and schedules before ordering.

Holiday Hassles

If you decide to buy your gifts over the Internet, be sure that they can deliver in time for the holiday. You should start early enough to avoid the cost of overnight shipping. Be sure the site is secure if using a credit card online.

How About Homemade?

You can also turn the hectic activity of shopping for the holidays into a stress-free craft session by making gifts for the people on your list. Lots of ideas for seasonal crafts in this book would please the people on your list—from the smallest tyke to the wiser, more mature recipient. If you shop for the materials right after the holiday is past and save them for next year, you can make a killing on craft supplies for your projects. Be sure to buy enough supplies to make a couple of the crafts that you really like so you and/or your kids can keep a few for yourselves! You could also check out *The Complete Idiot's Guide to Making Great Gifts* for more gift ideas.

The following are some fun holiday ideas for making homemade gifts. These projects can be found in the book, but I've included some suggestions for presenting them:

➤ Make the Christmas stocking in Chapter 4, "Christmas Cheer," and fill it with craft supplies for kids (such as beads and other supplies for making jewelry, scrapbook supplies, and items for working with clay). You could put aromatherapy items (such as candles, bath salts, and aromatic sprays) in the stocking for adults. A college kid would probably appreciate a stocking full of health and beauty supplies.

➤ Make the wire picture frame in Chapter 5, "Hanukkah Happiness," and place a picture of the kids in it for their grandparents.

➤ Make the woven basket in Chapter 6, "Kwanzaa Creations," and fill it with fruit to bring to a Kwanzaa dinner.

➤ Make the bottle bag in Chapter 7, "In with the New," and fill it with a bottle of champagne or wine for a New Year's Celebration. You might want to include a set of flutes for toasting in the New Year right.

➤ Make the flocked box in Chapter 8, "Be My Valentine," to present a lovely piece of jewelry for someone special.

➤ Make the leprechaun with the growing hair in Chapter 9, "Kiss Me, I'm Irish," and present it to a hospitalized friend.

➤ Make the memory game rocks in Chapter 10, "Earth Day," and sew a velvet bag for them using the directions for the bottle bag in Chapter 7 (modified to fit the rocks). You can change the symbols on the rocks to fit the season. For example, you could make dreidels, Stars of David, menorahs, and so on for a Hanukkah theme, or bunnies, eggs, chicks, and so on, for an Easter theme.

➤ Make the decoupage Seder plate in Chapter 11, "Passover Celebration," along with the Elijah's Cup and present them to the host of your Seder dinner.

➤ Make the Old-Tyme Basket in Chapter 12, "Easter Excitement," and fill it with gardening supplies for a gardener, baby supplies for a new baby, pet supplies for a pet, and so on.

➤ Make the tackle box presented in Chapter 13, "Parent Perfect," and fill it with fishing supplies for Dad or a child who's interested in the hobby.

Holiday Hints

If you decide to make a gardening basket as a gift, you'll want to check out the mosaic stepping stones in Chapter 13 to include with the gift. You could also paint and stencil a clay pot or gardening gloves or make a garden stone to add to the basket.

➤ Make the cardboard boxes in Chapter 14, "Patriotic Pride," and fill them with treats for Christmas, Hanukkah, or Kwanzaa.

➤ Make the clothespin cat in Chapter 15, "Halloween How-To's." Place the cat plus other supplies needed to make wooden animals (such as bags of wooden pieces, pom-poms, feathers, glue and so on) in a gift bag. Present this to a child for a holiday present.

➤ Make the woven mats in Chapter 16, "Talking Turkey," in seasonal colors to use for a Kwanzaa, Hanukkah, or Christmas dinner.

These are just a few ways you can turn your holiday crafts into unique presents for the people on your gift lists. Don't be afraid to modify the crafts in this book to fit your holiday needs. Many times, simply changing the colors on a project will make it appropriate for a different season.

Decking the Halls

Decorating your home for the holidays doesn't have to be a dreaded chore. You can dress up your home inside and out with a few holiday decorations that you can use over and over again. Think about where you and your family spend the most time together and concentrate your efforts on that room. The more items you put out, the more you have to pack away after the holiday season.

Festive Facts

One of the most elaborate holiday decorations is the Christmas tree. In pre-Christian times the evergreen was worshiped as a symbol of immortality. Because of its constant living state, it was thought to possess magical powers. However, the tree we decorate in the home stems from Christian symbols, specifically the paradise tree and the Christmas light. During medieval times, miracle plays took place that enacted biblical scenes. Adam and Eve's fall from Paradise was a popular theme and the stage was decorated with a fir tree hung with apples. The Christmas light represented the miracle of the birth of Christ as the light of the world. Pyramid-shaped frames were erected by Christians and decorated with tinsel, glass balls, and candles. In sixteenth-century Germany, people began combining the two trees and added cookies and other treats to remind them that this was no longer a tree of sin.

You might want to check out the sections in this book containing seasonal symbols in each holiday chapter to get ideas for handcrafted decorations. If you decorate with your own creations, you can wrap them up and give them away if you need a quick holiday gift. Just to whet your appetite, here are a few suggestions for Holiday decorations that you'll find in the book:

➤ **Chapter 4:** An Advent calendar to count down the days until Christmas, a trendy clay pot Santa, a heavenly angel, beaded ornaments to grace your Christmas tree, and stockings to hold Santa's goodies.

➤ **Chapter 5:** A lovely glass menorah, a dreidel made from clay with a matching box, a 3-D dreidel garland, and a beautiful Star of David to hang on your door.

➤ **Chapter 6:** A unique Kinara made from wood, a beautiful unity cup for the Kwanzaa feast, a braided basket to hold the fruits and vegetables of Kwanzaa, and a reusable calendar to mark important holiday events.

➤ **Chapter 8:** A heart wreath with a Victorian look, Valentine's Day cards that say "I Love You," a welcoming slate heart painting, and a tin of roses to add an element of warmth to your home.

➤ **Chapter 9:** A smiling leprechaun made from a box, a good-luck elf, and a mischievous leprechaun that grows its own hair.

➤ **Chapter 11:** A modern Afikomen to hold the Matzoh, a beautiful Seder plate with gold accents, a wire-and-bead Elijah's cup, and a trendy pillow to recline upon.

➤ **Chapter 12:** A cute pot of bunnies, an old-tyme Easter basket, a Popsicle cart candy dish, and lacy Easter eggs.

➤ **Chapter 15:** A stuffed paper ghost to scare trick-or-treaters, a wicked witch to hang on your door, and a cute black cat made from clothespins.

➤ **Chapter 16:** A fall wreath to welcome guests, a hand-carved pumpkin centerpiece, wooden turkey place cards, and woven place mats to grace the dinner table.

These are just a few decorating ideas that you can find in this book. You might want to spend some of your decorating time and budget enjoying the art of crafting with your friends and family.

Kitchen Quickies

Whether you throw an elaborate banquet for the holidays or have a scaled-down version of your traditional family favorites, you can't go wrong by starting some cooking traditions with your family during the holidays. Once again, this book will come to your rescue when planning your holiday meals. At the end of each chapter you'll find

a few traditional meals of the season to get you started with your menu. You can also find many recipe and menu ideas on the Internet. Get your family involved in the food planning and shopping so that they'll be more interested in helping you prepare it for the big day.

If you don't have a lot of time to cook over the holidays, you might want to consider having a caterer supply the main dishes and concentrating on one aspect of the meal, such as appetizers or desserts. If your budget is stretched, you could supply the main dish and have guests bring a dish that is their specialty. Try making up some side dishes or desserts ahead of time and freezing them until the party.

If you like to bake a lot of cookies over the holidays, you might want to get together with some neighbors and form a cookie swap. Each family involved should bake two or three batches of their favorite recipe (depending upon how many families are participating—you'll want at least two dozen of each type of cookie for every family). You can plan a small get-together to swap the cookies. If you're throwing the get-together yourself and you celebrate Christmas, you might want to consider combining this event with a tree-trimming party to help get your house decorated.

Crafty Cleanups

One of the best ways to keep an area clean is to not get it dirty in the first place. You might want to keep these tips in mind when working on your craft decorations and gifts.

➤ Save old newspapers to cover your work area when you use messy mediums like paint, dough, glue, and so on. You could also purchase plastic tablecloths at party stores to cover your work area. If you shop for these items after a holiday season, you can usually get them on clearance for pennies. Keep a trashcan handy for quick cleanups.

➤ Consider taking your crafting outside, if the weather permits, and using a picnic table or deck. You'll enjoy the fresh air and easy cleanup.

➤ Use the cardboard boxes that come with cases of soda to transport and spray paint smaller

Holiday Hints

Consider cooking your dinner on the grill when you craft outside. You're already out there, and it will save cleaning up a kitchen afterward.

Holiday Hassles

If you decide to take your craft projects outside to spray them, be sure you still protect the area around the project with newspapers or cardboard boxes. Sprays such as paint and finishers will kill any areas of grass that they touch. Some finishing sprays—even though they're clear—can change the color of a finish on a deck.

craft projects. You could also use these boxes as backdrops when spraying larger projects to catch any wandering sprays.

➤ Buy a plastic organizer to carry your paints, brushes, and immediate crafting supplies to your work area. You can keep these basic supplies handy and organized and save yourself the time spent gathering them each time you need them.

➤ Save old Styrofoam meat trays, plates, and cups to use when painting projects. Disinfect the meat trays with hot soapy water before using them, and toss them into the garbage when you're finished.

The Party's Over

All that work, and the next day you're left with a huge cleanup! It hardly seems fair that you should have to be stuck in the kitchen again, only this time scrubbing floors and scouring pans. This is where it's a wise idea to get a little help from your family. You might want to make a list of cleanup chores on a pad of paper, cut them into strips, and place them in a bowl. Then make a list of rewards on paper (such as a movie, a bubble bath, a trip to the ice-cream parlor, or a back rub), cut them into strips and place them in another bowl. Have members of the family pick from the yucky bowl first, and when they've finished their chore, they can pick from the rewards bowl. For fun, you might want to allow trading, selling, and auctioning off of chores and rewards.

You could also play a game to see who can finish their chores first and award a prize (such as a candy treat or a favorite game) for a job well done. During holiday time—or all the time, for that matter—you might want to assign areas of the house for each family member to police and pick up as necessary. You'll find the stress levels go down when you aren't the only one picking up dirty clothes or placing kicked-off shoes in the closet.

Avoiding the Post-Holiday Blues

The holidays are such exciting times that it's possible to get so wrapped up in parties, events, and activities that you don't know whether you're coming or going. The stress of preparing for and enjoying all of this activity, coupled with the feeling of relief or letdown when it's all over, can have an emotional effect upon you and your family. Kids in particular are usually on an emotional high during the holidays. School is on break and they have whole days to obsess about the exciting times ahead. The anticipation may be a bit much to handle, but the letdown that occurs when it's all over and time to go back to school is sometimes a cause for concern.

You can help to alleviate these emotional highs and lows by moderating the level of activity. Try to find fun things to occupy their time during the days before and after a big event. Once again, you'll find activities in the kids' sections of each chapter that

will fit the bill. For example, you could have the kids help make decorations for a holiday one day, help prepare a menu another day, pick up the house another day, and so on. Once the holiday is over, plan some after-school activities that they can look forward to when the school day is over. Consider your own emotional needs also, and hire a babysitter to watch the kids while you go out with a spouse or friends to a movie or dinner.

The Final Word

Hopefully, this chapter has helped you find some time in your busy schedules and has given you some ideas of how to use this time efficiently. People are the root of all holiday celebrations, and they, not the trappings, should be the focus of attention. Keeping your family central to the holiday events will provide many warm and rewarding memories for the years to come. Make it a family tradition to forgo the stressful aspects of the holidays and focus on quality time spent enjoying the company of friends and relatives.

The Least You Need to Know

➤ You can craft holiday decorations and also use them as last-minute gift ideas.

➤ Get your house cleaned for the holidays by organizing your own family cleanup crew.

➤ Cooking for holiday meals is always easier with a little help from your friends.

➤ You can avoid the stress of the holidays by giving yourself a break and divvying up the chores.

Part 2

Curing the Winter Doldrums

Once the passage of Thanksgiving has officially kicked off the winter holiday season, it's time to start thinking about plans for the upcoming holidays. Whether you celebrate Christmas, Hanukkah, Kwanzaa, New Year's Day, or several of these holidays, you'll want to check out these chapters for craft ideas to brighten up your winter festivities.

You'll learn how to create beautiful symbols of these seasons that will be handed down from generation to generation. You'll also find New Year's Eve party ideas that will make your guests want to remember their old acquaintances.

So put some holiday music on the CD player, read this part, and get busy creating a festive mood for your next holiday celebration.

Christmas Cheer

> ### In This Chapter
>
> ➤ Making symbolic Christmas trimmings to decorate your home
>
> ➤ Designing creative containers and wrappings for your gifts
>
> ➤ Crafting fun for your kids during Christmas break
>
> ➤ Turning your kitchen into Santa's workshop

Christmas is a unique holiday, celebrated in many different ways by people throughout the world. But one common thread is that Christmas celebrates a spirit of generosity, represented by a jolly old elf called Santa Claus. Like most other families, you probably spend time together during this season by decorating your home, buying and wrapping presents, and preparing food for the festivities.

Christmas vacation is a perfect opportunity to take some time from the hustle and bustle of the season and create your own version of good will on Earth. Make a date with your loved ones to try out some of the crafts in this chapter. You can get ahead of the game by substituting a hectic shopping trip to the mall with a relaxing session of craft-making. You might even decide to share some of these handcrafted treasures with the people on your gift list.

Christmas Creations

Plenty of Christmas symbols can be crafted into stylish decorations for your home. Check out the following crafts to get you started on the path to Christmas cheer.

Festive Facts

The American Santa Claus legend is based on the life of a real person—Saint Nicholas. Nicholas was a bishop of the city of Myra in Turkey in the fourth century. He was known for his generosity to the poor and for his love of children. The Dutch kept his spirit alive, calling him "Sint Nikolass," which in America became "Sinterklass." "Santa Claus" was a later derivative of the Dutch name. The figure of the modern-day Santa Claus is credited to Thomas Nast who, in the mid-1800s, created a series of Christmas drawings for *Harper's Weekly*. Much of the lore of Santa Claus was provided by Dr. Clement Clarke Moore's account of *The Night Before Christmas*.

Countdown to Christmas

With this Christmas calendar, you and your loved ones can enjoy the daily surprises under each door. Melissa LeBon, of Mountaintop, Pennsylvania, designed this clever house-shaped Advent calendar to count down the days to Christmas. (See the color insert for more details.)

Marking off the days to Christmas.

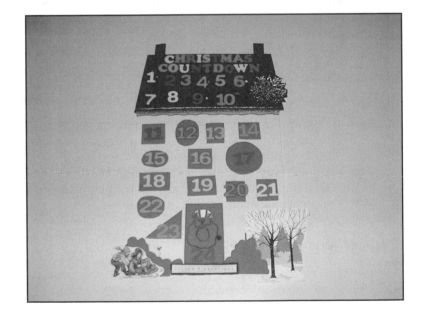

Level: Moderately easy

Time involved: Two to three hours

Materials:

> 12 × 18 inch foam sheets: one green, one brown, one red, two white
>
> Scissors
>
> Exacto knife
>
> Cutting board
>
> Glue gun
>
> Bag of foam letters (These can be found in craft stores.)
>
> Old Christmas cards
>
> Bag of foam numbers (These can be found in craft stores.)

1. Using scissors, cut two pieces of white foam sheet 13 × 11 inches. Cut two pieces of brown foam sheet 12 × 7 inches. Cut the sides of the brown foam sheet on an angle to resemble a roof and make two chimneys on top as shown. Glue the brown roofs onto the top edges of the white foam sheets to form two houses.

2. Cut a rectangle out of the red foam sheet that is 3 × 5 inches to make the front door. Glue the door onto the white foam house. Place the house on a cutting board and cut around the top, bottom, and right edges of the door using an Exacto knife to make a door that opens. Make a 2-inch wreath out of the green foam sheet and glue it to the door. Cut a small red ribbon out of red foam sheet and glue it to the wreath as shown.

3. Make hedges out of the green foam sheet and glue them to the bottom of the house. If desired, decorate the bottom of the house with scenes cut from Christmas cards.

4. Form the words "Christmas Countdown" out of the foam letters and glue them to the top of the roof.

5. Cut 10 brown boxes (doors), approximately $1\frac{1}{2}$ inches square, out of the brown foam sheet. You can mix up the sizes and make different shapes if desired. Glue these doors onto the roof of the house form containing the front door. Place the house on a cutting board and cut around the top, bottom, and right side of the boxes with the Exacto knife to form doors that open.

6. Cut pictures out of old Christmas cards that fit the size of the doors. Glue the pictures onto the back of the foam sheet so that they are visible when the doors are opened.

7. Repeat steps 4 and 5, making 13 green foam sheet boxes and placing them on the white section of the house. If desired, you can use a marker to make frames around the boxes, to resemble windows or shutters. Doors can also be placed in the shrubs around the house.

8. Place the finished house over the second house, lining up the roof and sides. Glue the two pieces together.

9. Glue the foam numbers 1 through 24 to the outside of the doors. The number 24 should be on the front door. If desired, you could glue small doorknobs to the door by using the dots that result when you punch out the foam numbers.

For added interest, make a production out of opening your calendar each day by gathering the family together and taking turns opening the doors. You might want to enhance this activity by reading a story or singing a song related to the picture behind the opened door.

Designing and cutting out your Christmas calendar.

(© Melissa LeBon)

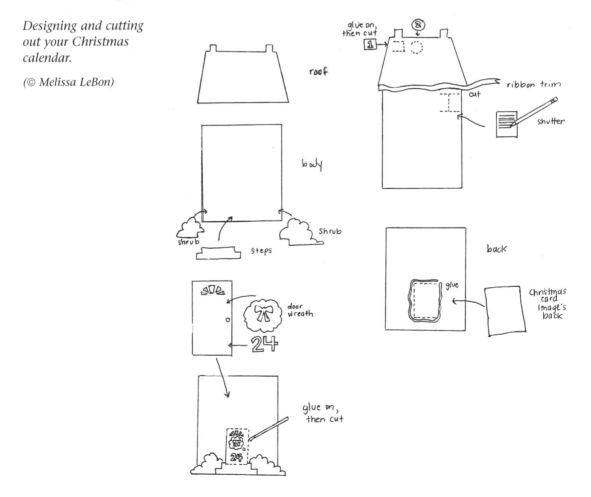

Holiday Hints

The foam sheet Advent calendar will most likely become a family heirloom that can be used year after year. If you like the idea of making a calendar, but don't have a lot of time, try this simpler version made out of an old calendar or a calendar printed from your computer. Cut out 24 holiday pictures the size of the calendar boxes. Glue these pictures onto a piece of poster board or construction paper. Then cut the boxes out of the calendar and form a door by gluing the left side of each box onto the sheet covering the pictures. For variety, you could let the kids draw the pictures for this project and/or intersperse some surprise activities under several doors, such as baking cookies together, making Christmas ornaments, or watching a Christmas movie together.

Santa's Scene

Give Santa a "pot belly" by making this cute Santa out of clay pots. This easy-to-make Santa will look great on your mantel, keeping an eye on your Christmas stockings.

A clever rendition of a Santa made from clay pots.

Level: Easy

Time involved: Three to four hours, including drying time

Materials:

Paintbrushes

Red, light pink, gold, and black craft paints

Two 4-inch clay pots

One 2-inch clay pot

One 3-inch clay pot

Jar of *snow texture paint*

Glue gun

$^1/_2$-inch white pom-pom

Clear acrylic finish spray

1. Paint the outside (except the rims) of the two 4-inch pots and the 2-inch pot red and allow to dry.

2. Paint the outside (except the rim) of the 3-inch clay pot light pink and allow to dry.

Seasonal Sense

You can find **snow texture paint** in a craft store. It's usually packaged in a small jar and can be applied to a craft with a paintbrush, sponge, or spatula. This stucco–effect paint is perfect for winter projects that require a snow effect. It can also be mixed with colored paints to create a unique textured surface.

3. Paint the outside rim of each pot with white snow texture paint and allow to dry.

4. Using the glue gun, glue the two 4-inch pots together, rim to rim. Glue the top of the 3-inch pot to the bottom of the 4-inch pot. Glue the top of the 2-inch pot to the bottom of the 3-inch pot as shown. Glue the white pom-pom on the bottom of the 2-inch pot. (This is the top of the hat.)

5. Paint a $^1/_2$-inch band of black around the bottom of the 4-inch pot for boots. Paint four gold dots to form buttons on the middle 4-inch pot. Paint a face on the 3-inch pot by making a red oval for the nose, two small red circles for the cheeks, and two smaller black circles for the eyes. Allow to dry several hours.

6. Spray your Santa with clear acrylic finish spray and allow to dry.

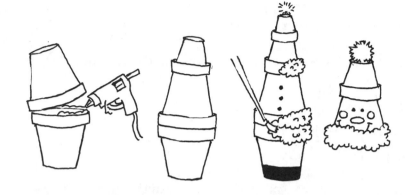

Assembling and creating the details for a clay-pot Santa.

(© Melissa LeBon)

Angelic Accents

Trumpet in the glories of Christmas by making decorative angels this holiday season. Use different colored and textured doilies to create a flurry of angel designs. Try singing along to some "angelic" Christmas music when working on this family craft. (See the color insert for more details.)

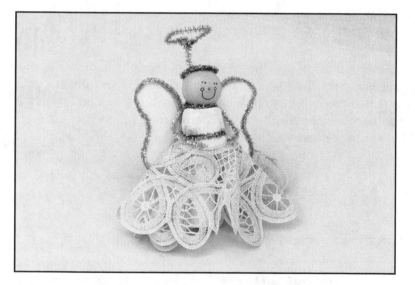

A heavenly accent for your home.

Level: Moderately easy

Time involved: One hour

Materials:

 Doily

 Scissors

Round peg clothespin

Glue gun

Round wooden head that fits over the top of a clothespin (You can find these in a craft store.)

Piece of white foam sheet

Silver and gold metallic pipe cleaners

Black fine-tipped marker

1. Make a $1/4$-inch slit in the middle of the doily. Make another $1/4$-inch slit intersecting the first slit. Insert the clothespin into the slit and glue it just below the round knob of the clothespin to form the neck of the angel. Glue the bead head to the clothespin.

2. Cut a piece of white foam sheet $3^1/_2 \times 2$ inches. Glue the $3^1/_2$-inch ends together to make a tube out of the foam sheet. Glue this tube to the top of the clothespin underneath the doily.

3. Cut two 2-inch pieces of gold pipe cleaner. Glue one around the neck of the angel and one around the waist of the angel, gathering the doily equally around the body.

4. Make angel wings by bending and twisting a silver pipe cleaner as shown in the figure. Using a glue gun, glue the wings onto a piece of white foam sheet. Cut around the wings. Cut a piece of silver pipe cleaner 6 inches long and form a 1-inch diameter halo in one end. Bend the other end around the wings. Glue the wings and halo onto the back of the angel.

Holiday Hints

You can make a different version of an angel by substituting a large silk flower (a magnolia or lily works well) for the doily. Omit the clothespin and foam tube and glue the bead head directly to the base of an upside-down single flower. Make the wings by twisting together two of the leaves and gluing them to the back of the angel. Add the hair and halo to your heavenly creation by following the directions for the doily angel.

5. Twist a 6-inch piece of silver pipe cleaner around the body of the angel to form arms. Make a coil out of a 3-inch piece of gold pipe cleaner and glue it to the top of the angel's head to form hair.

6. Make a face on the angel's bead head using a fine-tipped marker.

You can stand the angel up on its own or add an ornament hook to the back to hang it on your tree.

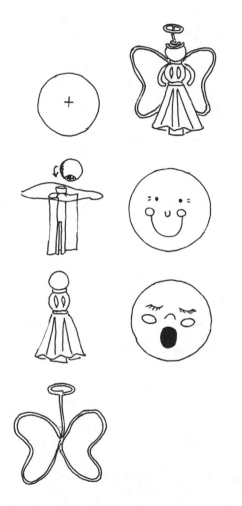

The steps to assembling a doily angel.

(© Melissa LeBon)

Crafty Containers

Instead of using store-bought paper on your presents this year, check out these craft ideas for unique finishing effects. You and your family will have hours of fun working on these clever gift-wrappings.

Stylish Stockings

"The stockings were hung by the chimney with care in hopes that St. Nicholas soon would be there …" Impress St. Nick with these elegant personalized stockings that will withstand the wear and tear of Christmas morning. You can make one for each member of your family or use one as a unique wrapping for a special gift.

Festive Facts

Do you know where the tradition for hanging stockings on the mantle originated? Some say that St. Nicholas started the custom when he tried to help the daughters of an impoverished man attract husbands by providing them with dowries. According to the legend, St. Nicholas dropped bags of gold in the windows of the girls' rooms. One night one of the bags landed in a stocking that had been hung up to dry. Thus, the tradition of putting gifts in stockings was born.

Level: Moderately difficult

Time involved: One to two hours

Materials:

Two pieces of 24 × 20 inch Christmas quilted material

Ruler

Scissors

24 inches of 5-inch-wide lace

Straight pins

Sewing machine

Thread

Iron and ironing board

30 inches of matching trim

Glue gun

Green fabric paint in a squeeze bottle

Gold bell (optional)

Needle and thread

1. Place the two pieces of quilted material right sides together on a flat surface with the 20-inch length horizontal. Starting at the upper-left corner of the material, use a ruler to mark off 12 inches. At this mark, cut a straight, vertical line 15 inches long. Then make a horizontal cut to the right that is 8 inches long to form the foot area of the stocking. Make a second vertical cut 9 inches long to complete the foot area. Round off the corners of the foot area and heel area as shown (see illustration).

Cutting and sewing a Christmas stocking.

(© Melissa LeBon)

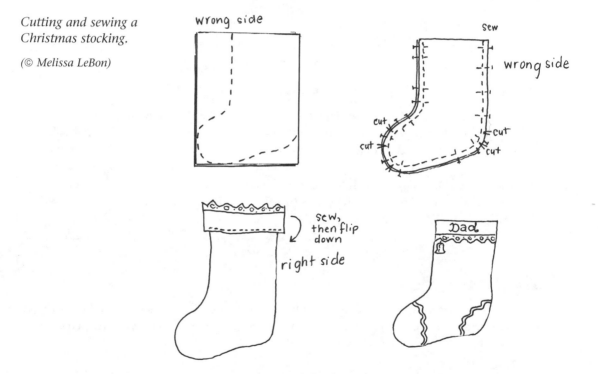

2. Cut two pieces of the lace 12 inches in length. Pin a piece of lace to the top of each stocking with the "right side" of the lace against the "wrong" side of the stocking material. Sew the lace along the tops of the stockings using a $^{1}/_{2}$-inch seam. Flip the lace over to the right side of the stocking and press it down with an iron. You should have two stocking forms with the lace trim on the "right side" of the material.

51

3. Pin the two stocking forms with the right sides together. Sew around the sides and bottom of the stockings using a $1/2$-inch seam. Cut slits into the bias of the seam around the corners to prevent the material from puckering. Turn the stocking right-side-out and iron it flat.

4. Glue a piece of trim across the top of the stocking. Glue another piece of trim along the heel and toe area of the stocking. Form a loop and stitch a piece of the trim onto the upper-left corner for hanging purposes.

5. Write a name on the lace trim with the squeezable fabric paint. If desired, sew a gold bell onto the side of the stocking.

Holiday Hassles

Here are some basic tips and techniques that can help take the hassle out of sewing fabric. First of all, be sure you have a flat working area to lay out your material. You should have special sharp scissors that you only use to cut fabric. Press your material before using it, and pin the area to be sewn together with straight pins to keep it from slipping apart when sewing it. Always leave at least a $1/2$-inch margin around the edge of the seam and cut slits in this margin around the curves to keep the stitches from puckering. (Be careful not to cut the thread when doing this.)

Embellished Boxes

You can transform ordinary cardboard boxes into these lovely decorative boxes in no time. Use sturdier gift boxes from department stores or buy relatively inexpensive cardboard boxes at a craft store for this project.

Using foil rub-on transfers to create a decorative box.

(© Melissa LeBon)

Level: Moderately easy

Time involved: Two hours, including drying time

Materials:

Cardboard box

White craft paint

Paintbrush

Foil rub-on transfers (You can buy these in kits at a craft store.)

Scissors

Clear acrylic finish spray

Decorative ribbon

Glue gun

Excelsior moss or crepe paper filler

Festive Facts

There are many legends surrounding the candy cane. One legend states that the candy cane was designed by an elderly man to display his love of Jesus. The candy cane is in the shape of a shepherd's staff which, when turned upside down, forms the letter "J" for "Jesus." The white stripes represent the virgin birth and the red stripes symbolize the blood that was shed by Jesus upon his death. The peppermint flavoring resembles hyssop, an herb from the mint family, which was used for purification and sacrifice.

1. Paint the outside of the box and the lid with white craft paint and allow it to dry.

2. Keeping the protective sheets of the transfers together, cut out your selected foil design. Peel off the protective paper sheet and press the design onto the lid of the box with your finger. (Do not rub the design.) Slowly peel off the protective plastic sheet.

Holiday Hints

While you're working on this project, try this special treat to stimulate your creative juices: Break off the curved end of a candy cane and stick the straight end in an orange to use as a straw. You'll love the minty taste the orange juice acquires as it flows through the candy-cane straw.

3. Cut the foil the same size as your design. Place the foil over your design with the shiny side facing up. Carefully press the foil down onto the adhesive design and slowly peel off the foil sheet. Repeat this process on two opposite corners of the box lid. Spray the box with clear acrylic finish spray.

4. Glue a piece of decorative ribbon around the lid of the box. Make a small bow out of the ribbon and glue it in the center of the box lid.

5. Fill the box with excelsior moss or crepe paper filler before adding your gift.

Wrapping It Up in Style

Homemade wrapping paper is fun and easy to make. Get the kids involved and see how many different designs you can create.

Level: Easy

Time involved: Two to three hours, including drying time

Materials:

 Roll of white or brown craft paper

 Scissors

 Protective plastic or newspapers

 Craft paints

 Foam plate

 Paintbrushes

 Christmas stamps or sponges

1. Cut a piece of craft paper the size of your package. Lay the paper on a flat working surface protected by plastic or newspapers.
2. Pour a small amount of different colored paints onto the foam plate. Using a paintbrush, paint the stamps or sponges with the desired color. Stamp a pattern of Christmas designs across the paper. Allow the paint to dry before wrapping your gift.

Children's Christmas Crafts

Let Christmas vacation bring out the kid in you. Finish off a lovely day of sledding or skiing with a quiet craft session in front of the fireplace. Or, if you live in a warmer climate, throw on a Christmas CD and enjoy the snow experience by making your own snow globes and snowflakes.

Let It Snow!

Why pay big bucks for a snow globe when you and your kids can design your own for pennies? It's simple to transform a plain glass jar into a winter wonderland scene created to your specifications. You might want to make several scenes, one for each of the bedrooms.

Level: Easy

Time involved: One to two hours

Materials:

Old jars with lids (Mason jars, peanut butter jars, and baby-food jars work well.)

Glue gun

Plastic Christmas figures (Check craft or hobby stores for the figures used in "under-the-tree" scenes.)

White rocks, marbles, or decorative glass pieces

Water

Food coloring (optional)

White glitter and/or white confetti (Use metallic or plastic confetti, not paper.)

1. Wash and dry the jar and the lid. Glue the figures and the rocks to the inside of the jar lid using a glue gun.

2. Fill the jar with cold water to within $1/3$ inch of the top. If desired, add a drop of food coloring (blue makes a nice sky effect). Add 2 tablespoons glitter and/or confetti.

3. Squeeze a line of hot glue around the inside rim of the lid. Immediately seal the jar with the lid.

Holiday Hints

You might want to try making paper snowflakes to go along with your snow globes. Start with a square piece of paper and fold it in half diagonally three times, keeping track of the center with your thumb. Cut half of a snowflake ray along each folded side of the paper, moving toward, but not cutting through, the center of the paper under your thumb. You should have a V-shaped design with the bottom point of the V being the center of the paper. Cut more designs into the paper, making sure to leave some sections of the folded edges together so the snowflake will stay together when unfolded. Open your snowflake, and decorate it with glitter if desired.

Wired Wonders

Jewelry wire is a fun craft medium that you can shape into various designs. This wire is perfect for making unique Christmas tree ornaments. You can follow the patterns detailed here, or try your hand at creating your own lovely designs. You might want to have a family contest to see who can come up with the most original creation.

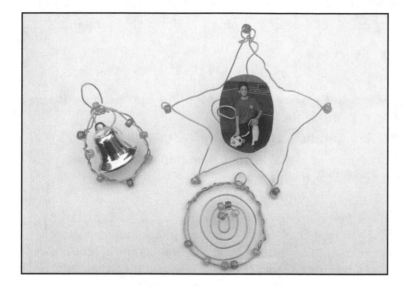

Whimsical wired Christmas ornaments.

Level: Easy

Time involved: Half to one hour

Materials:

> Three different colors of 18-gauge jewelry wire (I used green, gold, and blue.)
>
> Tape measure
>
> Wire cutters
>
> Plastic *pony beads*
>
> Small photograph (for star ornament)
>
> Gold bell (for bell ornament)

Seasonal Sense

Pony beads are round, plastic beads that are sold in bags in craft stores. These beads come in assorted colors and can be used in many different craft projects. If your kids enjoy working with beads, I'd recommend buying a pony-bead project kit for a rainy day.

To make the star:

1. Using wire cutters, cut a 30-inch length of gold jewelry wire. Start at one end of the wire and form a 2-inch-long star point. Thread a red pony bead onto the end of the point and twist the wire around it to hold it in place. Form a second point, and twist a green bead onto the end. Continue to make points until there are five points forming a star, with pony beads on the end of each point.

2. Twist the remaining length of wire into a spiral and center the spiral inside the star. Insert a small picture into the spiral shape.

To make the spiral ornament:

1. Cut an 18-inch piece of blue jewelry wire. Twist the wire into a spiral-shaped ball, creating a 3-D effect inside the ball.

2. Thread the pony beads onto alternating wire loops of the ball.

3. Cut a 10-inch piece of green wire and wrap it around the top of the ball, forming a small loop at the top for hanging purposes.

To make the bell ornament:

1. Cut a piece of green wire 15 inches long. Form the wire into an oval shape, leaving 3 inches of excess wire on either end at the top. Bend the excess wire on one end into a loop on top for hanging the ornament and the excess wire on the other end into a loop on the inside for hanging the bell.

2. Thread the gold bell onto the inside loop and twist the ends together at the top.

3. Cut a second piece of wire 12 inches long and, starting at the top of the ornament, twist the wire onto the first piece of wire. Add a pony bead and twist again. Add another pony bead about $1/2$ inch away and twist again. Continue around the ornament until you reach the other end.

Away in a Manger

Make a date with your kids to tell them the story of the first Christmas. Then, spend the afternoon making your own nativity scene out of wooden spoons and craft sticks.

Try your hand at this basic design and then let the kids craft their own figures to add to the collection. You could extend the craft sticks at the bottom of the blackboard to add additional figures such as the three kings, shepherds, and barn animals.

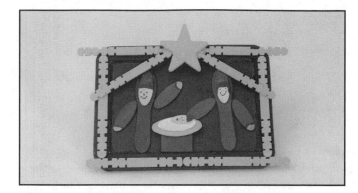

A simple but elegant rendition of the Nativity scene.

Level: Easy

Time involved: One to two hours

Materials:

Paintbrushes

Brown, blue, yellow, white, and light-pink craft paints

Foam plate

Wooden spoons

Bag of assorted wooden pieces (ovals and squares)

Unfinished chalkboard

Wooden star

Clear acrylic finish spray

Glue gun

Eight yellow wooden craft sticks

Brown and black fine-tipped markers

Seasonal Sense

You can find **clear acrylic finish spray** in craft stores, discount stores, and home-improvement stores. This spray paint adds a shiny, protective finish to craft projects. It works well on wood, cardboard, clay, cement mosaics, and just about any hard, dry surface. It shouldn't be used on fabric, plaster, or paper. Clear acrylic finish spray makes a painted surface more permanent and protects the designs from wearing off with passing time.

1. Paint one wooden spoon (body) and two oval pieces (arms) with blue craft paint, leaving a small oval area at one end of each oval piece to make hands. Paint one wooden spoon and two oval pieces with brown craft paint also leaving an area for hands. Make hands on the ends of the arms with light-pink craft paint. Paint a square wooden piece brown to form the base of the manger. Paint the frame of the blackboard brown and allow to dry.

2. Paint two oval pieces the same size as the arms light pink (for Mary's and Joseph's heads). Paint a smaller oval piece light pink (for the baby's head) and allow to dry. Paint the top half of the two adult heads blue and brown to form veils.

3. Paint an oval piece slightly larger than the baby's head with white paint to form the body, and another larger oval piece with yellow paint to form the hay. Paint the wooden star yellow and allow to dry.

4. Spray all of the painted pieces with clear acrylic finish spray and allow to dry.

5. Using a glue gun, glue the brown base of the manger to the bottom center of the blackboard. Glue the yellow oval to the square, the white oval to the yellow oval, and the pink oval to the white oval. Glue the brown and blue wooden spoon on either side of the manger. Glue the head and arms to the spoons.

6. Glue the yellow craft sticks onto the frame of the blackboard. You'll need two sticks for the top and bottom and one stick for each side. Glue two sticks into a peak on the top of the board. Glue the star on top of the peak.

7. Using a black fine-tipped marker, make facial features on the heads. Use a brown marker to make hair on Mary's and the baby's heads.

Festive Facts

The use of a star to symbolize Christmas dates back to the birth of Christ. It is said that an unusually bright star appeared quite miraculously in the eastern sky when Christ was born. This star led the magi (who were also astronomers) to believe that a great man was born that day. It also guided them to the birthplace (Bethlehem) of their newborn king. The star today symbolizes, within Christianity, high hopes and ideals for the future of humankind.

Christmas Cooking Crafts

Nothing is quite as special as a handcrafted gift from your kitchen. You can make these goodies for the people on your gift list in no time.

Cookies to Go

The basic method to making cookies in a jar is to layer the dry ingredients into clean jars and pack them down. A recipe should be attached to the jar, describing how to assemble the remaining ingredients and bake a finished cookie. A decorated Mason jar works well with these delicious creations.

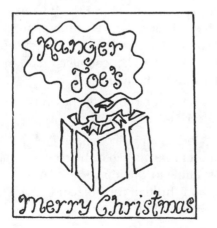

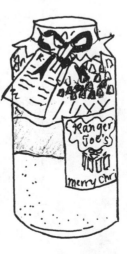

Making cookies to go.

(© Melissa LeBon)

Level: Moderately easy

Time involved: One to two hours

Materials:

Clean Mason jar with lid

Piece of fabric

Rubber band

Ribbon

Two cinnamon sticks

Piece of holly

Cookie recipe

Adhesive label

Paper

Fine-tipped marker or computer

Hole punch

1. Choose a favorite cookie recipe or use the one following.

2. Combine the flour and baking powder and stir well. Pack the mixture in a clean Mason jar. Add the sugars and pack this down. Add oats, coconut, and cereal, or any other dry ingredients (such as chocolate chips, nuts, or raisins).

3. Put the lid on the jar and screw down tightly. Place a square of cotton material on top of the lid. Gather the material around the lid and secure it with a rubber band. Tie a ribbon around the mouth of the jar, forming the ends of the ribbon into a bow. Catch a couple cinnamon sticks and a sprig of holly in the bow.

4. Print the name of the cookie recipe on the label and stick it on the jar.

5. Print the recipe on a piece of paper. (You could use a computer for this.) Fold the recipe in half and punch a hole in the top corner. Thread a piece of ribbon through the hole and attach the recipe to the ribbon on the jar.

Holiday Hints

If you liked making the cookies in a jar for your family and friends, you might want to try putting the dry ingredients for brownies or other dessert bars in a jar. You could also provide the ingredients for cut-out cookies and include some cookie cutters and tubes of icing with the gift.

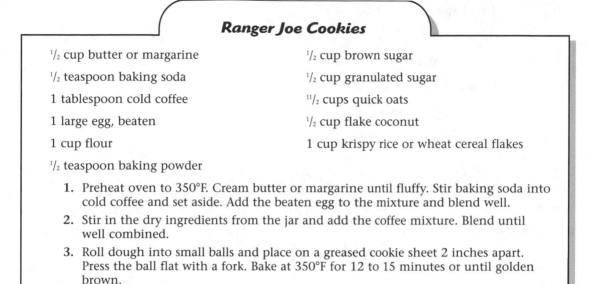

Ranger Joe Cookies

$^1/_2$ cup butter or margarine

$^1/_2$ teaspoon baking soda

1 tablespoon cold coffee

1 large egg, beaten

1 cup flour

$^1/_2$ teaspoon baking powder

$^1/_2$ cup brown sugar

$^1/_2$ cup granulated sugar

$1^1/_2$ cups quick oats

$^1/_2$ cup flake coconut

1 cup krispy rice or wheat cereal flakes

1. Preheat oven to 350°F. Cream butter or margarine until fluffy. Stir baking soda into cold coffee and set aside. Add the beaten egg to the mixture and blend well.
2. Stir in the dry ingredients from the jar and add the coffee mixture. Blend until well combined.
3. Roll dough into small balls and place on a greased cookie sheet 2 inches apart. Press the ball flat with a fork. Bake at 350°F for 12 to 15 minutes or until golden brown.

Cinnamon Cut-Outs

These cinnamon creations not only look nice, but they also smell great! Bring the heavenly aroma of baking cookies to your home by making these decorative cinnamon ornaments.

Level: Moderately easy

Time involved: Two to three hours, plus one to two days to dry

Ingredients:

Mixing bowl

Spoon

1 cup ground cinnamon

$^2/_3$ cup applesauce

1 tablespoon white glue

Rolling pin

Cookie cutters

Cookie sheets

Paintbrush or skewer

Fabric paints in squeeze bottles

Some examples of free-form cinnamon cut-out designs.

(© Melissa LeBon)

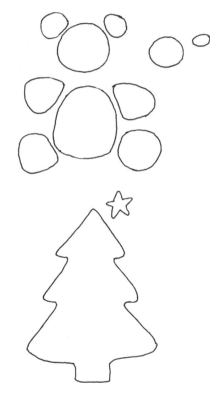

1. Mix the cinnamon, applesauce, and glue in a bowl until they form stiff dough. If the mixture is too thin, add cinnamon; if too dry, add applesauce.

2. Using a rolling pin, roll the dough out to about ¼ inch on a surface lightly sprinkled with cinnamon. Cut shapes out of the dough using Christmas cookie cutters. Place the cinnamon shapes on a cookie sheet and make a hole in the top using the sharp end of a paintbrush or a skewer. Allow the cut-outs to dry for 24 to 48 hours, or bake them in a 250°F oven until hard. You could also make these ornaments free-form by following the illustrations.

3. Decorate the ornaments with fabric paints in squeeze bottles.

Holiday Hassles

Cinnamon cut-outs take time to dry. You can bake them in a 250°F oven to speed up the process, but be sure not to over-bake them or to bake them at too high a temperature, or they'll crack. Cut-outs take one to two days to air dry. You might want to sand any rough edges with a piece of fine-grain sand-paper before painting them. A layer of varnish will protect your creations over the years.

Holiday Hints

You can also make Christmas ornaments out of salt dough that puffs up when you bake it. Just mix 2 cups flour, 1 cup salt, and 1 cup water together in a bowl. Knead the ingredients with your hands until they are well blended. Roll the dough onto a lightly floured surface to a ¼-inch thickness and cut out shapes with cookie cutters. Make a hole in the top of the shapes for hanging purposes. Bake them in a 350°F oven for 8 to 15 minutes or until the dough turns golden brown on the edges. Allow the ornaments to cool and then paint them with craft paints. Spray the dry-painted ornaments with clear acrylic finish spray for a lasting finish.

The Least You Need to Know

➤ You can turn your home into a Christmas fairyland by handcrafting your own ornaments and decorations.

➤ Wrapping the gifts you've chosen for your loved ones can be a fun and rewarding creative experience.

➤ Christmas vacation is the perfect time to pull the kids away from the TV and video games and to spend some time together crafting old-fashioned fun.

➤ Make some crafts in a cozy kitchen and allow the aromas to take you back to a simpler time.

Hanukkah Happiness

Many beautiful family traditions surround the solemn celebration of Hanukkah. Hanukkah, also spelled Chanukah, is a Jewish holiday that commemorates the rededication of the second temple of Jerusalem in 164 B.C.E. The temple had been desecrated three years earlier by order of Antiochus, IV Epiphanes, a Syrian king who was trying to destroy the Jewish faith. According to the account, a small group of Jewish rebels known as the Maccabees risked their lives to oppose the king and live according to the Jewish traditions. Although the Maccabees won the struggle, the Jewish temple was destroyed in the process. The Jewish people had to clean and repair their house of worship. They rededicated it to God by rekindling a menorah (candelabra) that symbolized the Jewish people's covenant with God.

Hanukkah is celebrated on the twenty-fifth day of the Jewish month of Kislev. In the year 2001, this date falls on December 10; in 2002, it begins November 30. During an in-home celebration, a menorah is still lit to recall the Talmud story of how one day's

supply of nondesecrated oil miraculously burned in the temple for eight days until new oil could be obtained. For this reason, Hanukkah is celebrated for eight days. During this time, Jews light ceremonial candles, play games, cook traditional foods in oil, and exchange gifts.

There's no time like the present to begin to prepare for this great holiday. You might want to gather your family together ahead of time and try some of these unique Hanukkah crafts. The best part of making crafts with your loved ones is the special time you share while working on a family heirloom. Whether you're an expert crafter or a novice at the crafting game, you should find some ideas in this chapter to pique your interest.

Traditional Treasures

You can't celebrate Hanukkah without a proper menorah to light or a dreidel to spin. Making your own Hanukkah symbols gives a special meaning to these traditional legacies.

Festival of Lights

Delight your friends and relatives with this traditional *menorah,* constructed from simple craft supplies. You might want to tell your kids the legend behind the menorah while they help you assemble it.

Seasonal Sense

The **menorah** is a candelabra that holds nine candles—one for each night of Hanukkah and one (a shamash or helper candle) that is used to light the other candles. The menorah should be kindled at nightfall on each of the eight nights of Hanukkah. Olive oil or paraffin candles that are large enough to burn until $1/2$ hour after nightfall should be used in the menorah. You should place the candles each night from the right to the left and light them from the left to the right. A benediction should be read when each candle is lit.

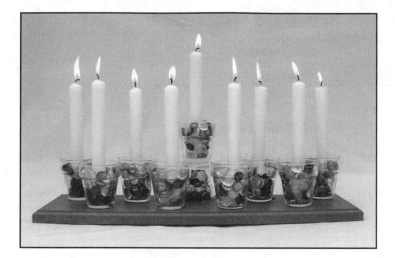

A stylish way to celebrate the Festival of the Lights.

Level: Moderately easy

Time involved: Three to four hours, including drying time

Materials:

> Newspapers or plastic
>
> Block of wood 26 × 4 inches
>
> Sandpaper
>
> Blue craft paint
>
> Paintbrush
>
> Clear acrylic finish spray
>
> 10 2½-inch glass flowerpots or votive lights
>
> Six bags of blue-and-white marbles or decorative glass pieces
>
> Piece of cardboard
>
> Glue gun
>
> Hanukkah candles

1. Cover your work area with newspapers or plastic. Sand any rough edges off the board with the sandpaper. Place the board on top of the prepared area and paint the top and sides with blue craft paint and allow to dry. If necessary, give the wood a second coat of paint. Spray the wood with clear acrylic finish spray and allow to dry.

Holiday Hints

You could make this glass menorah unique by substituting gel candles for the eight taper candles on either side of the shamash. Follow the directions on a container of gel wax for heating and pouring the wax. Place a wick in the middle of the pot with the glass pieces holding it in place, and pour the melted wax into each container. Be sure to keep the fifth candle (the shamash) a traditional candle in order to facilitate the lighting of the menorah.

2. Space the nine glass pots equally along the board in a straight line. Fill the fifth pot with the marbles or glass pieces, and place a piece of cardboard over the top of it. Turn this upside down using the cardboard to keep the marbles or glass inside. Slide the pot into its place on the middle of the board and remove the cardboard. Carefully lift up the edges of the pot and glue it onto the board using a glue gun. Glue the rest of the pots onto the board right side up. Glue the tenth pot right-side up onto the bottom of the fifth pot to form a holder for the shamash.

3. Place a candle in each pot. Fill the pots with decorative glass or marbles to hold the candles in place.

Festive Facts

Ideally, a menorah should be lit outside the doorway of your house on the left side when entering. If this isn't possible, you could place the menorah in a window facing the street. A menorah lit on a table also fulfills the requirement of "publicizing the miracle." The menorah should be lit at nightfall and continue to burn for at least 30 minutes after nightfall. During this time, no use should be made of its light.

"Dreidel, Dreidel, Dreidel, I Made It Out of Clay"

You can make your own *dreidel* out of clay by following these simple instructions. The accompanying box will store and protect your dreidel from season to season.

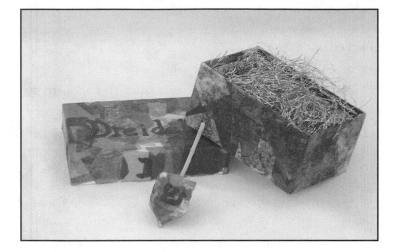

A lovely rendition of the traditional dreidel.

Level: Moderately easy

Time involved: Two hours, plus overnight to dry

Materials:

Sculpting clay (Sculpy or Fimo clay are popular brands.)

Thin wooden dowel, chopstick, or thick wooden skewer

Exacto knife

Cookie sheet

Small cardboard box

White craft paint

Paintbrushes

White glue

Paper cup

Blue, red, green, and yellow tissue paper

Black marker

Clear acrylic finish spray

1. Using sculpting clay, form a rectangle that is 3 × 2 inches. Form a round ball out of the clay about 1 inch in diameter. Shape the ball onto the bottom of the rectangle by smoothing the sides of the ball and forming the clay into a point.

2. Cut a 1¹/₂-inch piece of the wooden dowel, skewer, or chopstick with an Exacto knife. Insert the wooden piece into the top of the rectangle to about ¹/₂ inch.

3. Place the dreidel on the cookie sheet and bake it according to the directions on the sculpting clay. I baked my dreidel in a 275°F oven for about 18 minutes.

4. Remove the dreidel from the oven and allow it to cool.

5. Paint the outside of the cardboard box with white craft paint and allow to dry.

6. Make a mixture of ¹/₃ cup white glue and 3 tablespoons water in a paper cup.

7. Tear blue, red, green, and yellow tissue paper into about 2-inch pieces. Cover an area of the box with the glue mixture and place the tissue paper in a random pattern over the glue. If you keep one finger covered with the glue mixture, you can pick up the tissue pieces and smooth them onto the surface with this finger. Continue until the entire outside of the box is covered by at least two layers of tissue paper and allow to dry.

8. Repeat this process, covering the dreidel with at least two layers of tissue paper and allow to dry.

9. With the black marker, write the four Hebrew dreidel letters onto the four sides of the box and on the four sides of the dreidel. Write the word "Dreidel" on top of the box.

10. Spray the box and the dreidel with clear acrylic finish spray and allow to dry.

Seasonal Sense

A **dreidel** is a four-sided top with a Hebrew letter on each side. The four letters—nun, gimel, hey, and shin—stand for the phrase *Nes gadol hayah sham*, or "A great miracle happened here." At one time in history, the Syrians had forbidden the teaching of the Jewish religion. Jewish rebels pretended to play dreidel around enemy troops while they were actually discussing the Torah. The tradition of playing dreidel for gelt (candies or coins) delights young and old during the Hanukkah celebration.

The Hebrew letters nun, gimel, hey, and shin.

(© Melissa LeBon)

Play the dreidel game with your family, using candy as the gelt (prize). Here are the rules to refresh your memory:

➤ If the dreidel lands on nun (*nisht,* or nothing), the player wins nothing.

➤ If the dreidel lands on gimmel (*gantz,* or all), the player wins the entire pot.

➤ If the dreidel lands on hey (*halb,* or half), the player wins half the pot. If there is an uneven number of candies, the player takes the extra one.

➤ If the dreidel lands on shin (*shtel,* or put in), the player puts one candy into the pot ("shin, shin, put one in").

Hanukkah Crafts for Children

Eight days is a long time to celebrate a holiday. If you've run out of fun ideas to keep the kids occupied, you might want to check out this next section.

Menorah Moments

Children will delight in crafting this foam representation of a Hanukkah menorah. What makes this menorah even more special is the promise of a planned family activity that is written on each flame.

Steps to creating a foam menorah.

(© Melissa LeBon)

Level: Easy

Time involved: One to two hours

Materials:

> White, blue, and yellow foam sheets
>
> Scissors
>
> Fine-tipped magic marker
>
> Glue gun
>
> Hole punch
>
> Yarn
>
> Velcro tape

1. Cut a piece of white foam sheet into a 12-inch square.

2. Help your kids cut nine candles out of the blue foam sheet, each approximately 1×8 inches.

3. Cut oval flames approximately $1^1/_2$ inches long out of the yellow foam sheet.

4. Using a fine-tipped marker or pen, write a special Hanukkah activity on the back of the flames (such as baking Hanukkah cookies, playing spin the dreidel, making Hanukkah gifts, or playing a family game).

5. Glue the candles equally spaced onto the white foam sheet. Glue the middle shamash 1 inch higher than the other candles.

6. Cut a rectangle out of the yellow foam sheet that is 1×12 inches, and glue this to the bottom of the candles to form a candle base.

7. Punch a hole in the right and left corner of the top of the white foam sheet. Thread an 18-inch piece of yarn through the holes and knot in place for hanging purposes.

8. Cut a small piece of Velcro and glue it onto the back of each flame. Glue the matching pieces of Velcro onto the foam sheet above each candle.

9. Place the flames in a small bag or box. On each day of Hanukkah, have the kids take turns picking a flame out of the bag and gluing it onto the appropriate candle.

Enjoy the activity written on the back of the flame. This foam menorah could be used year after year. You might want to change the activities on the flames occasionally.

Holiday Hints

Instead of gluing the candlesticks onto the foam sheet, write the name of a Hanukkah story on the back of each of them. Let the kids take turns picking a candlestick as well as a flame to glue onto the menorah. Read the story they pick (but not by the candlelight, which should be used only as a symbol). Ask them what they think of the accounts and how they could take the message of Hanukkah with them throughout the year.

Designer Dreidel

Put a new spin on the dreidel design by creating these colorful decorations for your window or patio door.

A colorful dreidel with a stained-glass effect.

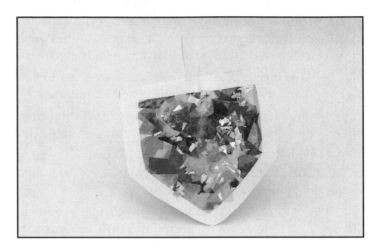

Level: Easy

Time involved: Half to one hour

Materials:

> Poster board
>
> Scissors
>
> Clear contact paper
>
> Several colors of tissue paper
>
> Confetti pieces
>
> White glue
>
> Hole punch (optional)
>
> Yarn (optional)

1. Cut two pieces of poster board 7 × 5 inches. Fold one piece of the poster board in half along the 6-inch length forming a 6 × 2^1/$_2$ inch rectangle. Draw half a dreidel along the fold. Cut along the half dreidel with scissors. You should have a whole dreidel folded in the middle. Cut out the center of the dreidel along the fold forming a 1/$_2$-inch dreidel frame. Trace this dreidel onto the second piece of poster board and cut out the second dreidel.

2. Cut two pieces of clear contact paper that are 7 × 5 inches. Lay one piece of the contact paper on a flat surface and remove the backing while keeping the sticky side up.

3. Place the dreidel frame on top of the sticky side of the contact paper and cut around the edges.

4. Cut small shapes (circles, squares, ovals, and so on) out of different colors of tissue paper. Sprinkle some confetti onto the sticky side of the dreidel and layer the tissue paper shapes over the confetti. Sprinkle some more confetti on top of the tissue paper. Trim any tissue paper that sticks out of the design.

5. Glue the second dreidel on top of the first dreidel. Remove the backing from the second piece of contact paper and place the sticky side on top of the second dreidel, covering the entire surface. Trim the contact paper around the dreidel frame.

6. If desired, punch a hole in the top of the dreidel and thread a 5-inch piece of yarn through the hole for hanging purposes.

Holiday Hints

Make several dreidel stained-glass ornaments to hang from each window, or string them together to make a garland. You might want to try making a Star of David design and alternating it with the dreidel. You can modify this project to fit any holiday theme by changing the symbol.

Perfect Presents

A fun aspect of Hanukkah is exchanging presents during the season. You might want to check out the following crafts for gift ideas for your loved ones.

Striking Star of David

Be the star of your Hanukkah celebration by making these lovely *Star of David* door or wall decorations for your friends and relatives.

Level: Moderately easy

Time involved: One to two hours

Materials:

Wire cutters

Gold berry garland (You can find these in the floral section of craft stores, especially during the holiday season.)

Wire

3 yards of 1-inch-thick blue ribbon

A simply crafted Star of David.

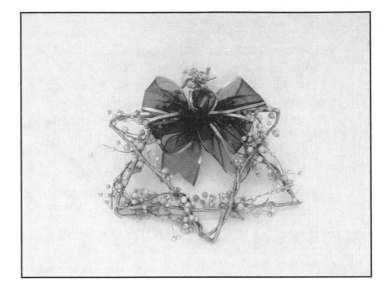

1. Using wire cutters, cut the berry garland in half. Make a triangle out of each half of the garland, and wire the ends together. Be sure to squeeze the points of the triangles together to form a sharp point on the star.

2. Place one of the triangles upside down, on top of the other triangle, to form a six-pointed star. Wire the two triangles together.

Seasonal Sense

The **Star of David,** known in Hebrew as Magen David or Shield of David, is a six-point star created by placing one triangle upside down on top of another triangle. This Star is an accepted symbol of Judaism and is on the flag of Israel.

3. Make a bow out of the ribbon: Start at one end of the ribbon and leave a tail about 6 inches long. Make a bow at this point with each loop about 6 inches long. Hold the middle of the bow in one hand and twist each loop around in the center one time to keep it firmly in place. Add another loop on each side and twist in place. Add a third loop on each side and twist in place. Add a final 3-inch loop in the middle and hold in place with your hand. Make a second 6-inch tail on the other side of the bow. Thread a piece of wire through all the loops and around the center of the bow. Twist the wire closed. Fluff up your bow and notch the ends.

4. Attach the bow to the top of the star with wire. Make a loop out of the end of the wire for hanging purposes.

Holiday Hints

You can use foam sheets to make a lovely Star of David refrigerator magnet. Cut two triangles, each 5 × 5 × 5 inches, out of the foam sheet. Glue one triangle upside down on top of the other triangle. Decorate your star by using bags of decorative foam shapes (from a craft store) or by cutting your own shapes out of foam sheets. Glue a magnet to the back of the star and hang it on your refrigerator.

Funky Frames

Make these modern *jewelry wire* frames to hold your favorite Hanukkah pictures. You can use the design in the picture or use your imagination to make your own special creations.

A clever way to display your Hanukkah photos.

Seasonal Sense

Jewelry wire is a product used for sculpting decorative designs, jewelry, and many other craft products. You can find this wire in craft stores, and it comes in different colors and gauges. This product is a versatile medium for crafting creative designs.

Level: Moderately easy

Time involved: One to two hours

Materials:

> 18-gauge *jewelry wire* in different colors
>
> Wire cutters
>
> Tape measure
>
> Beads
>
> Foam sheet
>
> Scissors
>
> Picture
>
> White glue

1. Cut a piece of wire that is 25 inches long. Start at the one end and make three 1^1/$_2$-inch loops at the top. Leave a 1-inch tail in the end of the wire to hold the bead and wire spring. Form a 4-inch line of wire down to the base. Shape the remainder of the wire into a flat circular spiral to form the base of the picture holder.

2. Cut a different color of wire 6 inches long. Wrap the wire tightly around a pencil. Remove the pencil from the wire carefully, keeping the wire in a spring form.

3. Attach a bead and the spring to the top of the frame, curving the tail you made at the top around the bead and spring.

4. Cut a piece of foam sheet that's slightly larger than your picture. Glue the picture to the foam sheet and insert it into the loops at the top of the frame.

Hanukkah Haven

Make your kitchen a haven by trying out some of these delicious Hanukkah delicacies. The oil that these foods are fried in is reminiscent of the oil that burned in the Temple of Jerusalem for eight days.

Holiday Hassles

A major cause of fires is a pan of cooking oil left unattended on the stove. Cooking oil should be heated gradually over a medium to medium-high temperature. You'll know the oil is ready to use when a drop of water thrown into the pan sizzles. If you place food in oil before it's ready, you increase the amount of oil the food will absorb. Be sure to drain your fried foods on paper towels or on clean paper bags to remove some of the grease.

Delightful Donuts

Popular in Israel at Hanukkah time are hole-less donuts, called Sufganiyot. This is my grandmother's recipe for fried and sugared doughnuts. When I was little, I sometimes got to help her make them. My job was to shake the doughnuts in a bag of sugar to coat them (and eat my fill of them in the process). It was a wonderful bonding experience, and I'll never forget how good they tasted—all warm and sugary. Try making these with your own kids or grandkids. They're best eaten when warm, but you might want to make a special Hanukkah tin container to store any of the uneaten doughnuts. (They'll still taste delicious.)

Level: Moderately difficult

Time involved: One to two hours

Ingredients:

> 3 eggs
>
> 1 cup sugar
>
> $1/2$ cup milk
>
> 3 cups flour
>
> 3 teaspoons baking powder
>
> Dash of salt
>
> 1 teaspoon vanilla
>
> Approximately 5 cups vegetable oil
>
> $1/2$ cup sugar (to coat the doughnuts)

Equipment:

> Deep-fryer or large, heavy pan
>
> Slotted spoon
>
> Paper bag

1. Beat the eggs in a mixer or food processor until well beaten. Add the sugar and beat again. Mix in the milk. Combine the flour, baking powder, and salt in a measuring cup or separate bowl and add it to the mixture. Add the vanilla and beat the mixture until it is well blended.

2. Heat the oil in a heavy pan or deep fryer. Drop heaping tablespoonfuls of the dough into the oil, about three or four at a time. Fry the doughnuts, turning them once until they are golden brown on each side. Remove them from the oil with a slotted spoon. Pour the sugar into the paper bag and then place the doughnuts in the bag. (The bag helps to absorb some of the grease.) Shake the bag until the doughnuts are thoroughly coated. Remove the doughnuts from the bag and enjoy!

Holiday Hints

You can transform a plain cookie tin into a Hanukkah treasure. This is perfect to make for a gift of baked goodies. Purchase a silver or gold cookie tin at a craft store, or recycle a cookie tin you have at home by spray painting the outside. Take six craft sticks and spray paint them gold. Form three of the sticks into a triangle by gluing the ends together. Form the other three sticks into a second triangle by gluing them together. Place one triangle upside down on top of the other triangle and glue them together to form a six-pointed star. Paint some white glue on the sticks and shake gold glitter over the star. Glue the star onto the lid of the cookie tin. Write the words "Happy Hanukkah!" around the rim of the lid using blue fabric paint in a squeeze bottle. Allow the tin to dry for two to three hours before using it.

Luscious Latkes

No matter what your traditional holiday dinner menu dictates, you can't go wrong with these easy-to-make potato delicacies. Serve these hot with a side dish of home-made applesauce.

Level: Moderately difficult

Time involved: One to two hours

Ingredients:

> 6 to 8 potatoes
>
> 1 small onion
>
> 2 eggs
>
> $1/3$ cup flour or matzoh meal
>
> 1 teaspoon salt
>
> $1/2$ teaspoon pepper
>
> Vegetable or peanut oil (approximately 1 cup)

Equipment:

> Colander
>
> Paper towels
>
> Mixing bowl
>
> Food processor
>
> Spoon
>
> Large griddle or frying pan

1. Wash and peel the potatoes. Cut them into quarters and grate them in a food processor, one potato at a time, until finely grated.
2. Put the grated potatoes in a large colander lined with heavy-duty paper towels. Drain the excess moisture from the potatoes and remove them to a large mixing bowl.
3. Place the onion in the food processor and chop finely. Add to the potato mixture. Add two beaten eggs, flour, and salt and pepper to the mixture, and mix well with a spoon.

Holiday Hints

Make your own applesauce to complement your latkes. Just wash, peel, and core 2 to 3 pounds of tart baking apples. Cook over medium heat with about $1/3$ cup water until tender. Mash with a potato masher and add sugar (approximately $1/2$ cup or less) and cinnamon to taste.

4. Cover the bottom of a large frying pan or griddle with vegetable oil (to about $1/2$-inch deep). Heat on medium-high until a drop of water sizzles in the oil. (While you're waiting for the oil to heat, you might want to ask your kids if they know what oil symbolizes in the Hanukkah celebration.)

5. Spoon the potato mixture into the pan and flatten it to form pancakes.

6. Fry the pancakes on each side for approximately four minutes or until golden brown. Try to flip them only once to keep them from getting too greasy.

7. Remove the pancakes from the pan and drain on paper towels. Serve immediately with sour cream and/or applesauce.

The Least You Need to Know

➤ You can make your Hanukkah special by crafting a menorah and dreidel out of simple craft supplies.

➤ Hanukkah has only a few symbols, but you can make the most of these by using different craft mediums to create holiday heirlooms.

➤ Have some fun with your family by spending your holiday vacation handcrafting gifts for the eight days of Hanukkah.

➤ Enjoy traditional holiday dishes that symbolize the spirit of Hanukkah.

Kwanzaa Creations

In This Chapter

➤ Incorporating the traditions of Kwanzaa into your family celebration

➤ Handcrafting meaningful seasonable symbols to grace your Kwanzaa table

➤ Spending time having fun with the kids with simple but creative craft projects

➤ Paying a tribute to African cuisine with traditional Kwanzaa dishes

Kwanzaa is an African-American spiritual holiday that is celebrated from December 26 to January 1. Dr. Maulana Ron Karenga established it in 1966 to promote African-American unity. The word "Kwanzaa" is an African word meaning "First Fruits," which symbolizes the first harvest of crops in Africa. The celebration is committed to strengthening family ties, supporting a community atmosphere, and struggling for equality.

Kwanzaa, which has no ties to any particular religion, is a way of life, not just a celebration. There are certain principles, symbols, and practices involved that are relevant to the social and spiritual side of the African-American culture. The week-long festivities establish a link to the past, giving new meaning to the present and future of the African-American heritage.

There are seven principles known as *Nguzo Saba* that are the focus of Kwanzaa and that create themes for the celebration. On each of the seven nights, a candle that represents the principle of the day is lit. Families come together for a traditional feast and participate in a special program that expresses their views and values.

Whether you already celebrate Kwanzaa or are interested in starting this worthwhile tradition, the holiday craft ideas in this chapter are a great place to start. You can make your celebration even more meaningful by creating seasonal symbols that will become cherished family treasures.

Seasonal Sense

Nguzo Saba is the African-American word for the seven principles of Kwanzaa. There is a principle for each day of the holiday. These principles are:

Day one: Umoja (*oo-MOE-jah*): Unity—sticking together as a family and community.

Day two: Kujichagulia (*koo-jee-cha-goo-LEE-ah*): Self-determination—being proud of who you are and what you do.

Day three: Ujima (*oo-JEE-mah*): Collective work—everyone working together toward a common goal.

Day four: Ujamaa (*oo-JAH-mah*): Cooperative economics—taking pride in cultural expressions.

Day five: Nia (*nee-AH*): Purpose—taking responsibility for your own actions.

Day six: Kuumba (*koo-OOM-bah*): Creativity—using your talents to express yourself in any way you can.

Day seven: Imani (*ee-MAH-nee*): Faith—being committed to believing in something.

Signs of the Season

Several symbols exemplify the Kwanzaa celebration. These symbols include a candle-holder (kinara), straw mats (mkeka), fruits and vegetables (mazao), ears of corn (muhundi), and a unity cup (kikombe cha umoja). Try spending a special family day preparing for your Kwanzaa celebration by handcrafting these traditional symbols. Be sure to play some African-American music to set the mood for working together as a family (Umoja).

Festive Facts

There is a special meaning behind the symbols of Kwanzaa. The Kwanzaa table is set with straw mats (mkeka), which are reminders of starting places and family traditions. Fruits and vegetables (mazao) represent the fruits of the harvest. The ears of corn (muhundi) represent the children who are the center of the celebration. There should be one ear present for each child. The unity cup (kikombe cha umoja) symbolizes just that—the uniting of the family. The candles of the kinara (mishumaa saba) represent the seven principles.

United We Stand

A unity cup is a key symbol of the Kwanzaa celebration. You might want to make this lovely cup to signify your unity as a family. Get the kids involved in helping to pick out the symbolic pieces that adorn this kikombe cha umoja (unity cup), and try out different designs and fabrics for variety. You might want to make an extra unity cup to give to a friend as a gift at the final feast (Karamu).

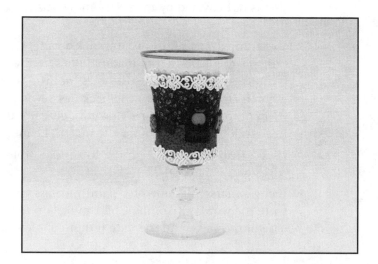

A lovely expression of family unity.

Level: Moderately easy

Time involved: Three to four hours, including drying time

Materials:

Remnant material

Lace trim

Scissors

Large stemmed glass

Decoupage clear finish (You can find this in craft stores in the decoupage section.)

Paintbrush

Symbolic buttons (You can find bags of decorative buttons in craft stores—pick through these to find meaningful symbols.)

Glue gun

Marker designed for glass

1. Cut two strips of material approximately 1 inch wide and long enough to fit around the middle of the cup. Brush the backs of the material strips with decoupage clear finish and stick them onto the outside middle of the cup.

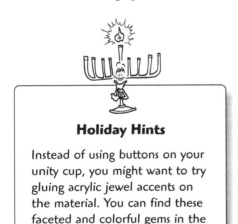

Holiday Hints

Instead of using buttons on your unity cup, you might want to try gluing acrylic jewel accents on the material. You can find these faceted and colorful gems in the jewelry section of a craft store.

2. Paint the right side of the glued-on strips with decoupage clear finish to protect them. Be careful not to get the finish on the glass portion that is not covered by material. Allow this to dry.

3. Sort through your buttons and pick a variety of symbols to glue onto the material. Be sure the buttons you use are flat with holes, not the type with an attached loop on the back (for sewing them onto fabric). Using a glue gun, glue these in a random pattern around the material band.

4. Glue a strip of lace trim on the top and bottom edges of the material.

5. Using a marker designed for painting glass, write the words "Kikombe Cha Umoja" on the base of the glass, and the date if desired.

Kinara Kuumba (Creativity)

Be the first in your family to celebrate Kwanzaa with a handmade kinara. This unique candleholder can be handed down from generation to generation, encompassing the principle of incorporating the past into the present and future. Before beginning this project, you might want to gather the family together and discuss the significance of lighting a kinara and the meaning behind each principle represented by a candle. Assigning a principle or two for each family member to research will add a deeper meaning to your celebration.

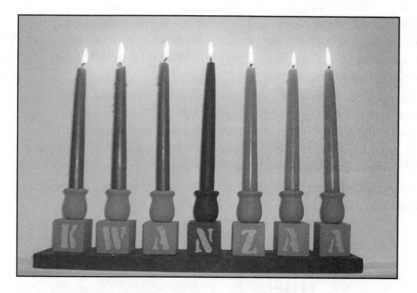

The perfect symbolic candleholder for Kwanzaa.

Level: Moderately easy

Time involved: Three to four hours, including drying time

Materials:

Newspaper

Sandpaper

Piece of wood approximately 17 × 3 inches

Seven 2-inch wooden blocks

Seven 1-inch wooden candle cups

Red, green, and black craft paints

Paintbrushes

Foam plate

Clear acrylic finish spray

Letter stencils

Yellow stencil paint

Stencil paintbrush

Glue gun

Seven taper candles—three green, three red, and one black

1. Layer your work area with newspapers to protect it. Sand any rough edges off of the wooden pieces. Paint the 17 × 3 inch board with black craft paint and allow it to dry. Paint a second coat if necessary. Spray this with clear acrylic finish spray and allow it to dry again.

2. Paint the wooden blocks—three green, three red, and one black and allow to dry. Using yellow stencil paint, stencil the letters "K," "W," and "A" on one side of the green blocks, the letter "N" on the black block and the letters "Z," "A," and "A" on one side of the red blocks. Allow the blocks to dry. Spray the blocks with clear acrylic finish spray and allow to dry.

3. Paint the wooden candle cups: three green, three red, and one black and allow to dry. Spray each piece with clear acrylic finish spray and allow to dry.

Holiday Hints

You can add to the family fun by trying your hand at making a kinara out of decorative paper or foam sheets. For the foam sheet kinara, simply cut the candles and flames out of red, green, black, and yellow foam sheets and glue them onto an oval or rectangular foam base. Write the principle on each candle and add a flame to it on the appropriate nights. For a paper kinara, you can use toilet paper rolls. Cover them with green, red, and black construction paper and glue them onto a piece of black cardboard. You can leave these tubes hollow and add a paper flame each night, or line them with tissue paper and fill them with treats to be eaten on the day they are "lit."

4. Equally space the blocks, spelling the word "Kwanzaa" along the black board. You should have three green blocks followed by one black block and then three red blocks spelling out "Kwanzaa." Using a glue gun, glue the blocks to the board.

5. Glue the same colored candle cup to the top of each block. Place the same color of candle into each candle cup.

A candle in the kinara should be lit at each night's celebration starting with the black candle. The candles are lit from left to right and the principle represented by the candle should be discussed. Encourage the children to participate in the ceremonies, and, with adult supervision, to take turns lighting the kinara each night.

Magnificent Mkeka

Straw is the material of choice when making a mat for Kwanzaa, but fabric is an acceptable alternative. You can incorporate this medium into a specially designed mat that is sure to become a family heirloom. You might want to make a mat to hold the Kwanzaa symbols on the table and then let each family member design his or her own personal place mat.

Festive Facts

The colors of Kwanzaa are represented in the flag of Pan-Africanism or Black Nationalism. The red in the flag signifies the blood that was shed by the African people. This is a reminder that people must retain freedom even at the risk of bloodshed. The black color represents the face of the people, and the green symbolizes hope and the color of the motherland.

Creating a stunning mat to adorn the Kwanzaa table.

(© Melissa LeBon)

Level: Moderately easy

Time involved: One to two hours

Materials:

 Burlap

 Iron-on vinyl

 Scissors

 One piece each of red, green, black, and yellow felt

 Fabric glue

 Bag of red felt letters

 Red, green, and black yarn

 Iron and ironing board

1. Cut the burlap and two pieces of the vinyl into rectangles that are 12×18 inches.

2. Cut out seven candles that are 7×1 inch—three from the green felt, one from the black felt, and three from the red felt. Place these candles equally spaced in the center of the mat in the following order: three green, one black, and three red. Glue these candles to the burlap with fabric glue. Cut out seven $1^1/_2 \times 1$ inch flames from the yellow felt, and glue the flames onto the top of the candles.

3. Cut an oval base out of the black felt that is 12×2 inches and glue this to the bottom of the candles. Glue the felt letters forming the word "Unity" on top of this base.

4. Cut two strands of each color of yarn (red, black, and green) 18 inches long and two strands of each color of yarn 12 inches long. Glue a red, a green, and a black piece of yarn around the edges of the mat to form a border.

5. Follow the directions on the vinyl package to iron the vinyl onto the back of the mat. Repeat this process on the front of the mat.

Holiday Hassles

Before using iron-on vinyl you should test it on a piece of the material you are using. The vinyl worked fine on burlap and felt, but it may not work as well on more delicate fabrics. You should use a dry iron on medium temperature. The usual ironing time is about six to eight minutes, but may vary according to the manufacturer's directions. Be sure always to use the protective paper shiny-side down in between the iron and the vinyl, or the vinyl will melt onto your iron.

Crafty Gifts for Karamu

It's encouraged to give gifts at the final feast of *Karamu,* but gifts can be given at any time during the week of Kwanzaa. Many parents and children exchange gifts on the last day of Kwanzaa, January 1. It's better if the gifts represent the African heritage and are designed with kuumba (creativity). A gift that is uniquely handcrafted by you and your family members is perfect for the loved ones on your gift list.

Seasonal Sense

The word **karamu** is Swahili for "feast." It is the final celebration of Kwanzaa held on December 31. The room should be decorated for the event with a black, red, and green motif. There should be a special program planned beforehand that includes cultural expressions and traditions. The mkeka should be placed on a low table or on the floor, and the food and symbols of the season should be placed creatively on the mat.

Luminous Lights

You can turn an ordinary vase into a lovely stained glass votive in a few easy steps. If you use the colors of Kwanzaa, the votive would make a festive greeting for guests attending your Karamu (feast).

A meaningful design for a Kwanzaa vase.

(© Melissa LeBon)

Knowledge

Level: Moderately easy

Time involved: Two to three hours

Materials:

> Glass vase with a wide opening or a recycled glass jar with a wide opening
>
> High-heat glue gun
>
> *Colored glue sticks*
>
> Tracing paper or copy paper (optional)
>
> Scissors (optional)
>
> Thin black marker (optional)
>
> Set of glass paints
>
> Paintbrushes
>
> Votive candle

1. Wash and dry the glass jar. If using a recycled glass jar, soak it in hot, soapy water to remove the label. Be sure the sticky adhesive is thoroughly removed.

2. Place a colored glue stick in your glue gun. A high-heat glue gun is recommended when using colored glue sticks on glass, but a low-heat glue gun will also work. (Higher-heat glue guns provide a more permanent bond on smooth surfaces.)

Seasonal Sense

You can purchase **colored glue sticks** for your glue gun at a craft store or the craft section of a discount store. The sticks come in different sizes and colors. There's even a colored glitter version. Colored glue sticks are perfect for writing on fabric, glass, wood, or any medium that can be painted.

3. Discuss with your kids what design you'd like to make on the jar. You can use your own design or follow the illustrated pattern. Trace the pattern onto paper and cut it out. Place the pattern over the glass and draw around it with a thin black marker. Using the colored glue, trace over the marker. Or make your own design on one side of the glass with the marker and trace over it with the glue. Allow the jar to dry.

4. Repeat this step using a different-colored glue stick and another pattern on the opposite side of the jar and allow it to dry.

5. Fill in the patterns with the appropriately colored glass paint.

6. Place the votive candle in the jar or vase.

Days of Kwanzaa

Count down the days of Kwanzaa with a customized calendar that marks off the special events and celebrations surrounding this season. The special event pieces are made of felt so the kids can easily stick them to the felt calendar on the appropriate day without using adhesive. You can use the calendar year after year, with new pieces added as desired. This calendar begins two weeks before Kwanzaa and ends one week after Kwanzaa to include the pre-Kwanzaa preparation and the final day itself—January 1.

Counting down to the Karamu.

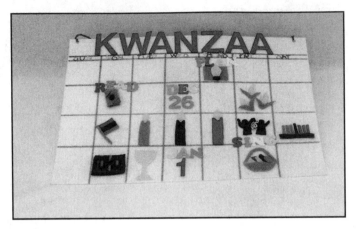

Holiday Hints

A handcrafted box would keep your felt symbols safe from year to year. You can purchase an un-finished cardboard or wooden box at a craft store and cus-tomize it by gluing on felt or painting it in Kwanzaa colors. If you use felt, design some extra felt symbols to glue onto the box for decoration.

Level: Moderately easy

Time involved: Two to three hours

Materials:

Large sturdy piece of white felt approximately 12 × 18 inches (Craft stores sell this size felt that is stiff like cardboard but flexible.)

Yardstick

Pencil

Black fine-tipped marker

Sticker letters

Scissors

Bag of felt numbers

Bag of felt letters

Glue gun

Hole punch

Yarn

Assorted colors of felt squares

1. Lay the white felt on a work area so that the 18-inch side is horizontal. Using a yardstick and pencil, mark off a 2-inch border at the top of the felt. Draw a light pencil line at this marking. Measure a $^1/_2$-inch section above this line and draw a line at this mark to create boxes for the days of the week.

2. Mark off four $2^1/_2$-inch sections below the drawn lines and down the 12-inch length of the calendar. Draw these lines in pencil.

3. Mark off seven $2^1/_2$ sections across the 18-inch length of the felt (also below the top, 2-inch border) and draw the lines in pencil intersecting the lines drawn horizontally. You should have seven $2^1/_2$-inch blocks across and four $2^1/_2$-inch blocks down.

4. Go back over the pencil lines with a fine-tipped marker. Use sticker letters to spell out the days of the week (Sunday through Saturday) in the small boxes you made in the top of the border.

5. Spell out the word "Kwanzaa" by gluing the appropriate felt letters onto the top of the calendar. Using the felt numbers and letters, place "Dec. 26" and "Jan. 1" on the calendar to represent the days of Kwanzaa.

6. Punch a hole in the upper-left and upper-right corners of the calendar. Tie each end of a 25-inch piece of yarn through the holes to form a hanger.

7. Cut out a red, a green, and a black $2 \times ^1/_2$ inch candle from the felt. Cut out three yellow flames. If desired, you could make enough candles for each day of Kwanzaa. Follow the patterns provided to make other Kwanzaa symbols out of the felt. Use your kuumba (creativity) to think of other symbols that might be appropriate.

This can be an ongoing project, and you can add new symbols as desired from year to year. You might want to get together with your family and brainstorm about the symbols you want to create. For example, you could make a symbol of a book and place that on the date you'd like to have a family story hour. Or, you could place a present on the date or dates you wish to exchange presents.

Keep your symbols in a special box until you're ready to place them on the calendar. You might want to purchase some two-sided sticky tape to keep them tightly secured to the calendar, while allowing them to be reused each year.

To save time, you could also make this calendar out of a blank paper calendar form and cut pictures, letters, and numbers out of magazines to mark the special events.

*Some special symbols for
a Kwanzaa calendar.*

(© Melissa LeBon)

Flag of Black Nationalism (Bendera Ya Taifa)

A flag representing Black Nationalism may be hung at a Kwanzaa celebration facing east. This flag is simple to make and will become a meaningful component of your ritual.

Level: Moderately difficult

Time involved: Two to three hours

Materials:

> One yard each of green, black, and red material
>
> Scissors
>
> Straight pins
>
> Sewing machine
>
> Thread

Iron and ironing board

Flag pole or dowel

Two-sided sticky tape (optional)

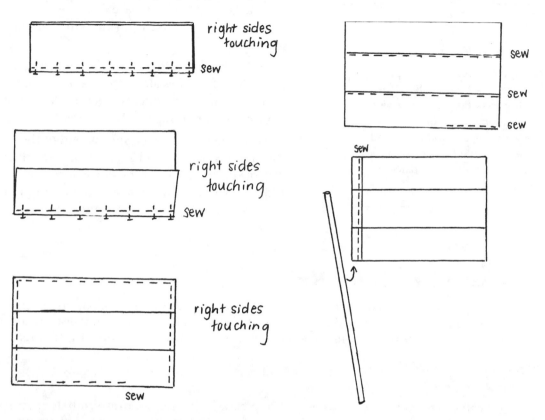

Cutting out and sewing a Kwanzaa flag.

(© Melissa LeBon)

1. Cut each color of the material into two strips that are 8 × 36 inches.

2. Place one red and one black strip with right sides touching, and pin one of the longer edges together. Sew the two strips together using a $1/2$-inch seam. Remove the pins and press the seams flat (open).

3. Pin the green strip on top of the black strip, with the right sides touching along the edge that isn't sewn to the red strip. Sew the green strip to the black strip using a $1/2$-inch seam. Remove the pins and press the seams flat.

4. Repeat steps 1 through 3 using the other strips of material. You should have two rectangles of red, black, and green.

Holiday Hints

You could make a unique pillow by modifying the directions for the Kwanzaa flag. Before sewing shut the opening, stuff the pillow with polyester fill to desired fullness. Sew shut the opening and set the pillow in a place of honor on your sofa.

5. Pin these rectangles on top of each other, right sides together, with the same colors touching. Sew around the perimeter of the rectangle leaving a 3-inch open space to turn the flag right-side out. Be sure to backspace over the beginning and end of the opening to keep the stitches intact.

6. Turn the flag right-side out. Press the flag flat. Sew a line of stitches along the seams of each color to keep the two pieces together. Hand-sew or machine-stitch the 3-inch opening together.

7. Make a 3-inch flap on the shorter end of the flag, and sew this down to form a tube for the flagpole or dowel. Insert the dowel into the flag and use two-sided sticky tape to hold it in place if necessary. Hang your flag (facing east) with pride at your next Kwanzaa celebration.

Kwanzaa Krafts for Kids

Hopefully you've already gotten your kids involved in planning your Kwanzaa celebration and creating the symbols that you'll enjoy year after year. The following are a couple of craft ideas that will make the holidays spent with family more meaningful.

Clay Jewelry

You can create endless jewelry designs from clay. Make the Kwanzaa symbols to string on a necklace or glue onto a pin or barrette form. You can also use your imagination to make traditional beads, geometric designs, and everyday objects. Try some of the designs in the figure, and then let your ideas soar to new heights in clay creativity.

Level: Easy

Time involved: Two to three hours, including baking time

Materials:

Sculpting clay (Fimo or Sculpy clay are quality products.)

Plastic knife

Toothpick

Plastic eyes (optional)

Cookie sheet

Glue gun

Pin forms

Barrette forms

Bead elastic

Colorful clay keepsakes.

1. Roll small pieces of the dough between your fingers to make it pliable. Sculpt the dough into the design of your choice. If making beads, roll the dough into a snake form and cut the beads with a knife. You can roll several colors of clay together to make multicolored beads. Use a toothpick to make a hole in the beads for stringing them. You can roll a small snake into a spiral to create a snail (and later glue a plastic eye in each side at the top). Or you could use the sample designs shown in the photo.

2. Place the designs on a cookie sheet and bake them according to the manufacturer's directions (usually in a 275°F oven for 15 to 20 minutes). Remove the sheet from the oven and allow the designs to cool.

3. Glue the designs onto the pins or barrette forms, or string them onto bead elastic.

Seasonal Sense

Two types of **sculpting clay** are typically sold in craft stores—modeling clay and baking clay. The modeling clay doesn't harden and can be shaped into objects and used over and over again. The type of clay you bake hardens to form a permanent object. Some popular brands of this type of clay are Sculpy and Fimo. When purchasing clay to make jewelry, be sure it can be baked to form a permanent bead or design.

Earth Paintings

Capture the colors of your environment by using the earth around you as paint.

Level: Easy

Time involved: One to two hours

Materials:

> Samples of soil (You should be able to find yellow, brown, rust, orange, and red if you look in different areas; do not use potting soil!)
>
> Disposable cups
>
> Water
>
> White glue
>
> Construction paper
>
> Paintbrushes
>
> Craft paints (optional)

1. Place the soil sample in a cup, filling it to about half full.
2. Mix enough water into the soil to get a paint consistency. Start with 1 teaspoon and stir, and then add small increments of water as necessary, stirring in between. The mixture should be able to coat a brush but shouldn't be runny. If you add too much water, add a little more soil.

3. Add 1 teaspoon glue to each cup and stir. Add more glue if the sample is sandy. Repeat these steps with the remaining earth samples.

4. Paint a mural or abstract design on a piece of construction paper using different paint colors. Create different textures by adding layers of paint or thinning the paint for a transparent effect. You can also add different colors of craft paint to the cups to create a rainbow of earth colors.

Display your creations proudly at a Kwanzaa celebration, or frame them to give as gifts to relatives.

Festive Facts

Many types of paints are on the market that are used for different purposes. Watercolors use water as the medium and can be easily cleaned up. They have a slightly transparent effect. Oil colors use oil as the medium and are bolder and more permanent. Oil paints require solutions such as turpentine to clean your brushes (although canola oil works well, too). Craft or acrylic paints are water-based and can be cleaned up with soap and water. The colors are permanent and fast-drying. I used craft paints in most of the projects in this book. There are also glass paints, fabric paints, spray paints, and special-effect paints (such as stone, crackle, marble, or rust effect paint). Tempera paints that are nontoxic and easy to clean up are recommended for kids' crafts. Basically, the nature of the project dictates the type of paint that is recommended.

Crayon Runoff

Explore the effect of painting over crayon with your kids and watch the surprise on their faces when the paint runs off the crayon design.

Level: Easy

Time involved: One to two hours

Holiday Hints

You might want to try using a coloring book and watercolors to create crayon runoffs. Leave enough spaces uncolored on the page to get the full effect of the paints.

Materials:

Poster board

Crayons

Nontoxic tempera paints

Paintbrush

1. Using crayons, draw a landscape or a special design on a piece of paper. Press hard on the crayons to form a thick line.

2. Color over the area with nontoxic tempera paints. The paint will run off the crayon design, creating an interesting effect.

Kitchen Kreations

Certain foods are traditional fare for a Kwanzaa celebration. Use the principle of ujima (collective work and responsibility) to enlist the help of your family to make these Kwanzaa delicacies.

African Stew

Yams are a staple in the African diet. You can't go wrong serving this delicious stew for Kwanzaa dinner.

Level: Moderately easy

Time involved: One to two hours

Ingredients:

2 yams

1 large, sweet onion

2 cloves garlic

2 tablespoons vegetable oil

1 bunch spinach

3 tomatoes

1 can garbanzo beans

$^3/_4$ cup raisins

Salt and pepper to taste

³/₄ cup uncooked rice

Tabasco sauce (optional)

Equipment:

Potato peeler

Paring knife

Cutting board

Large stock pot with lid

1. Scrub the yams and peel them. Cut them into thick slices. Chop the onion and garlic. Fry them in vegetable oil in a large pot until tender.
2. Cut the spinach and tomatoes into small pieces and add them to the pot.
3. Add the garbanzo beans, yams, raisins, salt, and pepper and cook on medium heat for five minutes.
4. Place the rice in the center of the pot and press it into the liquids until covered. Add Tabasco if desired.
5. Cover and cook over medium heat approximately 25 minutes or until the rice is done.

Benne Cakes

Benne cakes originated in West Africa. Benne means sesame seeds, and they are eaten for good luck. Bring some luck to your Kwanzaa celebration by trying these delicious and simple cakes.

Level: Moderately easy

Time involved: One to two hours

Ingredients:

¹/₄ cup butter or margarine, softened

1 cup finely packed brown sugar

1 egg, beaten

¹/₂ teaspoon vanilla extract

1 teaspoon freshly squeezed lemon juice

¹/₂ cup flour

$^1/_2$ teaspoon baking powder

$^1/_4$ teaspoon salt

1 cup toasted sesame seeds

Vegetable oil

Equipment:

Cookie sheet

Mixer or food processor

Cooling racks

1. Preheat oven to 325°F. Lightly oil a cookie sheet.
2. Mix together butter and brown sugar in a mixer or food processor and beat until creamy.
3. Mix in egg, vanilla, and lemon juice. Add flour, baking powder, salt, and sesame seeds. Mix together.
4. Drop by teaspoonfuls onto cookie sheets about 2 inches apart. Bake at 325°F for 15 minutes or until lightly browned. Remove the cookies from the cookie sheets and allow them to cool on cooling racks.

The Least You Need to Know

➤ You can become an expert on celebrating Kwanzaa by incorporating traditional themes into your own family celebration.

➤ The Kwanzaa symbols are rich in meaning and can be handcrafted to use in the celebration or to give as gifts at the Karamu (feast).

➤ Live the principle of Ujamaa (cooperative economics) by making creative crafts with your kids.

➤ Enjoy tasty and meaningful foods at your Kwanzaa dinners.

In with the New

In This Chapter

➤ Learning how to create special favors and decorations that will be the hit of your New Year's party

➤ Spending the New Year's holiday making fun crafts with the kids

➤ Making special drinks to toast in the New Year

Ring in the New Year with your own signature style. New Year's Day is a relatively uncomplicated holiday, dedicated to the tradition of marking the passage of another year in our lives. It's time to reflect upon the past and look forward to the new challenges of a fresh year.

People around the world celebrate the New Year on varied dates due to their use of different calendars. For example, in China the New Year is celebrated sometime between January 17 and February 19, depending upon the arrival of the new moon. The Jewish New Year, called Rosh Hashanah, is a holy time based on the Jewish calendar. People reflect on the good they have done in the past and promise to do better in the new year. The movements of the moon determine the Muslim calendar; therefore, New Year's Day arrives 11 days earlier each year. Although the dates may change, ringing in the New Year usually involves a variety of traditions and time spent together in celebration with family and friends.

If you haven't done anything in the past to commemorate this special time, why not take a look at the New Year's crafts in this chapter. You might want to spend some of your time off working on these fun projects with your family and friends. It's the perfect holiday to turn off the TV, computers, and video games and grab your kids to create some old-fashioned fun. Hopefully the bonds you're forming with them will take you through the New Year and beyond.

Toasts and Tokens

Toast the New Year in style. Be the first on your block to make your own party hats and supplies for the big New Year's Eve event. Get the kids together to help you decorate your home and table to start the New Year right.

Tricky Toasts

You won't get a hangover from these martinis—which are actually martini glass candles—but you will get a lot of comments on your creative style. You can make any drinking glass into a gel candle and dye it to match the color of the supposed libation inside. Just be careful your guests don't actually try to sip from this unique "drink"!

Level: Moderately easy

Time involved: Two to three hours

Materials:

> Newspapers
>
> Martini glass
>
> Candle wick (The stiff [waxed] wicks with a metal tab work best.)
>
> Glue gun
>
> Pencil
>
> Small piece of yellow wax or yellow crayon
>
> Peeler
>
> Gel wax (I used about ¼ of the 23-ounce container.)
>
> Medium saucepan
>
> Candy thermometer
>
> Tweezers

1. Spread newspapers on your work area to protect it. Prepare the martini glass by gluing the metal tab of the wick to the bottom of it. If the wick is not stiff (waxed), tape the other end of it to a pencil and lay it across the top of the glass. Before pouring the hot wax in the glass, run some hot water in it so it doesn't crack with the heat of the wax.

2. Using a peeler, peel a sliver of wax from the yellow wax piece or peeled crayon. The wax should curl a bit and resemble a lemon peel.

3. Spoon out about $1/4$ of the gel wax into the saucepan. You might have to use a knife to cut around the edges of the gel to facilitate an easy removal. Melt the wax on low heat for 5 to 10 minutes or until it turns liquid. Place the thermometer in the gel when melting; do not exceed 260°F.

> **Holiday Hints**
>
> You might want to try making gel wax candles in different glassware, such as a mug, a champagne glass, a wine glass, or even a fancy coffee cup with a saucer. Be sure to run hot water into the glass or cup before pouring in the hot gel to keep it from breaking.

4. Carefully pour the wax into the prepared glass, keeping the wick straight in the center. Allow the wax to cool for about 5 minutes. Using the tweezers, insert the wax lemon peel into the gel on the side of the glass, away from the wick. Allow the candle to cool thoroughly (several hours) before handling.

> **Holiday Hassles**
>
> You should take care when heating gel wax. Gel wax should not be microwaved. It should be melted in a pan on the stove with a candy thermometer inserted in it to make sure it doesn't exceed 260°F. If the wax should accidentally catch on fire, douse it with baking soda—not water—as water will spread the fire. If you are inserting objects into the wax, be sure to keep them away from the wick so that they don't melt or burn when the candle is burning.

Hats Off to the Guests

There's nothing like a homemade party hat to kick off a New Year's Eve gala. Impress your friends and family by making several creations and providing the materials for guests who want to make their own designs. For the kids involved, you might want to award a prize for the most original hat, the funniest hat, the most colorful hat, and so on.

Sample party hats for your New Year's celebration.

(© Melissa LeBon)

band

samples for band:

Festive Facts

The origins of the celebration of a new year can be traced back to the Egyptians and Babylonians more than 4,000 years ago. Each year in September, the Nile River flooded, enriching the farmland and signaling a new beginning for the farmers. The Egyptians would parade statues of the god Amon and Amon's wife and son on a boat on the river and feast for a month. The Babylonians celebrated the new year on March 23 to signify the beginning of a new cycle of planting and harvesting crops. They would strip the clothing from their king and send him away for a few days. When he returned during a procession, he was decked out in glorious new robes. It wasn't until the Roman emperor, Julius Caesar, established his own calendar in 46 B.C.E. that January 1 was picked to be the start of the new year in the Julian calendar.

Level: Easy

Time involved: One to two hours

Materials:

> Tape measure
>
> Multicolored pack of foam sheets
>
> Scissors
>
> Low-temperature glue gun or foam sheet glue
>
> Assorted bags of foam shapes, letters, animals
>
> Bag of feathers (optional)
>
> Glitter pens

1. Cut the basic shape of your hat by measuring your head and cutting a 3-inch band of foam sheet to that dimension. Glue the two ends of the foam band together to form a circle.

2. Cut another shape out of a different color of foam sheet and glue it to the front of the band. One idea is to make a circular shape and draw a fireworks display on it.

3. Add details to your hat by cutting shapes out of other foam sheets or by gluing pre-cut foam shapes onto your hat. Add feathers if desired.

4. Write "Happy New Year!" and the date on the band of your hat.

New Year's Poppers

These unusual New Year's favors will brighten any dinner table. Watch the kids' faces light up when they find their favorite trinkets and candies inside!

Assembling a New Year's popper.

(© Melissa LeBon)

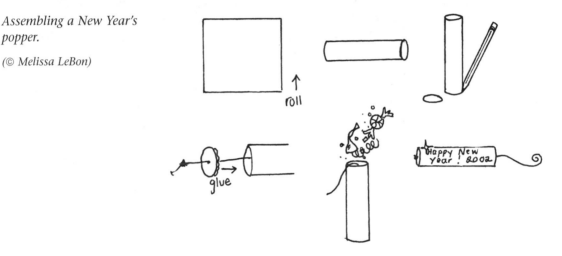

Level: Easy

Time involved: One to two hours

Materials:

> White poster board
>
> Scissors
>
> Glue gun
>
> Yarn
>
> Confetti
>
> Trinkets and wrapped candies
>
> Glitter pen

1. Cut a piece of poster board into a 6-inch square. Roll the poster board into a tube and glue the sides together to form a tube with open ends. Or, you could

omit this step and use a cardboard toilet paper roll covered with tissue or construction paper.

2. Place the end of the tube on the poster paper and trace around it to make discs for the ends of the tube. Cut two circles out of the poster board.

3. Poke a hole in the centers of the discs. Cut a piece of yarn that is 10 inches long. Thread the yarn into the hole in one of the discs and tie a knot to secure it. Glue this disc onto the inside of the one end of the tube as shown. Pull the yarn through the tube so that it extends out the other end and allow to dry.

4. Add confetti, trinkets, and candies to the tube. Fill the tube to the top or add some crumpled tissue paper to fill it. Keep the piece of yarn taut and in the center of the tube.

5. Thread the second prepared disc onto the end of the yarn and push it up to seal the tube. Glue the disc in place and allow it to dry.

6. Write "Happy New Year" and the date on the outside of the tube with a glitter pen. Open the firecrackers together by quickly pulling the yarn through the tube. Be prepared to clean up a little confetti or omit this ingredient if you don't want a mess.

Holiday Hints

New Year's poppers would make great favors for a kid's birthday party. You can fill the poppers with wrapped gummy candies and with trinkets that reflect the age and gender of the guests. Write the names of the guests on the outside with a glitter marker and place them on the party table.

Spirits Sack

Get the party started by presenting the host with this crafty bag containing his or her favorite spirits. You can make this bag from scratch or decorate a store-bought bag.

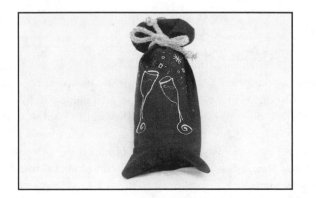

A stylish wrapping for a gift of spirits.

Level: Moderately easy

Time involved: Six to eight hours, including drying time

Materials:

Two 15 × 7 inch pieces of canvas material

Iron and ironing board

Straight pins

Sewing machine or sewing needle

Thread

Fabric paints in squeeze bottles

22-inch piece of thick cord or trim

1. Using an iron, press both pieces of material. Press a $1/4$-inch hem in the top of the 7-inch length of both pieces of material. Make sure the two wrong sides of the fabric are together. Sew these hems with a machine or needle and thread.

2. Pin the two pieces of material, right sides together, with both hems at the top. Using a $1/2$-inch seam, sew along both sides and the bottom of the material, leaving the top unsewn. Turn the bag right-side out and press it flat.

3. Use your imagination to create a design on the front using fabric paints, or follow the steps illustrated here. Allow the paint to dry for four to six hours.

4. Place your bottle inside the bag and tie the cord or trim around the neck of the bottle.

Holiday Hassles

You can avoid ruining a project by practicing with squeezable fabric paints on paper before using them. You should never make a long continuous line with fabric paint since it will tend to crack when the fabric moves. You should paint right from the bottle so the applicator tip touches the fabric surface. Allow the paint to seep into the fibers by squeezing and dragging the tip along the design. You can also brush on the paint or add water to the paint to fill in larger areas. Allow the project to dry for at least 4 to 6 hours and wait 72 hours before washing it.

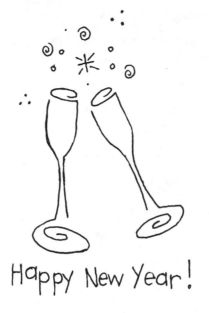

The perfect New Year's design for your spirits bag.

(© Melissa LeBon)

Happy New Year!

Picture Perfect

Display a holiday picture in this lovely New Year's picture frame. Start with an unfinished wooden frame, add some paint, glitter, and a family photo, and voilà—the perfect gift for Grandma!

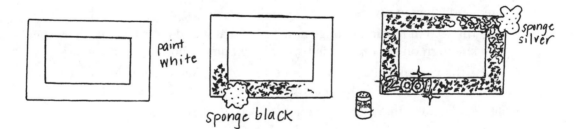

Applying paint to a frame with a sponge.

(© Melissa LeBon)

Seasonal Sense

You can buy a variety of **textured sponges** in craft stores or the craft section of discount stores. They come in different patterns or textures and in all shapes and sizes. These sponges create a unique effect on craft projects and can also be used to create a new look on a wall in your home.

Level: Easy

Time involved: Two to three hours including drying time

Materials:

Newspapers or plastic

Unfinished wooden picture frame

Black, white, and silver craft paints

Foam plate

Paintbrushes

Two *textured sponges*

White glue

Silver glitter

Family photo

1. Cover your work area with newspapers or plastic. Place the picture frame on the prepared surface. Squeeze about one tablespoon each of black, white, and silver craft paint onto the foam plate. Paint the frame white and allow to dry.

2. Dip the textured sponge in black paint. Press the sponge in a pattern over the white frame. Add more paint to the sponge as necessary until the frame is covered and allow to dry.

3. Dip the second textured sponge in the silver paint and press this on top of the black pattern on the top and left side of the frame. Allow the frame to dry.

4. Write the year in white glue on the bottom of the frame. Sprinkle the silver glitter over the glue and allow to dry. Shake the excess glue off the frame.

5. Place a family photo into the frame.

Holiday Hints

If you liked making a New Year's picture frame, you might want to experiment with other holiday themes. You could buy flat wooden Christmas ornaments, paint them, and glue them onto a wooden frame. You could also use holiday stencils or stamps on a cardboard frame. Or, try your hand at decoupage by cutting pictures from old holiday cards, gluing them onto a wooden frame, and finishing it with a layer or two of varnish.

Kid Kapers

Start the New Year right by getting your kids involved in these creative learning activities and crafts. Check out these crafts and make family fun a New Year's resolution.

Bodacious Bottles

Capture the kids' imagination by helping them make these beautiful decorative bottles that display a swirl of colors and designs. Spend some time with your kids choosing the perfect confetti and color for their creations.

Festive Facts

The month of January was named for the Roman god Janus who is depicted with two heads—one looking forward to the future and one looking back at the past. The Greeks held a parade in January and carried around a baby to represent fertility. The New Year's baby may have originated from this custom. Nowadays we emulate these rituals by depicting the old year as an old man and the New Year as a fresh new baby.

An imaginative suspension of color and glitter.

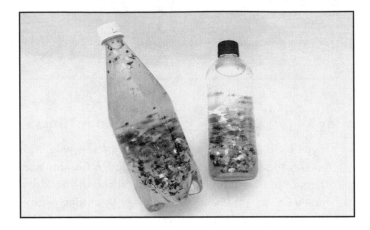

Level: Easy

Time involved: Half to one hour

Materials:

> Clear plastic bottle with cap (A water bottle works well.)
>
> Corn syrup or vegetable oil
>
> Glitter
>
> Metallic confetti
>
> Food coloring

1. Soak the bottle in hot soapy water to remove the label. Remove any sticky residue from the label area. Fill the bottle with corn syrup or vegetable oil until it is ³/₄ full. Using corn syrup produces a plopping bubble effect, while using vegetable oil produces a fragmented bubble effect. You might want to make one of each to see the two different effects.

2. Add 2 tablespoons glitter and 2 tablespoons metallic confetti to the bottle. Add 2 drops food-coloring in your choice of color.

3. Fill the bottle to the top with cold water. Seal the bottle with the cap. Turn the bottle over and shake it slightly to produce a swirling effect.

Elegant Etchings

A few crayons and some paper are all you need to make these fireworks etchings with your kids. This craft is simple to do and provides hours of creative entertainment. You might want to try other designs with your kids if this project was a success!

Level: Easy

Time involved: Two to three hours

Materials:

 Newspaper

 White poster board

 Crayons

 Black nontoxic tempera paint

 Paintbrush

 Large paper clip

1. Cover your work area with newspapers. Place the poster board on top of the newspapers and color the entire surface with different colors of crayon. Use a heavy hand with the crayons.

2. Paint the poster board with black paint and allow it to dry.

3. Unwind the paper clip and scratch a design into the paint, being careful not to rip the poster board. The areas that are scratched will show through with a rainbow effect.

Holiday Hints

As long as you have the crayons out, you could try making carbon paper with your kids. Just help them color an entire sheet of copy paper using different colors of crayons. Be sure to make a thick layer of crayon. Place a second sheet of copy paper over the top of this paper and staple them together at the top. Have the kids draw a design or message on the back of the colored sheet with a pen or pencil and watch it mysteriously appear in color on the attached sheet.

Delightful Dragons

Celebrate the Chinese New Year by making these fun dragon puppets out of paper plates and foam sheets. You could make several interesting creatures and let the kids put on a puppet show for some after-dinner entertainment.

Dragon in the New Year.

Level: Easy

Time involved: One to two hours

Materials:

> Two 9-inch paper plates
>
> Scissors
>
> Two 12 × 10 inch green foam sheets
>
> Pack of assorted foam sheets, including red for the mouth
>
> Glue gun
>
> Large plastic eyes
>
> Fabric paints in squeeze bottles (optional)

1. Fold one paper plate in half. Cut the second paper plate in half. Place half of the plate on top of the first folded plate, matching up the rims to form a mouth. Glue along the edges of the mouth. Repeat this with the second half of the plate, gluing it onto the bottom of the folded plate. You should have a mouth that opens with spaces on the top and bottom for your fingers and thumb.

2. Cut two pieces of green foam sheet 12 × 9 inches. Place the paper-plate mouth over the end of the 9-inch end of the foam sheet and trace the mouth onto the

green foam sheet. Cut this curve out of the end. Repeat this process with the second green foam sheet. Glue the foam sheet onto the paper-plate mouth. Continue gluing the sides of the two foam sheets together to form the body of the dragon.

3. Open up the mouth of the dragon and trace this circle onto a piece of red foam sheet. Cut out the circle and glue it to the inside of the mouth.

4. Glue two plastic eyes onto the top of the dragon. Cut a tongue out of the red foam sheet and wings out of the yellow foam sheet as shown. Glue these to the dragon. If desired, you could use fabric paint in squeeze bottles to decorate your dragon.

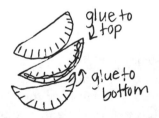

Assembling your dragon and adding the features.

(© Melissa LeBon)

Luscious Libations

Whether you celebrate New Year's Eve with a toast of spirits or prefer to omit the alcohol, you should check out these recipes for delicious and refreshing holiday drinks. These libations will be sure to please a crowd!

Strawberry Slush

Level: Easy

Time involved: Half hour

Ingredients:

> One quart of strawberries, washed and hulled
>
> One 12-ounce can of frozen lemonade
>
> 6 to 12 ounces of light rum (optional)
>
> One tray of ice cubes

Equipment:

> Blender
>
> Drink glasses

Place the strawberries and lemonade in the blender. Blend on high until slushy. Add the rum if desired. If you don't add rum, you'll have to add about $1/_2$ cup water. Fill the blender to the top with ice cubes and blend on high until the mixture is slushy. If you are replacing the alcohol with water, you might need to add a little more water to get the mixture to a smooth consistency.

Note that if you omit the strawberries and change the rum to whiskey in this recipe, you'll have a frozen whiskey sour. Just add a cherry and orange slice to garnish this drink.

Holiday Hints

You might want to make a holiday tray to serve your party drinks. You can buy an unfin-
ished wooden tray in a craft store for about $5. Paint the tray with white craft paint on
the top and bottom. Buy decoupage designs at the craft store or cut pictures out of
magazines and old greeting cards. You might want to check a card shop or party supply
store for New Year's symbols to use. Glue the pictures onto the tray. Apply a light coat of
varnish to the tray and allow it to dry. Brush on a second coat and allow it to dry
overnight before using it.

Merry Margarita

Level: Easy

Time involved: Half hour

Ingredients:

1 cup tequila

$^1/_2$ cup *triple sec*

One 12-ounce can frozen lemonade

Tray of ice cubes

Lemon wedge (optional)

Salt (optional)

Seasonal Sense

Triple sec is an orange-flavored
liquor that is a key ingredient in
margaritas and other drinks. This
liquor is also a key ingredient in
some cooking recipes. You can
make a fruit salad special by
pouring a small amount of triple
sec over it before serving it.

Equipment:

Blender

Margarita glasses

Place the tequila, triple sec, and frozen lemonade in a blender. Blend on high
until slushy. Add ice cubes to the top of the blender and blend well. If desired,
rub the rim of a cocktail glass with the lemon wedge and sprinkle salt along the
rim. Pour the liquid into the glass.

Orange Oasis

Level: Easy

Time involved: Half hour

Ingredients:

$^1/_2$ pint orange sherbet

$^1/_2$ pint vanilla frozen yogurt

$^1/_2$ cup milk

1 teaspoon vanilla

Equipment:

Blender

Drink glasses

Place the sherbet, frozen yogurt, vanilla, and milk in a blender. Blend on high until smooth and creamy.

Champagne Punch

Level: Easy

Time involved: Half hour

Holiday Hints

You might want to make these champagne cocktails even more appealing by pouring them into hand-etched flutes. You can buy a kit at the craft store that contains two flutes and all the ingredients you need to etch the glass into your own personal design.

Ingredients:

Juice of 1 dozen lemons

1 cup powdered sugar (more or less to taste)

1 pint brandy

2 bottles of champagne

$^1/_2$ cup triple sec

Block of ice

Orange slices

Maraschino cherries

Equipment:

Punch bowl set

Mix the lemon juice and sugar in the punch bowl until the sugar is dissolved. Add the remaining ingredients and garnish with orange slices and maraschino cherries. You could substitute two cans of frozen lemonade for the fresh lemons and sugar, if desired.

The Least You Need to Know

➤ You can make a New Year's celebration even more special by creating your own party favors and hats.

➤ Spend the time watching the countdown to the New Year together by getting your kids involved in easy, creative kid crafts.

➤ You can be the life of the party by serving specially concocted drinks on a handcrafted drink tray.

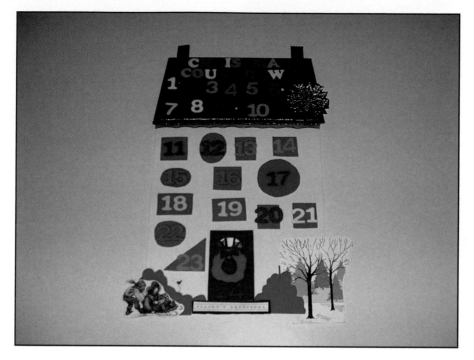

A family heirloom to count down the days to Christmas.

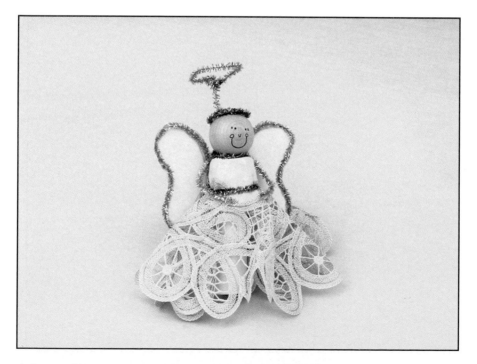

A heavenly ornament to grace your Christmas tree.

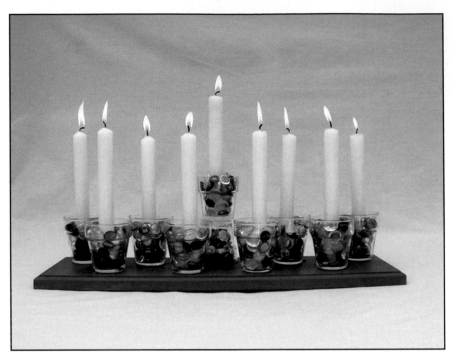

Celebrating the Festival of Lights with a homemade menorah.

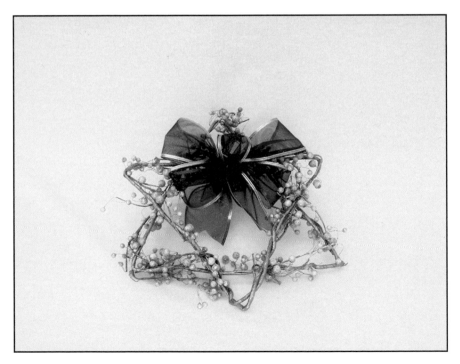

A unique Hanukkah wreath to welcome family and guests.

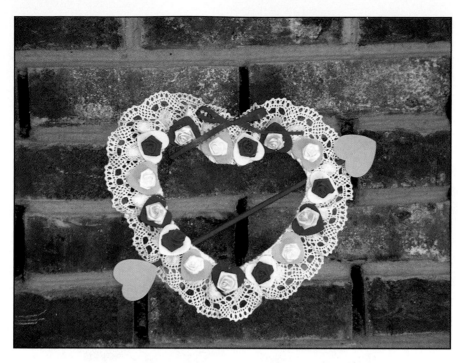

A lovely heart wreath to celebrate Valentine's Day.

A lucky leprechaun caught on St. Patrick's Day.

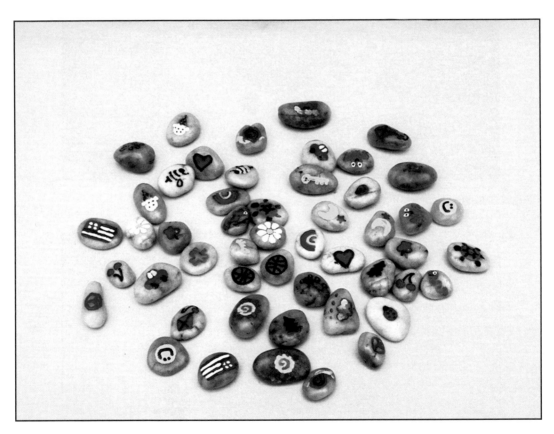

A fun-to-make memory game crafted from river rocks and craft paint.

A unique handcrafted Easter decoration.

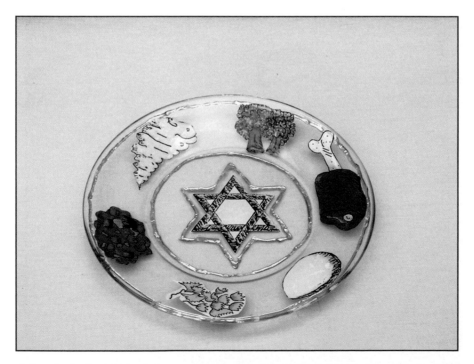

A lovely Seder plate that can be passed down from generation to generation.

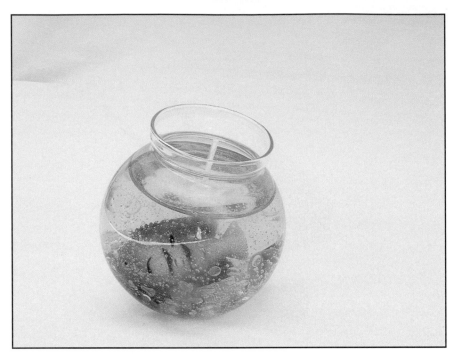

A homemade gel candle that makes a perfect gift for Mom or Dad.

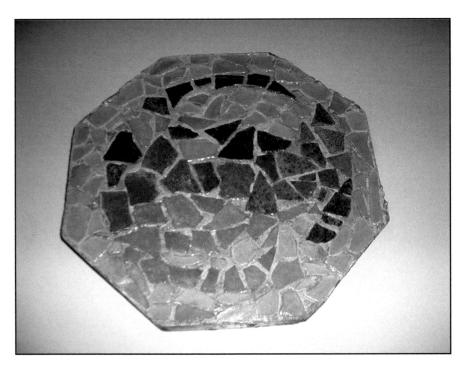

Stepping into your garden in style.

A new design in clothespin art.

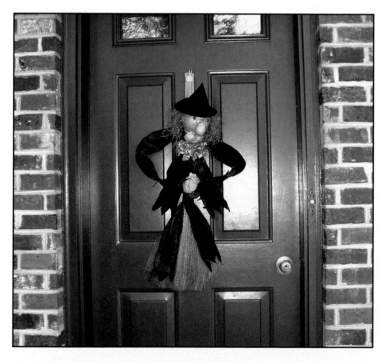

A spooky welcome for trick-or-treaters.

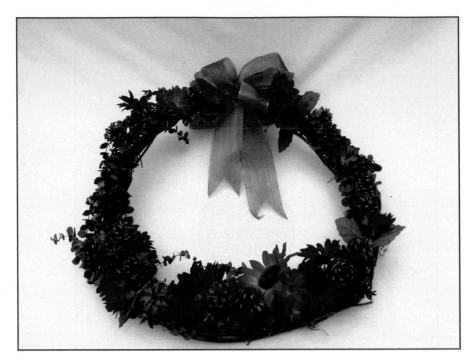

A graceful wreath to herald the fall season.

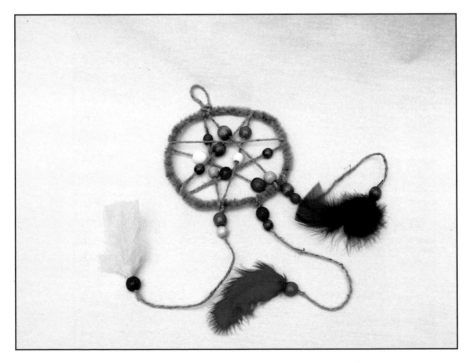

Filtering out bad dreams with a handcrafted dream catcher.

Part 3
Time-Honored Holidays

Sometimes the less-hectic holidays like Valentine's Day and St. Patrick's Day are more enjoyable because there are no unrealistic expectations involved in celebrating them. You don't have to shop 'til you drop, spend days in the kitchen cooking, or go overboard decorating for these events. You can just appreciate the time set aside to remember your loved ones and spend some time enjoying each other's company.

The following chapters contain many ideas on how to celebrate these holidays in style. Keep on reading to find unique seasonal and children's crafts, fun family activities, and ideas for traditional foods to serve for dinner. Remember, these holidays only come around once a year so you'll want to be prepared!

Be My Valentine

In This Chapter

➤ Crafts to create an atmosphere of love in your home

➤ Homemade cards and presents that express your feelings for family and friends

➤ Kid-designed crafts for special family time

➤ Sweets for your sweetie that will earn you extra points

Love is always patient and kind; it is never jealous; love is never boastful or conceited; it is never rude or selfish; it does not take offense, and it is not resentful.

—1 Corinthians 13

This Biblical statement of love encompasses the heart and soul of Valentine's Day. It's a time when people remember their loved ones with flowers, cards, gifts, and other expressions of their affection. Sweethearts are taken out to dinner, and in many cases marriage is proposed. It's a great time to gather family and friends together and tell them what we should be telling them all year long—"I love you!"

But where and how did this special day originate? Some experts say that Valentine's Day was based on the ancient Roman festival—Lupercalia—which was celebrated on the eve and day of February 15. This festival was dedicated to courtship, good crops, and mating. It was the custom for the men in the village to strike people with animal

hides to ensure their fertility. After the arrival of Christianity, in many areas this festival was replaced with a Christian celebration, based on the life of St. Valentine. Many scholars believe that there were several martyrs named St. Valentine whose feast days were held on February 14. It is unsure, however, if there was any connection between them and the Valentine's Day custom of love and courtship.

Nowadays, to celebrate Valentine's Day is to open your heart to love and enjoy a relaxing day with your family and friends. It's a perfect holiday to make a special craft for a loved one or to just spend some time together eating chocolates and having fun.

Counting the Ways of Love

How do I love thee? Let me count the ways …. You can express your love for your family and friends by making them a symbol of your affection. Check out this section for great ideas for your soulmates.

Festive Facts

Did you ever wonder where the tradition of giving Valentine's Day cards originated? One theory is that they were a result of a Roman lottery that was held in honor of the god Lupercus during the festival of Lupercalia. In this lottery, the names of willing young women were placed in a box and picked out by young men. The matched pair would share companionship during the year. Pope Gelasius outlawed the pagan festival of Lupercalia and created a Christian festival based on the life of Saint Valentine. He replaced the old lottery with a new lottery that celebrated the lives of the saints. In this lottery the names of saints were placed in a box. Both men and women picked a saint that they were expected to emulate during the year. Many men were unhappy with this new arrangement and, instead, sent letters of affection to the women they wished to court. These greetings are thought to be the first Valentine's Day cards.

Love Letters

It just wouldn't be Valentine's Day without Valentine's Day cards. Remember when you were little and stuffed your Valentine's Day cards for your classmates into a big decorated box? When they were passed out, there was usually one that stood out in

the mass of greetings—that special homemade card. Recreate this memory by making your own personalized cards for your loved ones.

Level: Easy

Time involved: Half to one hour

Materials:

> Card stock
>
> Pack of foam letters
>
> Glue gun
>
> Pack of foam hearts
>
> Piece of jewelry wire
>
> Calligraphy marker

1. Fold the card stock in half to make a card with the fold at the top. Spell out the word "Valentine …" with the foam letters, and glue them onto the front of the card.

2. Glue large foam hearts onto each side of the word "Valentine …." Glue a smaller heart of another color on top of the first hearts and an even smaller heart of another color on top of the second hearts. You can also use any design of hearts you choose.

3. Allow the hearts to dry. Meanwhile, make a tiny spring out of the jewelry wire by twisting a 4-inch piece of wire into a spiral. Glue together the same order of hearts as on the front of the card. Glue these to the spiral. Glue the spiral of hearts onto the inside of the card. When the recipient opens the card the hearts will spring out at him or her.

4. With a calligraphy marker, write: "You make my heart leap" on the inside of the card.

Checkers Anyone?

Play a quiet game of checkers with your Valentine using these unique heart-shaped pieces and checkerboard. The fun part is collecting your rewards when you capture your opponent's pieces.

Level: Moderately easy

Time involved: Two to three hours, including drying time

Materials:

Newspaper or plastic

24 1-inch wood hearts

Red and white craft paints

Paintbrushes

Black fine-tipped marker

Clear acrylic finish spray

Checker board

1. Place a layer of newspaper or plastic on your work area to protect it. Paint 12 hearts with red paint and 12 hearts with white paint and allow them to dry.

2. Using the marker, write a favor on one side of each piece, such as a back rub, a kiss, a hug, a special treat, or a candy. Once a checker is captured, it can be re-deemed for that prize. Spray the checkers with clear acrylic finish spray and allow them to dry.

If you don't want to bother with paints but would like to play this game of favors, try using pre-cut heart-shaped foam pieces as the checker pieces.

Holiday Hints

You might want to make your own checker board out of 12 × 6 inch square red-and-white foam sheets and a 12-inch square piece of cardboard. Mark off eight $1^1/_2$-inch spaces across the top and bottom of the white foam sheet. Mark off four $1^1/_2$ inch spaces along the sides of the foam sheet. Using a ruler, draw the vertical lines matching up the $1^1/_2$ inch marks. Draw horizontal lines matching up the $1^1/_2$ inch marks along the sides, making 32 $1^1/_2$ inch squares. Repeat this step using the red foam sheet. Cut out 32 $1^1/_2$ inch red squares and 32 $1^1/_2$ inch white squares. Glue the squares onto the cardboard, alternating colors. You should have eight squares across and eight squares down the board. The squares should completely cover the cardboard.

A Hearty Welcome

Welcome visitors to your home with this lovely heart-shaped slate sign. You can put this out for Valentine's Day or make other signs with your kids' names on them to hang on their bedroom doors.

A welcoming sign for visitors to your home.

Level: Moderately easy

Time involved: One to two hours

Materials:

> Transfer or carbon paper
>
> Scissors
>
> Heart-shaped slate (This can be found in craft stores in the slate section.)
>
> Masking tape
>
> Copy paper or tracing paper
>
> Pen
>
> Pink, red, brown, black, and white craft paints
>
> Paintbrushes
>
> Foam plate
>
> Clear acrylic finish spray

Festive Facts

Roses are a symbol of Valentine's Day. In ancient times roses symbolized peace and war as well as love and forgiveness. The type of roses you send to a loved one can have a hidden meaning. Red roses symbolize passion, white roses are for true love and innocence, yellow roses mean friendship, and black roses symbolize farewell.

1. Cut a piece of transfer or carbon paper to fit the heart-shaped slate. Tape this to the slate. Using copy or tracing paper, trace the following Valentine design. Place the copy or tracing paper on top of the transfer paper and tape it in place. Using a pen and moderate pressure, trace over the design to transfer it to the slate. Remove the copy paper and transfer paper from the slate.

2. Paint the design in with the appropriately colored craft paints. Paint the bear brown with a black nose and the hearts pink or white. Allow the slate to dry.

3. Spray the slate with clear acrylic finish spray and allow it to dry.

Sample design for a Valentine's Day welcome.

(© Melissa LeBon)

Scent-Sational Soaps

Making homemade soaps is easier than you might think. You can make these heart-shaped soaps to decorate your bathroom or give them to your loved ones as gifts.

Level: Moderately easy

Time involved: Two to three hours, plus overnight to harden

Materials:

 Glycerin block

 Knife

 Microwave-safe disposable cup

 Soap scent

 Red and white soap dye

 Craft stick or old spoon

Heart-shaped soap molds

Bag of white soap chips

Toothpick

Bag of red soap chips

Soap dish

1. Cut off two squares of the glycerin block and place them in a microwave-safe cup. Microwave this on high for 40 seconds, or according to manufacturer's directions, until melted. Add 2 drops of soap scent and 1 drop of red dye to the mixture. Stir the mixture with a craft stick or old spoon.

2. Pour the mixture into the heart-shaped mold. Add a few white soap chips to the mixture and stir. Use a toothpick to poke any bubbles that may occur and refill if necessary.

3. Repeat this step using red and white dye to make pink soap and then again using only white dye and red soap chips. You should have approximately two heart soaps that are red with white chips, two that are white with red chips, and two that are pink.

4. Allow the soaps to harden overnight. Remove the soaps from the molds and place them in the soap dish.

Holiday Hassles

You can avoid the hassle of collecting all the ingredients necessary for soap making by buying a kit that contains the materials, the molds, and the directions. That way you can see if you enjoy the craft before investing a lot of money in the individual products.

Heart to Heart

This simple Valentine's Day wreath would make an elegant decoration for your home or a perfect gift for a friend or relative. (See the color insert for more details.)

Level: Moderately easy

Time involved: One to two hours

Materials:

25-inch piece of pre-gathered, 2-inch-wide lace

25-inch piece of 18-gauge jewelry wire

10- or 12-inch wood dowel

Red craft paint

Paintbrush

Bag of pink, white, and red foam hearts

Glue gun

Bunch of pink, white, and red satin ribbon roses (the $\frac{1}{2}$-inch size)

Thin red satin ribbon

A Victorian-style Valentine's wreath.

Festive Facts

Laces and ribbons probably became a symbol of love stemming from the days of knighthood. Knights would go into battle carrying a piece of ribbon or lace given to them by their beloved ladies.

1. Thread the lace onto the wire, in and out of each hole at the inside edge of the lace. If you don't have gathered lace, you can use straight lace and gather it in place along the wire. Make sure the lace lies flat when placed on a hard surface. Bend the ends of the wire together and form a loop out of one of them for hanging purposes. Keeping the loop in the center, bend the wire into a heart shape.

2. Paint the dowel with red craft paint and allow it to dry. Thread the dowel through the heart from side to side on an angle. The dowel will keep the wire and lace heart from bending out of shape. Glue a foam heart on each end of the dowel, keeping the pointed side out for the tip of the arrow and the curved side out for the end of the arrow.

3. Glue pink, red, and white foam hearts around the middle of the heart on top of the wire base. Glue a contrasting color of satin rose on top of each heart. The hearts should be big enough to show beneath the roses (approximately 1 inch).

4. Make a small bow out of the satin ribbon and glue it to the top of the heart.

Holiday Hints

You could change the look of the lace heart wreath by using dried roses and baby's breath in the center as decorations instead of hearts and satin roses. You also might want to try making a grapevine heart-shaped wreath by wiring eucalyptus branches and dried or satin flowers around the wreath and topping it off with a satin bow.

Holiday Hints

You might want to try making painted doodle bugs with your kids using tempera paints and copy or construction paper. First, fold the paper in half. Open up the paper and help your child paint his or her name with heavy paint on the top half of the paper along the fold line. Fold the paper in half again to form a creature made out of the child's name. Let your kids paint the bug and add features such as wings, stripes, eyes, antennae, and so on. See who can come up with the most creative names for their bugs.

Seasonal Sense

You might want to invest in **opaque paint markers** to simplify the process of painting on craft projects. The markers are easy to use and work well on glass, ceramics, paper, wood, and just about any surface except fabric. To use the markers, shake well and press the tip on the surface until the paint starts to flow (in approximately 10 to 60 seconds). Repeat this step as needed during use. Keep the markers capped when not in use.

Shrinkable Shapes

Here's a new product you'll *want* to shrink! You can help your kids make funky jewelry, magnets, key chains, and more with shrinkable plastic. Just get them started and let their imaginations take over to create their own unique designs.

Sample shrink shapes to copy.

(© Melissa LeBon)

Level: Easy

Time involved: One to two hours

Materials:

> Shrinkable plastic (You can find this in craft stores.)
>
> *Opaque paint markers* or acrylic paints (Use only permanent markers or paints, not watercolors.)
>
> Paintbrushes
>
> Transfer or carbon paper and pen (optional)

Hole punch for jewelry (optional)

Brown paper bag

Baking sheet

Oven or toaster oven

Jewelry and barrette forms (optional)

Magnet sheet (optional)

Key-chain forms (optional)

Glue gun

1. Paint or draw on the rough side of the shrinkable plastic and allow it to dry. You could use your imagination or trace the sample illustrated designs onto the plastic using transfer or carbon paper. Just trace the sample design onto a piece of copy paper or tracing paper. Place the transfer or carbon paper over the rough side of the plastic. Lay the copy paper on top of this and trace the design again using a pen. The design will appear on the plastic. Cut the designs out of the shrink plastic. Punch any holes you need in the designs with a hole punch before baking it. (The hole will shrink to about half the size.)

2. Place the designs on a piece of brown paper and then on a cookie sheet with the decorated side up. Bake in an oven at 325°F for one to three minutes. After the pieces lie flat, bake for 30 seconds more. Remove the designs from the oven and allow them to cool.

3. Glue the designs onto jewelry forms, magnets, key chains, and so on.

Flocked Box

Create a Valentine's Day work of art with your kids by making this professional-looking flocked box to hold their jewelry or trinkets.

Steps to making a flocked heart box.

(© Melissa LeBon)

Level: Moderately easy

Time involved: One to two hours, plus overnight to dry

Materials:

>Newspaper or plastic
>
>Heart-shaped cardboard box
>
>White craft paint
>
>Paintbrush
>
>Shallow cardboard box lined with waxed paper
>
>Valentine's Day stencils of choice
>
>Masking tape
>
>Spouncer
>
>Red *soft flock* kit (Plaid makes this product, which contains adhesive and fibers and can be found in craft stores.)

1. Cover your work area with newspapers or plastic. Paint the outside of the heart-shaped box and lid with white craft paint and allow it to dry.

2. Place the heart-shaped box on the shallow box lined with waxed paper. Position the stencils in the middle of the lid of the heart-shaped box and tape them in place. Load a damp spouncer (stencil brush) with a liberal amount of adhesive. Holding it vertically, spounce (dab) the adhesive through the stencil.

3. Immediately remove the stencil and apply the fibers. Hold the fiber bottle three to four inches from the stencil and squeeze short bouts of fibers onto the stencil with a continuous flow. Apply a liberal layer of fibers. Do not shake or tap the box; allow it to dry at least an hour before moving it. If desired, you can stencil the sides of the box with different stencils in the same manner.

4. Allow the box to cure overnight before using it. You might want to flock the inside of the box by painting it with red craft paint first and allowing it to dry. Then, paint a layer of the adhesive onto the inside of the box. Apply the fibers to the adhesive as described in step 2 and allow this to dry.

Seasonal Sense

Soft flock is a trademarked product that creates a velvety effect on projects. The kit, made by Plaid, contains a bottle of adhesive and a bottle of tiny fibers. You could use your own stencils and stencil brush (spouncer) to brush a pattern of adhesive onto your project. Then, use the bottle of fibers and spray them onto the adhesive by squeezing the bottle and releasing it, creating short blasts of fiber. Place the project on a box lined with waxed paper to collect (and reuse) any excess fibers. Do not move the project until it has dried at least an hour. Be careful using this product if you are allergic to fibers (a mask and protective eyewear are recommended).

Kitchen Fun

Ever notice how the kitchen is the heart of the home? Families naturally congregate in the kitchen for everything including meals, homework, after-school snacks, family discussions, and school projects. Make the most of this family enclave by cooking up some kitchen fun.

Basket of Love

Puffy dough is a versatile craft medium. You can mold it into various shapes or roll it out and cut it into shapes with cookie cutters. The shapes will harden when baked to form permanent objects that can be painted. You might want to try your hand at making this unique basket out of cut-out hearts.

Level: Moderately difficult

Time involved: Three to four hours, plus overnight to dry

Ingredients:

> 2 cups flour
>
> 1 cup salt
>
> 1 cup water
>
> Vegetable oil

Creating a puffy dough basket.

(© Melissa LeBon)

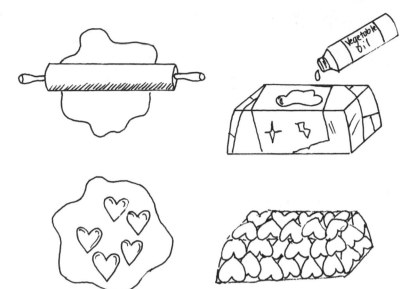

Equipment:

 Mixing bowl

 Rolling pin

 Heart-shaped cookie cutter (approximately 2 inches wide)

 Loaf pan

 Tinfoil

 Cookie sheet

 Cooling rack

 Varnish

 Paintbrush

1. Mix the flour, salt, and water in a mixing bowl. Knead the ingredients with your hands until they are well blended. If the mixture is too runny, add more flour; if it's too stiff, add more water. Roll the dough onto a lightly floured surface to about $1/4$ inch and cut out the hearts with the cookie cutter.

2. Turn the loaf pan upside down and line the bottom and sides with tinfoil. Grease the tinfoil with a layer of vegetable oil. Start on the bottom of the pan and layer the cut-out hearts covering the entire surface and overlapping the

sides and bottoms of the hearts. Press the dough together to cover any open spaces between the hearts. Continue this process on all sides of the pan until the entire bottom of the pan is covered with dough hearts. Pinch the hearts together on the edges of the pan to form a continuous basket form.

3. Place the pan on a cookie sheet and bake in a 350°F oven for 15 to 20 minutes or until the dough begins to brown on the edges. The dough should be firm to the touch. Remove the basket from the oven and carefully pry the dough off of the loaf pan. Remove any tinfoil that sticks to the basket. Allow it to cool on a cooling rack.

Festive Facts

In the Middle Ages men picked names from a bowl to see who would be their Valentine. The men would wear the names on their sleeves for a week. Thus the saying "wearing your heart on your sleeve" originated.

4. Coat the basket with a thin layer of varnish inside and out and allow it to dry. Apply a second thin layer and allow this to dry overnight.

5. Line the basket with pink plastic wrap before filling it with cookies or other food products.

Creative Concoctions

You'll need some homemade cookies to put in your dough basket. Make these delicious butter cookies and let the kids help decorate them with gel icings.

Level: Moderately easy

Time involved: Two to three hours

Ingredients:

Basic Butter Cookie recipe:

> 4 sticks butter (Don't substitute with margarine.)
>
> 2 cups sugar
>
> 1 egg, beaten
>
> 1 teaspoon vanilla
>
> 4 cups flour
>
> Powdered sugar
>
> Gel icing

Equipment:

Electric mixer

Rolling pin

Cookie cutters

Cookie sheet

Cooling racks

1. Cream the butter and sugar in an electric mixer until well blended. Add the beaten egg and vanilla and mix together. Add the flour gradually until you have a smooth, stiff dough mixture.

2. Refrigerate the dough for one hour before using. Roll the dough out ¼-inch thick onto a surface dusted with powdered sugar. Dip the cookie cutters in powdered sugar and cut shapes out of the rolled dough. Place the shapes on a cookie sheet and bake in a 350°F oven for approximately 10 minutes. The edges of the cookies will be golden brown when fully cooked.

3. Remove the cookies from the oven and cool them on cooling racks. Decorate the cookies with gel frostings.

Stolen Hearts

A decorative box of homemade chocolate hearts will stave the chocolate cravings of your favorite Valentines. Make these for your friends and family or keep some hidden for those moments when nothing will do except a bite of chocolate.

Forming hearts and flowers on your chocolate candies.

(© Melissa LeBon)

Level: Easy

Time involved: Two to three hours

Ingredients:

> 1-pound bag brown melting chocolate (This can be found in blocks or discs in supermarkets or craft stores.)
>
> 1-pound bag white melting chocolate
>
> $\frac{1}{2}$ pound pink melting chocolate
>
> $\frac{1}{4}$ pound green melting chocolate

Equipment:

> Double boiler (or two pans that fit inside each other)
>
> Heart-shaped candy molds
>
> Two sandwich bags
>
> Scissors

1. Place about 1 inch of water in the bottom of the double boiler and bring it to a boil over medium-high heat. Put the brown chocolate in the top pan of the double boiler and place it on top of the bottom pan.

2. Lower the heat to medium low and cook the chocolate until melted. Once the chocolate begins to bubble, it's ready to pour. Don't overcook the chocolate or it will scorch and taste burnt.

3. Pour the chocolate into the heart molds. Allow these to harden, and then place them in the refrigerator for two hours before removing the chocolate from the molds. Carefully push the chocolate from the molds, applying pressure to the back of them.

4. Repeat steps 1 through 3 using the white chocolate.

5. Melt the pink chocolate and place it in a sandwich bag. Squeeze the chocolate to one corner and cut a small hole in this corner. Squeeze the pink chocolate into a flower or heart shape on top of each of the chocolate hearts and allow it to harden.

6. Melt the green chocolate and place it in a sandwich bag with a small hole cut in one corner. Squeeze the green chocolate onto the hearts with flowers to form leaves. You might want to make a green arrow on the pink heart shapes.

7. Allow the candies to harden in the refrigerator overnight before packing them into a container.

Holiday Hints

You might want to buy and decorate a candy box for your chocolate hearts. If you check out the box section of a craft store, you'll find white glossy boxes that you can decorate with stencils, paint, rub-on transfers, and so on. I found a box that resembles a cigar box that would be the perfect size for storing candies. You could also use a plastic box and decorate it with painted wooden shapes, foam shapes, or strips of fabric and specialty buttons arranged in a pattern on the lid.

The Least You Need to Know

➤ Creating a specially designed craft project for a loved one is a perfect way to celebrate Valentine's Day.

➤ There are many symbols of love that you can use to express your feelings on Valentine's Day.

➤ Show your kids you love them by spending time with them enjoying simple and creative crafts.

➤ Don't forget to indulge your sweet tooth this Valentine's Day. Make your own cookies and candies and share them with someone special.

Kiss Me, I'm Irish

In This Chapter

➤ Simple crafts to show off your Irish pride

➤ Fun with the kids making magical crafts

➤ Recipes to celebrate—from unusual to traditional

Who said you had to be Irish to enjoy St. Patrick's Day? You can get in on the luck of the season by chasing after leprechauns and finding your own pot of gold. Get your kids involved in the action and spend the day making magical crafts and specialty foods. You can have lots of family fun and help cure the winter doldrums by celebrating this special spring holiday. If an elder parent is living with you, give him or her a big Irish kiss and have them join in the festivities.

Each year, St. Patrick's Day is celebrated on March 17. There are mischievous leprechauns, pots of gold, and shamrocks associated with this holiday. However, St. Patrick's Day is based upon the life of a Saint named Maewyn Succat. According to the legend, Maewyn was kidnapped from his home in Britain and sold into slavery in Ireland. There he became a shepherd and turned to religion for solace. After six years of slavery, he managed to flee to Gaul where he entered a monastery. It was here that he changed his name to Patrick, a more Christian name. Patrick's mission in life was to convert the pagans of Ireland to Christianity. He traveled the land and set up schools and churches to educate the Irish masses. It is said that he drove the snakes (a pagan symbol) out of Ireland, but there is little proof to this claim. Patrick died in

Festive Facts

The color green is associated with St. Patrick's Day because it represents spring and shamrocks. It is said that St. Patrick used the shamrock (a three-leaf clover) to teach the concept of the trinity—the Father, the Son, and the Holy Spirit.

County Down on March 17, in 461 C.E. This day was set aside to commemorate his life. The first St. Patrick's Day celebration in the United States was held in Boston, Massachusetts, in 1737.

On the lighter side of the holiday, it is suggested that a mischievous leprechaun rules this day. He upsets chairs, turns foods green, and is impossible to catch. If you were lucky enough to see a leprechaun, you could force him to lead you to his pot of gold. Of course, the minute you take your eye off of him, he'll disappear and take his treasure with him. This St. Patrick's day you could capture your own treasure by working together to strengthen your family bonds. You can have lots of fun with your own little leprechauns by trying the unique crafts in this chapter. As you know, time spent together with your friends and family is the best treasure you could ever own!

Festive Folklore

The Irish heritage is rich in traditions and legends. From leprechauns to Blarney stones, you can have lots of fun crafting symbols for St. Patrick's Day. It's good luck to wear green on St. Patrick's Day and even better luck to find a four-leaf clover. This year, don't get pinched for not wearing green—celebrate the luck of the Irish by making these green Irish symbols.

Irish for a Day

You can sculpt your own shamrock to wear with pride on St. Paddy's Day. Double your luck by wearing this green clover to school or work.

Level: Moderately easy

Time involved: Two to three hours, including baking time

Materials:

 Copy or tracing paper

 Pen or pencil

 Scissors

 Green sculpting clay (one block)

 Rolling pin

 Exacto knife or sharp kitchen knife

Jewelry pin

Cookie sheet

Cooling rack

Gold or black paint marker

Clear acrylic finish spray

1. Trace the illustrated shamrock onto copy paper and cut it out. Knead the green sculpting clay between your fingers until it is soft. Use the rolling pin to roll out the clay to about $\frac{1}{3}$-inch thick.

2. Place the paper shamrock on top of the clay. Cut around the pattern with an Exacto knife. Use your fingers to smooth off the edges. Push a jewelry pin into the middle of the shamrock. Or if you'd rather wear this on a chain, poke a hole in the top of the shamrock with the pointed end of a paintbrush. Place the shamrock on a cookie sheet.

3. Bake the shamrock in a 275°F oven for approximately 15 to 20 minutes or until it is firm to the touch. Remove the shamrock from the oven and allow it to cool on a cooling rack.

4. Using the paint marker, write the words "Kiss Me, I'm Irish" on the front of the shamrock and allow it to dry. Spray with clear acrylic finish spray and allow this to dry before wearing it.

Holiday Hints

You can make a shamrock pin out of shrinkable plastic by following the directions for shrinkable shapes in Chapter 8, "Be My Valentine." Use the sample shamrock from the "Irish for a Day" project and trace it onto the rough side of the plastic. Paint the shamrock green with acrylic paints or markers. Shrink the plastic shamrock in the oven according to the manufacturer's directions. Glue the shamrock onto a jewelry pin.

A simple pattern for a shamrock pin.

(© Melissa LeBon)

Lucky Leprechaun

Bring the luck of the Irish into your home with this easy-to-make *leprechaun* that you won't have trouble keeping in one place. (See the color insert for more details.)

Seasonal Sense

A **leprechaun** is an Irish fairy who is often unfriendly. According to the legend, leprechauns live alone and make shoes for a living. They are small in stature and resemble an old man. It is said that they own a pot of gold, which can be taken from them if you can capture them. Be aware, however, that if you catch a leprechaun, you must always keep your eye on him, or he'll disappear with his treasure intact.

A leprechaun that's easy to catch.

Level: Easy

Time involved: One to two hours

Materials:

>Heart-shaped cardboard box

>One small wooden oval piece

>Green and flesh-tone acrylic paints

>Paintbrushes

Foam plate

Green and black foam sheets

Scissors

Glue gun

One gold and one green metallic pipe cleaner

Two green acrylic gemstones

Two small white foam hearts

Small red foam heart

Eight white pom-poms

Four green chenille pipe cleaners

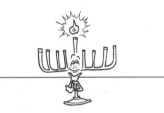

1. Paint the upper pointed half of the cardboard lid and the small oval wooden piece with flesh-tone paint. Paint the bottom half and sides of the heart lid with green paint. Paint the outside bottom and sides of the box with green paint and allow to dry.

2. Cut a hat out of the green foam sheet by making two rectangles that are 7 × 1¹/₂ inches and 6 × 3 inches. Glue the 6 × 3 inch rectangle to the top of the 7 × 1¹/₂ inch rectangle, and glue this to the pointed end of the heart-shaped cardboard box lid. Cut a black band that is 6 × 1 inch out of black foam sheet. Glue this on top of the hat to form a band.

3. Bend the gold metallic pipe cleaner into a square and glue this in the middle of the black band to form a buckle. Bend the green metallic pipe cleaner into a three-leaf clover and glue this to the top of the hat as shown.

4. Glue the two green gemstone eyes onto the white hearts. Glue the hearts and the wooden nose onto the face of the leprechaun. Glue a small red foam heart on the face for a mouth. Glue the eight pom-poms around the face to form a beard and hair.

5. Bend the two green chenille pipe cleaners into arms and hands and the remaining two green pipe cleaners into legs and boots as shown. Glue the arms and legs onto the sides and bottom of the box.

Holiday Hints

You might want to fill your elf box with wrapped candies and set him on a coffee table or give him as a gift. You can also change the holiday theme of this project. For example, you could make a bunny box for Easter, a witch or cat box for Halloween, and Santa Claus or snowman box for Christmas.

Mischievous Elf

A cute little bookshelf elf.

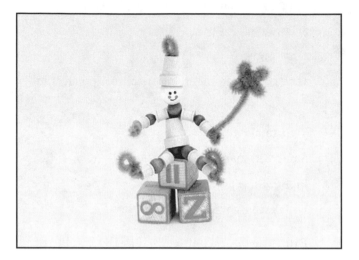

Level: Easy

Time involved: Half to one hour

Materials:

Four green chenille pipe cleaners

Two 1 × 1 inch wood flower pots

One bead head

Eight ¹/₂ × ¹/₂ inch wooden spools

Eight green wooden beads

1. Form a loop at the top of two pipe cleaners by twisting the ends together. Thread the pipe cleaners with the loop on top through the bottom of one wooden flowerpot and then through the bead head. The wooden pot will form a hat on the head. Thread a green bead onto the pipe cleaners to form a neck.

2. Twist a second pipe cleaner around the two pipe cleaners below the bead to form two arms. Thread a small spool, a bead, and another small spool onto each arm. Twist the remainder of the pipe cleaner to form hands that will hold the spools and beads in place.

3. Thread the two pipe-cleaner legs through a wooden pot that is upside down to form the body. Thread a large wooden bead onto the pipe cleaners to sit inside the pot. Separate the pipe cleaner legs and thread a bead, a small spool, another bead, and another small spool onto the individual pipe cleaners to form the legs. Twist the ends of the pipe cleaners into a boot shape as shown.

4. Form another green pipe cleaner into a four-leaf clover with a 3-inch stem. Thread the stem into the spool at the end of one of the arms to make the lep-rechaun hold the shamrock.

Have a contest with your kids to come up with the perfect name for your elf. You might want to hide him and award a prize to the child who finds him.

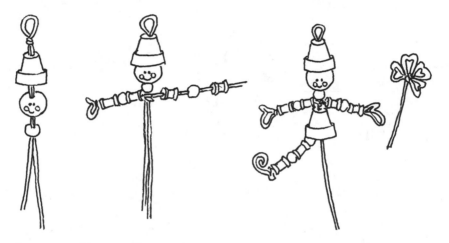

Steps to making an elf.

(© Melissa LeBon)

Childish Capers

Don't forget the "wee ones" this St. Patrick's Day. These kid crafts and activities are sure to make their Irish eyes smile.

Lucky Stone Tic-Tac-Toe

Help your kids design their own tic-tac-toe game that they can play in the dark. The game also makes a nice decorative piece for their bedroom shelf or dresser.

Invoking the luck of the Irish for a simple game.

Holiday Hints

In case you can't find the glow-in-the-dark stones, you can substitute regular stones and paint them green and gold with craft paints. You also might want to consider making this board and using it as a shadow box to hold miniatures that reflect your tastes.

Level: Easy

Time involved: One to two hours

Materials:

Eight yellow craft sticks

17 green craft sticks

Glue gun

Bag of glow-in-the-dark stones (You'll need five stones of two different colors.)

1. Connect a green craft stick to a yellow craft stick in the end slots and glue them together with the glue gun. Alternate the colors and glue the craft sticks together to form a 4-inch square with the craft sticks standing on their sides. Repeat this process to form a second level.

2. Glue nine craft sticks on the bottom of the square to form a shadowbox effect. Use your stones to play tic-tac-toe.

Festive Facts

Speaking of stones, are you aware of the legend behind the Blarney Stone of County Cork, Ireland? This stone is located in the southern tower wall of Blarney castle (built in 1446). It is said to be good luck to kiss the blarney stone, but to do this takes some effort. One has to lie on his back and then tilt his head backward to kiss the stone, holding iron bars for support. Legend has it that an old woman put a spell on the stone to reward a king for saving her from drowning. The stone is thought to have given the king the ability to speak sweetly and persuasively.

Pot 'O Gold

Send the kids on a treasure hunt for that elusive pot 'o gold. Tell them you found Lucky Leprechaun's secret map to his treasure chest, and watch their eyes light up as they find the clues leading to their prize. You should get the kids involved in making the chest before hiding it.

Level: Easy

Time involved: One to two hours, plus hunting time

Materials:

> Newspaper
>
> Unfinished wooden or cardboard treasure chest (You can buy a wooden treasure chest or use a wooden or cardboard box.)
>
> Green craft paint
>
> Paintbrushes
>
> White glue
>
> Water
>
> Disposable cup
>
> Gold glitter

Holiday Hassles

Here's how to avoid making a mess and wasting glitter: Fold a piece of copy paper in half and then open it up. Set the object on the paper and sprinkle the glitter onto it. When dry, remove the object from the paper and bump the glitter to the fold in the center. Pour the unused glitter back into the container.

Acrylic gemstones

Glue gun

Candy coins wrapped in gold foil

Pieces of copy paper

Scissors

Glitter pen

1. Cover your work area with newspapers to protect it. Paint the treasure chest with green craft paint and allow it to dry. Make a mixture of $1/3$ cup glue and 2 tablespoons water in the disposable cup and mix together. Paint the glue mixture onto the painted chest. Sprinkle the glitter onto the chest and allow it to dry. Glue the acrylic gemstones around the chest. Place the candies inside the chest.

2. Cut three pieces of copy paper in half. Using the glitter pen, write clues to locations inside or outside your home that the kids can figure out. For example, you could write "Dad's Favorite Hobby" and lead them to his golf bag. The next clue will be placed in this golf bag, and so on, until the treasure chest is found.

Hair-Raising Event

Make this cute leprechaun with your kids and enjoy watching him magically sprout green hair. If you plant chives in the pot, you can grow edible hair. Let your kids give him a haircut and throw the ends into some scrambled eggs.

Steps to making a clay-pot leprechaun.

(© Melissa LeBon)

156

Level: Easy

Time involved: One to two hours

Materials:

> 4-inch clay pot and saucer
>
> Green, pink, red, and black craft paints
>
> Paintbrushes
>
> Foam plate
>
> Clear acrylic finish spray
>
> Potting soil
>
> Pack of seeds (chives)

1. Paint the leprechaun's face on front of the clay pot as shown in the illustration and allow it to dry. Spray the pot with clear acrylic finish spray and allow this to dry.

2. Fill the pot to within 1 inch of the top with potting soil. Plant the seeds in the soil according to the directions on the package.

3. Set the pot in a window and watch for "hair" to sprout.

Holiday Hints

You might want to make a garden of herbs to use in your favorite food dishes. Use several clay pots and plant basil, parsley, thyme, dill, and other herbs. You can decorate the pots with stenciled designs or decals or keep them natural. Or you could buy and stencil a rectangular box planter and plant a variety of herbs together to grow on your windowsill.

Magical Menus

St. Patrick's Day is the perfect time to plan a special menu that celebrates the Irish heritage. You can start the day by tinting your eggs or pancakes green with food coloring and finish up with a traditional corned beef and cabbage dinner.

Rainbow Cake

This recipe is a bit time-consuming to make, but it tastes wonderful and fits in perfectly with the St. Patrick's Day theme.

Level: Moderately difficult

Time involved: One to two hours

Ingredients:

　　1¹/₂ packages white or yellow cake mix

　　Cooking spray

　　³/₄ cup crushed pineapple (drained)

　　Yellow, red, and green food coloring

　　Two 8-ounce tubs frozen whipped topping (thawed)

　　¹/₂ cup thick raspberry jam

　　¹/₂ cup apricot jam, slightly beaten

　　¹/₂ cup instant pistachio pudding mix (not made up—just the powder)

　　Icing (See the following recipe.)

Equipment:

　　Electric mixer

　　Three 9-inch round cake pans

　　Toothpick or cake tester

　　Cooling racks

1. Mix the cake ingredients according to the directions on the cake-mix package. Spray the three round pans with cooking spray and pour the batter into the pans. Cook the cakes as directed on the box or until a toothpick inserted into the middle comes out clean. Remove the pans from the oven and cool on cooling racks. Wrap and refrigerate the layers for one hour.

2. Cut each layer in two. (You'll need only five layers—save one of the layers in the freezer for another time.)

3. Place the pineapple in a bowl and tint it yellow with two drops of yellow food coloring. Mix this with ¹/₂ cup whipped cream and spread it on the first layer. Place the raspberry jam in a bowl and mix it with two drops of red food coloring and ¹/₂ cup whipped cream. Spread this on the second layer. Place the apricot jam, one drop of red, and one drop of yellow food coloring in a bowl with ¹/₂ cup whipped cream and blend. Spread this on the third layer.

4. Place the pistachio pudding mix in a bowl and mix it with two drops of green food coloring and ¹/₂ cup whipped cream. Spread this on the fourth layer. Add the final cake layer on top and frost the entire cake with icing tinted green. (See following recipe.) Draw a shamrock on the middle of the cake with a knife and fill it in with green sugar or sprinkles.

For the icing:

> 5 tablespoons flour
>
> 1 cup milk
>
> 1 cup Crisco
>
> 1 cup sugar
>
> Dash salt
>
> 1 teaspoon vanilla extract
>
> Green food coloring

Equipment:

> Small saucepan
>
> Electric mixer

1. Gradually mix the flour into the milk a bit at a time and cook over low heat until thick (approximately 5 to 10 minutes), stirring constantly. Remove the mixture from the heat and cool.

2. Beat the Crisco in a mixer and add the sugar and salt. Beat until fluffy. Add the cooked mixture to the bowl 1 tablespoon at a time. Add the vanilla and 1 to 2 drops of green food coloring and mix until well blended.

Holiday Hassles

If you want to avoid the hassle and time it takes to make a rainbow cake, you could make a simple green cake for dessert. Mix together 1 box of cake mix, 1 box of instant pistachio pudding mix, 3 eggs, 1 cup cooking oil, and 1 cup club soda water in a mixer on medium speed for two minutes. Fold in $1/2$ cup chopped walnuts. Bake in a greased tube pan at 300°F for 45 to 55 minutes. Mix one 8-ounce tub of whipped topping together with one box of instant pistachio pudding and ice the cake when cool. Keep refrigerated.

Quick Corned Beef and Cabbage

Corned beef and cabbage is a traditional Irish meal for St. Patrick's Day. If you have to work on this day, you might want to check out the directions for cooking this in a Crock-Pot.

Level: Moderately easy

Time involved: Three to four hours, including unattended cooking time

Ingredients:

> 1 corned beef brisket
>
> 3 potatoes
>
> 3 carrots
>
> 1 small onion
>
> $^1/_2$ head cabbage

Equipment:

> Potato peeler
>
> Knife
>
> Cutting board
>
> Large stock pot

1. Remove the brisket from the package and rinse it off. Place the brisket in the pot and cover it with water. Boil the brisket for two to three hours or as directed on the package.

2. Peel the potatoes and carrots and slice them into quarters. Peel the onion and cut it into quarters. Cut the cabbage into wedges. Add the potatoes, carrots, and onions to the brisket and cook on medium heat until tender, approximately $^1/_2$ hour. Add the cabbage and steam until tender, approximately 10 minutes longer.

Holiday Hints

You might want to get your brisket started in a Crock-Pot by cooking it on low for 12 to 18 hours. Then turn the Crock-Pot to high and add the potatoes, onions, and carrots and cook until tender (one to two hours). Add the cabbage last and cook until tender (about one hour). If desired, you can add a glaze to the brisket and place it in an oven for $1/2$ hour to form a tasty crust on the meat. For glaze, mix $1/4$ cup brown sugar, 2 tablespoons Dijon mustard, and 2 tablespoons pickle juice together in a small bowl. Brush the mixture on the boiled brisket and bake it in a 350°F oven for about $1/2$ hour.

The Least You Need to Know

➤ You can show your Irish pride by making your own St. Patrick's Day symbols to wear to school or work.

➤ St. Patrick's Day is rich in legends and traditions that capture the imaginations of people from all walks of life.

➤ Learn how to win the leprechaun's treasure by stealing some time to spend with the kids on arts and crafts.

➤ Making delicious Irish dinners and desserts is the perfect way to celebrate St. Patrick's Day.

Part 4

Spring Ahead

If you haven't already done so, you'll want to spring ahead to these chapters to find all sorts of ideas for celebrating Earth Day, Passover, Easter, and Mother's and Father's Day. You'll learn how to make seasonal crafts to decorate your home or to give as a unique gift. The kids' activities included in each of these chapters will get the children involved and keep them busy during their spring break.

If you're not sure what food to serve on these special occasions, you can check out the ideas for traditional foods at the end of each chapter.

Now that you've been bitten by the crafting bug, you'll want to keep on reading for even more holiday ideas.

Earth Day

In This Chapter

➤ Involving your family and friends in your Earth Day celebration

➤ Recycling materials into your craft projects

➤ Finding precious natural ingredients for unique works of art

➤ Spending time together in the kitchen creating earthly desserts and snacks

Be a friend to the earth this year by making an effort to celebrate Earth Day on April 22. You could start by using recycled materials in your craft projects, planting a special tree, growing a garden, or just spending some time enjoying the outdoors with your family.

If you decide to celebrate Earth Day, you should know the facts behind this event. The first celebration of Earth Day occurred on April 22, 1970. United States Senator Gaylord Nelson (D-Wisconsin) organized this event in response to a growing awareness of environmental disasters occurring in our country. On this date, it is estimated that around 20 million people participated in rallies, demonstrations, and other environmentally related events. These events precipitated the creation of the Environmental Protection Agency and the clean air and water acts.

Whether you're a staunch activist in the ecological movement or you just want to give something back to the planet, you'll want to try out some of these nature crafts that complement Mother Earth.

Trash to Treasure

Be the first on your block to hold an Earth Day party. Invite your family, friends, and neighbors into your home to herald the arrival of spring. You could celebrate by gathering all your craft materials together and asking everyone to bring along items recycled from their trash. See how many creative objects you can make out of the gathered assortment of supplies, and auction them off to the highest bidder. Use the collected monies for a worthwhile ecological project—such as saving the rainforest, protecting endangered animals, and planting trees in your neighborhood. Here are some ideas for recycled crafts to get you started.

Recycled Paper

Making homemade paper from scrap paper is an easier process than you might think. Just follow these simple steps to turn used paper into beautifully textured craft paper.

Steps to making paper from scrap paper.

(© Melissa LeBon)

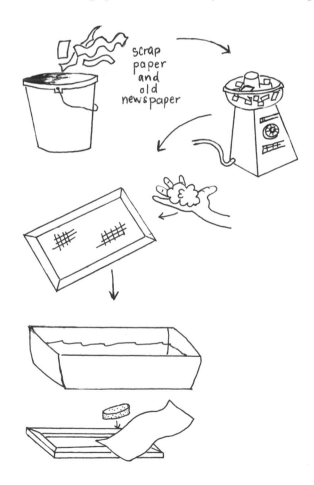

Level: Moderately easy

Time involved: Two to three hours, plus two nights to soak and dry the paper

Materials:

> Scrap paper and/or old newspapers
>
> Water
>
> Bucket
>
> 8 × 10 inch unfinished wooden frame
>
> 9 × 11 inch piece of screening
>
> Staple gun
>
> Food processor
>
> Textured materials such as plant parts, grass, weeds, flower petals, onion skins, tea leaves, or wood shavings (optional)
>
> Food coloring (optional)
>
> Dishpan
>
> Old towels
>
> Old sheet or pillowcase cut into 10 × 10 inch squares
>
> Sponge
>
> Iron and ironing board (optional)

1. Tear the scrap paper or old newspapers into small pieces and soak them in warm water in the bucket overnight. The number of newspapers/scrap papers you use depends upon the amount of paper you want to make. You might want to try filling the bucket about half full with scrap paper for your first batch of paper.

2. Prepare your papermaking frame by stapling the piece of screening onto the wooden frame.

3. Place a handful of the soaked paper into the food processor and surge it until the paper is broken up. Add the textured material to the mixture and food coloring, if desired, and surge again until well blended.

4. Lay the papermaking frame in the bottom of the dishpan. Add about 4 inches of water. Pour the mixture from the food processor into the dishpan. Slide the screen back and forth under the mixture to distribute the pulp evenly over the screen. Lift the screen out of the water and lay it on a towel to drain.

5. Place a piece of the sheet on top of the pulp and dab it with a sponge to remove excess water. Continue dabbing the pulp until almost all the water is removed.

6. Carefully turn over the screen to remove the pulp from the screen to the sheet. Lay this on a flat surface to dry. Peel the sheet away from the paper when it is slightly damp. Lay the paper on a flat surface to dry completely.

7. If desired, you can lay another sheet on top of the paper and press it with a hot iron (no steam) to speed the drying process and create flatter paper.

Festive Facts

Several laws were passed in the United States as a result of the first Earth Day celebration. These laws include the Clean Air Act (1970), the Endangered Species Act (1973), the Safe Drinking Water Act (1974), the Toxic Substance Control Act (1976), the Clean Water Act (1977), Superfund (1980), and the Oil Pollution Act (1990). You can read about these and other environmental laws and actions online at www.epa.gov.

Tin Can Treasures

You can use discarded tin cans and old magazines to make these useful containers for pens, cooking utensils, coins, and other small items.

Level: Easy

Time involved: Two to three hours, plus overnight to dry

Materials:

 Magazines

 Scissors

 White glue

Old tin cans

Varnish

Paintbrush

1. Look through old magazines to find appropriate pictures for your container. For example, if you decide to make a kitchen caddy you might want to use pictures of food. Or if you make a pencil caddy, you could use pictures of office supplies.

2. Cut the pictures out of the magazines and glue them onto the outside of the tin can covering the entire can. Allow to dry.

3. Paint the outside of the can over the pictures with a thin layer of varnish. Allow to dry, then paint on a second thin layer of varnish. Allow the can to dry overnight before using it.

Holiday Hints

You can also use tin cans to make attractive lanterns for your deck or garden. Just fill the tin cans with water and freeze them overnight. Make a design of holes around the outside of the cans using a hammer and a variety of nail sizes. The ice will keep the cans from crushing. Make a nail hole on either side of the top of the can. Allow the ice to melt and string a piece of wire through the two top holes for hanging purposes. Place a tea light or votive candle in the lantern.

For the Birds

Feed Mother Nature's birds by recycling trash into a bird feeder. Be sure to have your binoculars and bird identification book handy when you put up your feeder. You might want to encourage the kids to keep a diary of the birds that take advantage of your feeder.

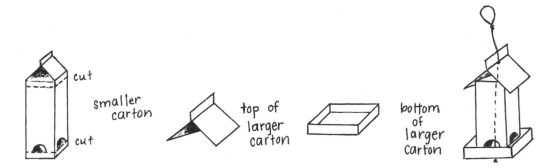

Steps to making a recycled bird feeder.

(© Melissa LeBon)

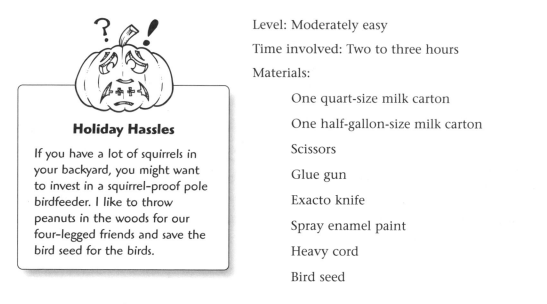

Holiday Hassles

If you have a lot of squirrels in your backyard, you might want to invest in a squirrel-proof pole birdfeeder. I like to throw peanuts in the woods for our four-legged friends and save the bird seed for the birds.

Level: Moderately easy

Time involved: Two to three hours

Materials:

> One quart-size milk carton
>
> One half-gallon-size milk carton
>
> Scissors
>
> Glue gun
>
> Exacto knife
>
> Spray enamel paint
>
> Heavy cord
>
> Bird seed

1. Wash out the cartons with soapy water and allow them to dry. Cut the top and bottom off of the quart-size milk carton, forming a rectangular tube that is about six inches tall. Cut a hole the size of a half a quarter in each side of the bottom of the tube (see illustration). Discard the top and bottom of this carton. Cut the top and bottom off of the half-gallon-size milk carton to make a sloped roof for the tube and a rectangular bottom piece for the base (see illustration).

2. Using the glue gun, glue the spout of the top (where the milk comes out) to-gether. Spray all three pieces with enamel paint and allow them to dry.

3. With the Exacto knife, make a hole in the center of the top of the bird feeder and the center of the bottom of the bird feeder. Thread a 20-inch piece of cord down through the hole, through the tube, and again through the hole in the bottom. Make a knot in the cord underneath the birdhouse. Make another large knot in the cord about three inches above the birdhouse roof. Form the top end of the cord into a loop for hanging purposes.

4. You can fill the feeder from the top by lifting the roof off of the birdfeeder and pouring seed into the tube. If you want to attract more exotic birds like cardinals and blue jays, try using sunflower bird seed. Keep in mind, however, that these birds are much more aggressive than other birds and may scare smaller birds away.

Wheels from Waste

Your little *NASCAR* fans will enjoy making these specially designed racecars from dish-detergent bottles. You might want to try making more than one and racing them to see whose car is the fastest.

A customized car to race to the finish line.

Level: Easy

Time involved: One to two hours

Materials:

Newspaper or plastic

Empty dish-detergent bottle

Scissors

Thin wooden dowel or wooden meat skewer

Exacto knife

Sandpaper

Four wooden wheels (You can find these in craft stores in the wood section.)

Heavy jewelry wire

Craft paints

Paintbrushes

1. Place a layer of newspaper or plastic on your work area to protect it. Rinse the detergent bottle in water to remove any soap from the inside. If there is a paper label on the bottle, soak and remove it. Allow to dry.

2. Lay the bottle on its side and cut away the top of the bottom end of the bottle with scissors to form the car's interior. Parents should help younger children with this step.

3. Poke a hole in the front and back of the bottle on either side to insert the wooden dowel for the wheels.

4. Cut the wooden dowel in half using an Exacto knife. If necessary, sand off any sharp edges. Insert the wooden dowel through the holes and place a wooden wheel on each end. Wrap a piece of jewelry wire around each end (about eight loops) to hold the wheels in place.

5. Paint the car with craft paint and add numbers and stripes to represent a racing car. Allow the car to dry.

Seasonal Sense

The **NASCAR** series has provided racing fans with exciting motorsport action since its beginning in Daytona in 1948. The series includes 13 divisions of races that occur on a weekly basis around the country. Some of the more popular races are the Winston Cup Series, featuring cars that produce 750 horsepower and can reach speeds of up to 200 mph on the race track, the Busch Series, featuring slightly lighter cars, and the Craftsman Truck Series, featuring pick-up trucks that produce about 750 horsepower and reach speeds of up to 190 mph.

Fooling Around with Mother Nature

You can make lots of crafts with your kids while taking advantage of Mother Nature's bounty. Enjoy a nice spring day walking outside with the kids and picking up materials for these crafts.

Sea Shell Symphony

You can take a walk on a beach with your kids to find shells for this project, or, if that's not possible, check out your local craft store for bags of shells. This shell wind chime should be hung in a garden or on a porch where it will make lovely music when moved by a breeze.

Making Mother Nature's music.

(© Melissa LeBon)

Level: Moderately easy

Time involved: One to two hours

Materials:

 Plastic milk jug

 Scissors

 Hammer

 Nail

 24 shells

 Cord

1. Cut around the plastic jug 1 inch from the bottom. Discard the rest of the jug or save it to make a scoop. Using the hammer and nail, make six holes in the center of this piece of plastic.

Holiday Hassles

Several varieties of marine life are on the endangered species list due to aggressive commercial shelling. If you find a shell on the beach with an animal still in-side, be sure to return it to the ocean.

2. Using the hammer and nail, make a hole in the top of each of the shells. Some shells might break, so you'll need to have a couple of back-ups. Parents should assist younger children with this step.

3. Cut six lengths of cord that are each 15 inches long. String four shells on each piece of cord, making a knot in between the shells to hold them in place. Thread the ends of the cord into the holes you made in the plastic.

4. Thread another length of cord through the first hole and knot it. Thread the other end through the last hole and knot this. If necessary, make two separate holes for this cord. Use the cord to hang your wind chime from a tree or porch.

Matching Stones

This game is based on the ancient Japanese shell game called kai-awase. You can make this game from stones found in your garden or a local park. (See the color in-sert for more details.)

Level: Easy

Time involved: Two to three hours

Materials:

> 30 smooth stones of approximately the same size
>
> Craft paints
>
> Foam plate
>
> Paintbrushes
>
> Clear acrylic finish spray

1. Take a walk with your kids in your garden or a local park to find stones for this game. Wash the stones in soapy water and allow them to dry. Or if you don't have time for a walk, you could purchase a bag of river rock at a craft store that would work well in this project.

2. Using craft paints, paint one side of pairs of the stones with similar colors and designs. You should have 15 pairs of colored stones. Allow these to dry.

3. Spray the stones with clear acrylic finish spray and allow this to dry.

To play the game, mix up the matching pairs and turn them design-side down on a flat surface. Let your kids take turns flipping over two stones. If a player gets a matching pair, he gets to keep the stones. The player with the most pairs at the end of the game wins.

Holiday Hints

As long as you're searching for stones, you might want to pick up a few extra ones along with some pinecones, acorns, and twigs to make into stone art. Get out your craft paints, some felt, feathers, pom-poms, plastic eyes, and glue and let the kids use their imaginations to shape the materials into creatures. This would be a good activity to keep kids occupied at a birthday party.

Picture Perfect

You can make lovely designs in waxed paper in most seasons by searching for leaves from a variety of trees and plants. However, you might want to try this in the fall for vibrant colors if you live in a climate where the seasons change. The best part of this project is taking a walk and getting some fresh air with your kids. You might want to take along a book to identify the leaves you choose.

Level: Easy

Time involved: One to two hours, plus several days to a week to dry the leaves

Materials:

> Bag for collecting
>
> Assortment of leaves
>
> Paper towels
>
> Heavy books
>
> Newspapers
>
> Waxed paper
>
> Scissors
>
> Copy paper
>
> Iron and ironing board
>
> Construction paper
>
> White glue

1. Take a walk in the woods or a park to find a variety of leaves. Bring along a bag to collect your leaves.

2. Place the leaves on a paper towel. Cover them with another paper towel. Stack several heavy books on top of the layers. Leave the books in place for several days to a week until the leaves are flat and dry.

3. Place a layer of newspapers on a flat surface. Cut a piece of waxed paper to the desired size of your leaf picture. Lay the leaves in a pattern on top of the waxed paper.

4. Place another piece of waxed paper of the same size on top of the leaves. Cover this with a sheet of copy paper. Using an iron on low temperature, press over the top of the copy paper to seal the leaves between the layers of waxed paper. Do not use steam or too high of a temperature.

5. Cut two pieces of construction paper to the same size as the waxed paper. Fold the papers in half and cut a 1-inch frame out of both pieces. Place your waxed paper picture on top of one frame and glue it down. Place the other frame on top of this and glue it to the bottom frame. Hang your work of art on a glass door or in a window.

Holiday Hints

You can also make beautiful prints from collected leaves by following either of these two methods. Place a piece of paper on a flat surface. Arrange the leaves on top of this paper and cover them with a second paper. Using crayons on their sides, color over the second paper. The leaf prints will mysteriously appear on the second paper. Or, you could paint the leaves with craft paint and, using a paper towel, press them onto a piece of paper to make a leaf imprint. Carefully pull the leaf off of the paper to avoid smudging the design.

Marvelous Mosaics

Plaster mosaics are the rage in craft circles. You can make your own mosaics out of some plaster and different sizes and colors of rocks or shells that you find in your environment.

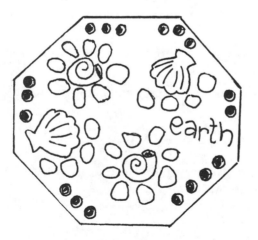

Making a design with rocks and shells.

(© Melissa LeBon)

Level: Moderately easy

Time involved: Two to three hours, plus overnight to harden

Materials:

 1-pound bag or box of plaster

 Disposable bowl

 Plaster mold of your choice (Check your local craft store for an octagon shape, heart shape, square shape, and so on.)

 Popsicle stick or trowel

 Assorted stones and/or shells

 Sponge

 Clear acrylic finish spray

1. Place the plaster powder in the bowl. Mix with water according to the directions on the package of plaster (usually about 2 parts water to 1 part plaster). Stir the mixture well until it is a thick, smooth consistency.

2. Fill the mold with the plaster almost to the top of it. Use a Popsicle stick or trowel to smooth over the top.

3. Lay the stones and/or shells on top of the plaster in the pattern of your choice, or you could follow the sample pattern in the illustration. Allow this to dry approximately 10 minutes and then wipe the top carefully with a wet sponge to remove any excess plaster from the design. Use a light motion to avoid disturbing the plaster.

4. Allow this to dry overnight without moving it. Remove the plaster from the mold by applying pressure to the back of it.

5. Spray the mosaic with clear acrylic finish spray and allow this to dry.

Earthly Delights

You can make these foods that taste like heaven on Earth for your Earth Day party or just keep them for your family to enjoy.

Dirt Pudding

What better way to celebrate Earth Day than with a delicious dessert that looks like an earthworm's paradise? For best results, make this classic recipe in a glass pot or vase so the gummy worms show through. For a finishing touch, plant a plastic flower (with the stem wrapped in plastic wrap) in the "dirt."

Level: Easy

Time involved: Half to one hour

Ingredients:

1 (16-ounce) bag chocolate sandwich cookies

2 cups cold milk

1 (4-ounce) package chocolate instant pudding

1 (8-ounce) tub whipped topping (thawed)

$^1/_2$ pound gummy worms

Equipment:

Food processor

Bowl

Electric hand mixer or wire whisk

Clean glass flowerpot or vase

Plastic wrap (optional)

Plastic flower (optional)

Holiday Hints

If you decide to have an Earth Day party with the kids, you could make dirt pudding in individual cups. The see-through plastic drinking glasses work well. You could make an edible flower for a decoration by wrapping a piece of fruit leather around a lollipop to form a rose.

1. Crush the cookies in the food processor. Pour cold milk and pudding mix into a bowl and beat it with a hand mixer or whisk for two minutes. Let this stand for about five minutes until set. Stir in the whipped topping and half of the crushed cookies.

2. If there is a hole in the pot, line the bottom with plastic wrap. Add the pudding mixture to the pot. Push the gummy worms into the pudding along the sides so they show through the glass. Save about five of them for the top. Top the pudding mixture with the remaining cookie crumbs.

3. Plant the five gummy worms in the crumbs so it looks like they're crawling out of the dirt. Wrap the end of the flower in plastic wrap and stick it in the pot.

Mud Pie

This is one time you won't mind having mud in your kitchen. Don't wait until you go out to eat to indulge—make your own version of this restaurant favorite.

Level: Moderately easy

Time involved: One to two hours

Ingredients:

 1 box chocolate graham crackers

 $\frac{1}{2}$ stick butter or margarine

 1 quart vanilla ice cream (softened)

 6 chocolate bars

 $\frac{1}{2}$ cup chocolate syrup

 1 quart rocky-road ice cream (softened)

 1 tub whipped topping

Equipment:

 Food processor

 Bowl

 Springform pan

 Ice-cream scoop

1. Pulse the chocolate graham crackers in a food processor until they are fine crumbs and place in a bowl. Melt the butter and add it to the crumbs. Mix them together with a fork or your hands until blended. Press the crumb mixture into the bottom of the springform pan, forming a solid crust. Allow this to harden for about 20 minutes.

2. Add the vanilla ice cream to the crust and press it down. Pulse the chocolate bars in the food processor until they are small pieces. Add half the chocolate pieces to the top of the vanilla layer. Drizzle the chocolate syrup on top of the chocolate pieces. Place this back in the freezer until hardened (about one hour).

3. Add a layer of rocky road ice cream and press it firm. Place the pie in the freezer until solid. Remove it from the spring pan, and ice it with whipped cream. Sprinkle the extra chocolate-bar pieces on top.

Holiday Hints

You can access the Internet to buy supplies for making your own trail mix. Just type "trail mix" in your favorite search engine for a list of suppliers and ideas for recipes.

Trail Mix

Trail mix is a versatile food that can be made at home and taken on hikes or picnics for instant energy. You might want to try some of these recipes or experiment with your own combinations. Just mix the ingredients together in a bowl and store in an airtight container until ready to use.

Level: Easy

Time involved: Half to one hour

Ingredients:

Monkey Business recipe:

> 2 cups peanuts
>
> 1 cup chocolate morsels
>
> 1 cup shredded coconut
>
> $^{1}/_{2}$ cup banana chips

Cereal Killer recipe:

> 1 cup peanuts
>
> 2 cups mini-pretzels
>
> $^{1}/_{2}$ cup Wheat Chex cereal
>
> $^{1}/_{2}$ cup Rice Chex cereal
>
> 1 teaspoon onion powder
>
> 2 tablespoons peanut oil

Fruits and Nuts mix:

> 1 cup dried apricot pieces
>
> 1 cup raisins
>
> $^{1}/_{2}$ cup dried pineapple
>
> $^{1}/_{2}$ cup shredded coconut
>
> $^{1}/_{2}$ cup walnuts
>
> $^{1}/_{2}$ cup almonds
>
> 1 teaspoon salt

Place ingredients in a mixing bowl and toss gently to mix. Store in an airtight container until ready to use.

181

> ### The Least You Need to Know
>
> ➤ You can hold your own Earth Day celebration and earn some money for worthwhile ecology projects.
>
> ➤ It's smart to recycle materials by using them in fun craft projects.
>
> ➤ You can tap many natural resources for creative experiences with your kids.
>
> ➤ Spend some time with your kids in the kitchen making the perfect foods to celebrate Earth Day.

Passover Celebration

In This Chapter

➤ Why we celebrate Passover and how to organize a Seder dinner

➤ Your own traditional Passover symbols to use during the celebration

➤ Fun, simple projects that teach kids the meaning of Passover

➤ Tasty traditional foods for the holiday

Why is this night different from all others?

Year after year, Jewish families congregate to celebrate Passover and answer this question. They share with their children the story of the Jewish triumph over enslavement in Egypt. Passover is an eight-day commemoration of the Jewish people's deliverance from slavery under Pharaoh Ramses II. It begins each year in the spring on the fifteenth night of the Jewish month of Nissan.

According to the Book of Exodus, Moses delivered the Jews from slavery in Egypt after initiating a series of plagues from God. These plagues became increasing deadly until the tenth and final plague—the killing of the first-born sons—which convinced the Pharaoh to heed Moses' warning to "Let my people go." On the night of this lethal plague, Moses instructed the Jewish families to sacrifice a lamb and rub the blood on their doorways. The angel of death would see the blood and "pass over" their homes, sparing their first-born son.

Nowadays, Jewish families commemorate Passover by holding a traditional dinner called a Seder. A small booklet describing the Passover, called a Haggadah, is usually distributed to the dinner guests so that they can participate in the special services. The word Seder is Hebrew for "order," and a certain order must be followed to properly celebrate this event.

Passover Dinner Primer

Several key components are necessary for a traditional Seder dinner. For example, a Seder Plate on the table holds the following symbolic foods:

➤ **Charoset:** A mixture of chopped apples, walnuts, wine, and cinnamon that represents the mortar used to make the Pharaoh's bricks; this mortar was often mixed with the blood of the slaves.

➤ **Karpas:** Parsley that is dipped in salt water to represent the tears of the Jewish people during slavery.

➤ **Beritzah:** A roasted egg that symbolizes the mourning of death by the Jewish people throughout the ages.

➤ **Zeroa:** A shank bone that represents the sacrificial lamb offering.

➤ **Maror:** Bitter herbs (usually horseradish) that represent the bitterness of the enslavement of the Jewish people over the years.

➤ **Chazeret:** A vegetable that also represents the bitterness of slavery, and is sometimes omitted from the Seder plate.

Another key component of the Seder dinner is the visit from the Prophet Elijah. A special cup of wine, known as "Elijah's cup," is set in the center of the table. During the dinner a child is sent to open the door for this ghostly visitor. At this time the father traditionally hides the *Afikomen,* or matzoh.

The asking of the four questions follows the end of the dinner feast. Usually the youngest participants pose these questions and the eldest at the table provides the answers, which give meaning to the celebration.

Symbols of Seder

The Passover celebration is rich in symbols that you and your family can handcraft. You can add a personal touch to your Seder dinner by making your own Seder plate, Afikomen, Elijah's cup, and pillow.

Seasonal Sense

The **Afikomen** is a holder for the matzoh that the father or eldest leader hides during the Seder dinner. The matzoh represents the bread that didn't have time to rise when the Jewish people left Egypt in haste. The bread was flattened and allowed to bake on hot rocks in the desert sun. Usually a small prize is awarded to the child who finds the Afikomen.

Festive Facts

The following are the questions and answers asked at the Seder dinner:

➤ Why do we eat unleavened bread? To remind us that the Jews had no time to bake their bread during their exodus from Egypt.

➤ Why do we eat bitter herbs? To remind us of the cruel way the Pharaoh treated the Jewish slaves.

➤ Why do we dip our foods twice tonight? To remind us how hard the Jews worked to make bricks for the Pharaoh.

➤ Why do we lean on a pillow tonight? To remind ourselves that once we were slaves but now we are free.

Food for Thought

A Seder plate is used as a centerpiece during the Seder dinner to hold the traditional symbolic foods of the meal. Gather your family together to make this lovely decoupage glass Seder plate to place on your table. (See the color insert for details.)

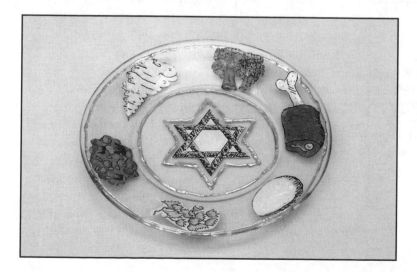

A special rendition of a traditional Seder plate.

Level: Moderately easy

Time involved: One to two hours, plus overnight to dry

Materials:

Pictures (See step 1.)

Scissors

Decoupage foil kit

Paintbrush

Clear glass plate (You can buy these in a craft store in the decoupage section.)

Spouncer

1. Cut out pictures that represent the six traditional foods on the Seder plate. You can find these in magazines, greeting cards, seed packages (for the parsley and vegetables), or downloaded images from the Internet. If you have a hard time finding pictures to represent the foods, you could copy the Hebrew words from a Haqqadah and use them instead, or you could draw and color your own renditions of the food. Also check out the illustrated paper Seder plate presented later in this chapter for foods that can be traced, cut-out, and colored for use in this project.

Holiday Hints

You might want to try making a decoupage plate to display during other seasons. For example, you could use fall pictures for a Thanksgiving plate, fruits and vegetables for a summer brunch plate, or winter scenes for a cookie plate.

2. Brush a light coat of decoupage finish onto the front of the pictures and place them onto the bottom of the plate. Allow some space around the rim to apply foil accents. Use your fingers to smooth the pictures into place. When this is dry, brush decoupage finish onto the entire surface of the bottom of the plate. Allow to dry and repeat with a second coat.

3. When the project is completely dry, you can add foil accents. Dip a spouncer in a small amount of the foil bond. Remove any excess bond onto a paper towel. Dab the bond around the rim on the bottom of the plate.

4. Allow the bond to dry until clear and sticky to the touch. Place the dull side of the gold foil to the bonded surface. Press this down with your finger and then peel the foil away with a quick motion. Repeat this action until the bonded areas are completely covered with foil.

Afikomen Art

An Afikomen that is used to hold the matzoh is a necessary component of the Seder dinner. You can get your family involved in making this family heirloom out of foam sheets. The stiffness of this material will help keep the matzoh from cracking.

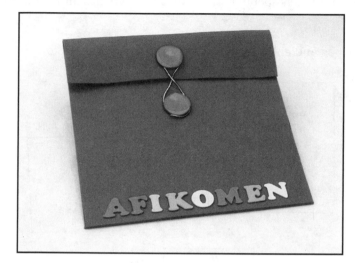

A unique Afikomen for Seder dinner.

Level: Easy

Time involved: Half to one hour

Materials:

> Two 9 × 12 inch blue foam sheets
>
> Scissors
>
> Glue gun
>
> Two buttons
>
> Needle and thread
>
> Piece of jewelry wire or elastic
>
> Wire cutters
>
> Bag of foam letters

1. Cut 3 inches off a blue foam sheet. Lay the smaller piece of foam on top of the larger piece, and line them up at the bottom along the 9-inch length. Glue the top sheet onto the bottom sheet around the sides and bottom and allow to dry.

2. Fold the extra length from the bottom sheet over the bag to form a flap to close the bag. Sew a button on the front of the flap. Sew a second button just below this button on the top foam sheet. Cut a small piece of elastic or jewelry wire to wrap around the two buttons to close the bag.

3. Gather together the foam letters spelling "Afikomen" and glue them to the front of the bag.

Insert the matzoh into the bag and enjoy the hunt for your handmade Afikomen.

Making a unique Afikomen for Seder dinner.

(© Melissa LeBon)

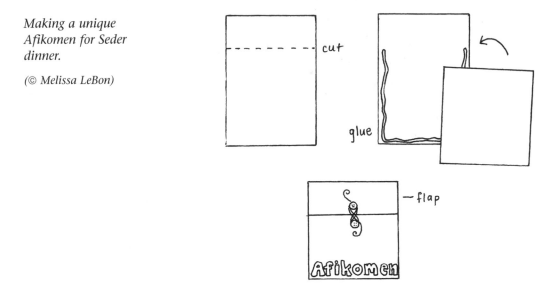

Elijah's Cup

Elijah's cup is placed on the Seder table to symbolize a visit from the prophet Elijah. The cup is traditionally a large silver goblet that is filled to the brim with a welcomed libation such as wine or juice.

An Elijah's cup that will stand out on your Seder table.

Level: Easy

Time involved: One to two hours

Materials:

> Large glass or silver goblet
>
> Glue gun
>
> 18-gauge blue, gold, and red jewelry wire
>
> Assorted colors of pony beads
>
> Black fine-tipped glass marker (optional)

Festive Facts

During the Seder celebration, there are traditionally four wine toasts that represent the four stages of the Jewish exodus from Egypt. These toasts are to freedom, deliverance, redemption, and release.

1. Start at the base of the goblet and place a line of glue around the stem. Hold the blue wire in place and wrap it around the stem of the glass.

2. Glue a layer of pony beads onto the glass above the wired stem.

3. Make a small line of glue above the pony bead layer and wrap the gold wire around the glass six times. Glue another row of pony beads around the glass. Finish with seven layers of red wire and glue the end to the cup.

4. If desired, write the words "Elijah's cup" on the base of the glass using the glass marker.

Pillows with Pizzazz

Recline in style at your Seder dinner by making this lovely Passover pillow.

Level: Moderately easy

Time involved: Two to three hours

Materials:

> *Transfer webbing*
>
> Scissors
>
> 12 × 12 inch piece of yellow felt
>
> Iron and ironing board
>
> Copy paper
>
> Pen
>
> Transfer paper

Two 12 × 12 inch pieces of blue felt

Damp cloth

Sewing machine and thread or fabric glue

Polyester fill

Steps and sample designs to complete your Passover pillow.

(© Melissa LeBon)

Seasonal Sense

Transfer webbing, or fusible webbing, is a paper-backed adhesive web that turns plain fabric into an iron-on fabric. You can find this easy-to-use webbing in craft or fabric stores. To make fusible fabric, place the rough side of the webbing against the wrong side of the fabric and press with an iron according to the manufacturer's directions (about five seconds). Let this cool, then draw the desired shape onto the fabric and cut it out. Peel off the paper backing and place the shape web side down on the project. Cover with a damp cloth and iron for about 10 seconds on wool setting. Repeat until the fabric is completely fused. Remove the cloth and press the fabric to remove any moisture.

1. Cut a piece of fusible webbing to fit the 12 × 12 inch yellow felt. Place the felt onto the rough side of the webbing. Press for five seconds (or according to manufacturer's directions) with a hot, dry iron and let cool.

2. Trace the sample designs and transfer them (using transfer paper) onto the yellow felt, or make your own pattern of designs.

3. Cut the designs out of the yellow felt. Gently peel off the paper backing. Position the shapes web side down on one piece of the blue felt. Cover this with a damp cloth and press with a hot iron for 10 seconds on wool setting or according to manufacturer's directions. Repeat until the fabric is completely transferred.

4. Place the second piece of blue felt on top of the first piece of blue felt, with the yellow designs in the middle of the two.

5. If using a sewing machine, sew around the perimeter of the felt, leaving a 3-inch opening on one end. Or, if using fabric glue, glue along the perimeter, leaving a 3-inch opening on one end, and allow to dry completely.

6. Turn the felt pillow right-side out and stuff the pillow with polyester fill. Stitch or glue the opening closed.

Talented Tots

Nurture the artistic ability in your kids by making these fun Passover projects together. You might want to tell them the Passover story or play some special music while you're working on these crafts.

Window Art

Sample window art design.

(© Melissa LeBon)

Holiday Hassles

You should not use paint, peel, and stick designs on furniture or painted walls. The designs work well on glass, mirror, or enamel surfaces (such as refrigerators).

Level: Easy

Time involved: One to two hours, plus overnight to dry

Materials:

> Patterns
>
> Copy or tracing paper
>
> Pen or pencil
>
> *Styrene blanks*
>
> Assorted colors of *paint, peel, and stick transparent paint*

Seasonal Sense

Styrene blanks are clear plastic boards that are used to make designs for projects made of **paint, peel, and stick transparent paint.** You can use any printed design as a pattern. You might want to print some designs from Passover sites from the Internet for this project. Just place the design under the blank and trace it with the black "paint, peel, and stick paint" (simulated lead) and allow it to dry. Then fill in the design with the special "paint, peel, and stick" transparent colors and allow this to dry. Peel the design off the styrene blank and stick it on a smooth surface such as a window or refrigerator.

1. Trace the sample pattern and place it under the styrene blank. Trace the pattern with black paint (simulated lead paint) and allow this to dry for one to two hours.

2. Squeeze the paint directly from the bottle onto the design, moving the bottle side to side and filling in the area to the same level as the black leading paint. Allow this to dry for 24 hours or longer in humid climates.

3. Gently peel the design off of the styrene blank and stick it on a window or smooth surface.

Holiday Hints

As long as you're getting messy with paints, you might want to try making a tin-can roller. Simply soak the label off of a tin can. Paint the can with white glue, and wrap string in a design around the can. You can wrap the string in a spiral pattern or a straight line around the can or from one end of the can to the other. Paint the string with paint and roll the can from the top of a piece of paper to the bottom to form a design on the paper. Add more paint as necessary and try different patterns of string on other empty cans.

Simple Seder Plate

Gather your kids together for a fun craft that teaches the meaning behind the symbolic foods on the Seder plate. You could research this on the Internet and find examples of the foods to draw by using the keywords "Seder plate" or "Passover."

Teaching kids the significance of the Seder plate.

(© Melissa LeBon)

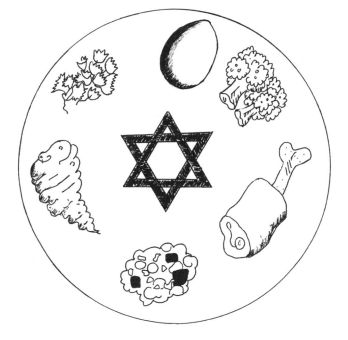

Level: Easy

Time involved: One to two hours, plus overnight to dry

Materials:

 Assorted colors of construction paper

 Markers or crayons

 Scissors

 White glue

 Paper plate

 Paintbrush

 Disposable cup

1. Explain to your kids the foods on the Seder plate and what they symbolize. (You can use the explanation of the foods that is presented earlier in this chapter.) Show them pictures of the foods or use the illustration accompanying this project as a sample. Have them draw small pictures of the foods (approximately 2 inches) on construction paper and color them with the markers or crayons. Help them cut out the pictures.

2. Glue their pictures around the edges of the paper plate and print the name of the food above each picture with a magic marker. Draw a Star of David in the middle of the plate.

3. Mix about $\frac{1}{3}$ cup white glue and 3 tablespoons water in the disposable cup. Paint over the pictures and the plate with this glue mixture and allow this to dry overnight.

Freedom Mural

Discuss what freedom means to you and your family and how this principle is celebrated in the Passover season. Have the children find pictures in magazines or draw pictures that represent freedom. Create a mural on poster board using these pictures, markers, and some sticker letters. You could also search the Internet for coloring pages to use in your mural.

Level: Easy

Time involved: One to two hours

Materials:

> Pictures from magazines or magic markers (See step 1.)
>
> White glue
>
> Poster board
>
> Sticker letters

1. Cut pictures from magazines, or draw and color your own pictures that represent freedom to you. For example, you might choose a picture of a wild bird, a warm home, or an entertainment event.

2. Glue these pictures onto the poster board. Use sticker letters to spell out the words that mean freedom to you and your kids. For example, you might spell out freedom of speech, ideas, choice of professions, or education.

You could make this an on-going family project during Passover and add to it as the days pass. You also might want to divide the poster in half and place traditional Passover symbols of freedom on one half and modern-day symbols of what this freedom means to you personally on the other half.

Meaningful Menus

During Passover, Jewish people eat several traditional foods that symbolize their struggle to be free from slavery. One food that is common to Passover recipes is the use of matzoh or matzoh meal as a substitute for bread or flour. The matzoh represents the unleavened bread that sustained the Jewish people in their flight through the desert. You might want to try making some of these easy Passover recipes for your celebration.

Matzoh Balls

Level: Moderately easy

Time involved: One to two hours

Ingredients:

3 eggs

3 tablespoons oil

$^3/_4$ cup matzoh meal

$1^1/_2$ teaspoon salt

$1^1/_2$ tablespoon chicken broth

Chicken soup

Equipment:

Mixing bowl

Whisk

Large cooking pot

Slotted spoon

1. Place the eggs in a bowl and beat them slightly. Mix in the oil, matzoh meal, and salt until well blended. Add the chicken broth and mix again. Refrigerate, covered, for about one hour.

2. Fill the pot with water and bring to a boil. With wet hands, form the matzoh mixture into small balls and drop them into the boiling water. Cover the pot with a lid and reduce the heat to medium. Simmer in the pot for 35 to 40 minutes. Remove from the water with a slotted spoon and serve with chicken soup.

Passover Pancakes

Start your day out right with these delicious pancakes made with matzoh meal. You might want to add some fresh fruit while they're cooking to make them tasty and nutritious. I'd recommend sliced apples, sliced peaches, sliced strawberries, or blueberries.

Level: Easy

Time involved: Half to one hour

Ingredients:

$^3/_4$ cup crushed matzoh crackers

$^3/_4$ cup scalded milk

1 tablespoon margarine, melted

1 egg, beaten

$^1/_4$ cup matzoh meal

2 teaspoons baking powder

$^1/_4$ teaspoon salt

Vegetable oil

Powdered sugar

Syrup

Holiday Hints

You can make your own Charoset to serve at your Seder dinner. Using a food processor, mix together 1 cup raisins, $^1/_2$ cup pitted dates, 2 peeled and cored apples, $^1/_2$ cup walnuts, $^1/_2$ cup almonds, $^1/_2$ teaspoon ground ginger, 1 teaspoon ground cinnamon, and 1 cup sweet red wine.

Equipment:

 Bowl

 Spoon

 Griddle

 Spatula

1. Place the matzoh crumbs in a bowl and add the scalded milk and melted margarine. Allow this to sit until the crumbs are soft. Add the beaten egg and the dry ingredients to the mixture, and mix with a spoon until blended.

2. Drop the batter by spoonfuls onto a heated, oiled griddle. Cook until lightly browned on one side and flip to the other side. Continue cooking until this side is golden brown. Remove to a plate and serve with powdered sugar and syrup.

The Least You Need to Know

➤ You can make your Seder dinner even more special by creating handcrafted symbols of the season.

➤ Get the kids involved in the Passover celebration by spending some time with them on kid-tested crafts.

➤ Reinforce the symbols and traditions that are passed down from generation to generation during the Passover season by weaving them into your craft projects.

➤ Cooking for Passover involves special foods that you can make from scratch with some help from your family.

Easter
Excitement

In This Chapter

➤ Special Easter crafts and decorations to welcome spring

➤ Fun, artistic holiday crafts for spring break

➤ Delicious Easter treats to sweeten the Easter vacation

By the time Easter rolls around each year, most of us are ready to shed our coats and race outdoors to celebrate this spring event. A break in the weather and the renewal that occurs in nature is the perfect setting for an Easter celebration. Even people in warmer climates can appreciate the arrival of spring and the hope for a gentler, easier pace of life.

For Christians, Easter Sunday commemorates the resurrection of their savior, Jesus Christ. Prior to the big event is the 40-day observance of Lent, which begins on Ash Wednesday and concludes at Midnight on Holy Saturday. Easter is a movable feast and is celebrated on a Sunday between March 22 and April 25. The holiday has pre-Christian roots, probably based on the Teutonic goddess of spring and fertility, Eostre, whose ancient festival was celebrated on the day of the vernal equinox.

Besides being a religious event, Easter is also a time for families to get together and enjoy the fun traditions surrounding this holiday. Kids get excited about the arrival of the Easter bunny, and people decorate their homes and participate in traditional Easter activities. If you're still watching out for Peter Cottontail, you should check out the fun crafts in this chapter. Don't forget to hop outside and take advantage of the spring weather!

Easter Enjoyment

Many of the symbols of Easter have survived since the pre-Christian spring festivals surrounding goddesses. For example, since ancient times, a bunny was a symbol of fertility, and dyeing eggs represented the colors of springtime. Eggs were used in egg-rolling contests or were given as gifts of courtship or friendship. Easter time is the perfect holiday to spend spring break with the kids working together on special crafts. You can indulge the kid in you by making these Easter symbols to place around your home.

Festive Facts

The Greek goddess Persephone, daughter of Demeter, was known as the goddess of the earth. According to the legend, she returned from the underworld to the light of day on Earth each year during the vernal equinox. Her return represented the resurrection of life in nature following the desolate winter months. Her arrival was celebrated with music and dancing, which occurred during spring festivals. Many ancient cultures share the legend of an awakening deity that symbolizes the beginning of spring.

Pot of Bunnies

This bunny pot would look adorable on your mantel or bookshelf, but it also makes a fun toy for the kids. These cuddly bunnies are wrapped in blankets and ready for a bedtime Easter story.

A cute pot of cuddly bunnies.

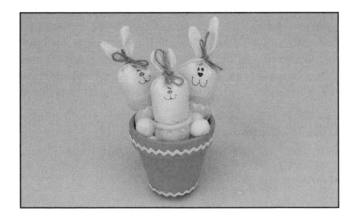

Level: Moderately difficult

Time involved: Three to four hours

Materials:

Four $7 \times 3^1/_2$ inch pieces of muslin or cotton material

Two $5^1/_2 \times 3$ inch pieces of muslin or cotton material

Scissors

Straight pins

Sewing machine and thread

Rub-on faces (You can find these in a craft store.)

Popsicle stick

Polyester fill

Three 6×5 inch pieces of pastel-colored felt

White glue or glue gun

Ribbon or rickrack

Cord

4-inch clay pot

Pastel-colored craft paint

Paintbrush

White pom-poms

Wooden robin's eggs painted pastel colors (optional)

1. Place two of the larger pieces of muslin together and fold them in half length-wise (along the longer length). Cut out a 2-inch-long ear starting at the center fold and rounding off the top as shown. Repeat this step with the other four pieces of muslin. You should have cut out two larger rabbits and one smaller one. The rabbits will look like a tube with two ears on top.

2. Place the cut-out rabbit shapes right-sides together and pin the edges with straight pins. Sew around the sides and ears of each rabbit, leaving the bottom open. Remove the pins, trim the seam, and cut a slit in the bias around the corners to keep the seams from buckling. Turn the rabbits right-side out.

3. Place the rub-on face on top of the rabbit below the ears. Rub the transfer with a Popsicle stick thoroughly until the face is transferred.

4. Stuff the bunnies' bodies (not the ears) with polyester fill. Sew the bottom opening together.

5. Cut three pieces of pastel-colored felt 6 × 5 inches to form blankets for the bunnies. Fold the felt blankets around the bunnies and glue them onto the bodies of the bunnies with fabric glue or a glue gun. Glue the bottom of the felt together. Tie a piece of ribbon or rickrack around the neck of the bunnies.

6. Tie a small piece of cord into a bow around the ears as shown.

7. Paint the clay pot a matching pastel color, and glue a piece of the ribbon or rickrack that you used around the necks of the bunnies onto the top and bottom of the pot.

8. Fill the clay pot with polyester fill and stick the bunnies inside the pot with the smaller bunny in front. Add a few white pom-poms on top for decoration. If desired, you could add a few painted wooden robin's eggs to the pot.

Steps to making a pot of bunnies.

(© Melissa LeBon)

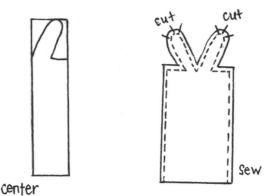

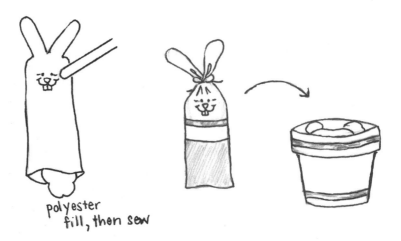

Holiday Hassles

Whenever you sew a seam around the corner of a project (as in making rabbit ears), the stitches will have a tendency to pucker and possibly break from stress. To resolve this problem, you should make diagonal slits around the bias (outside) of the seam on the curve, being careful not to cut the stitches. Then trim the sewn seams to $1/4$-inch wide. When you turn your project right-side out, it should lie flat.

Old-Tyme Easter Basket

Putting out an Easter basket is a traditional Easter activity that kids love. You can make special baskets for your kids that look like they were handed down from their grandparents. Baskets are relatively inexpensive and can be found in all shapes and sizes. Be sure to pick one that has smooth wooden surfaces that can be painted and stenciled.

A unique Easter basket with an antique look.

Level: Moderately easy

Time involved: Two to three hours

203

Materials:

Basket

Fine-grain sandpaper

Dry sponge

Purple and white craft paints

Foam plate

Paintbrushes

Disposable cup

Easter stencils

Masking tape

Stencil paint

Stencil brush

Pink and purple crepe paper (optional)

Crimper (optional)

1. Lightly sand the basket to rough up a surface for the paint. Brush off any particles with a dry sponge.

2. Paint the entire basket inside and out with purple craft paint. Allow the basket to dry.

3. Mix about $^1/_3$ cup white craft paint in a disposable cup with 6 tablespoons water. Brush the paint mixture on top of the purple paint. The purple paint should show through the white coating. If the white paint is too thick, add a little water; if too thin, add more white paint.

4. Using a wet sponge, rub some of the white paint off in places to allow more of the purple to show through. Allow the white coat to dry.

5. Tape the Easter stencils around the top rim of the basket (or on the handle if thick enough) and fill in the stencils with the appropriate color of stencil paint. You might want to make bunnies, Easter eggs, and flowers in a pattern. Allow the stencils to dry.

Seasonal Sense

A **crimper** is a tool that will cut different shapes out of paper products such as tissue paper, crepe paper, or construction paper. You can use these shreds of paper in baskets or gift bags for filler. If you own a paper shredder, you also might want to consider using it to make this filler.

6. If desired, fill basket with crepe paper. Or you could use a paper crimper to make basket filler out of matching colors of crepe paper.

Egg Cartin'

You can cart around the Easter bunny's eggs in this colorful handmade wheelbarrow. Make these cute bunny carts as decorations or fill them with Easter candies to give as gifts for your family or friends. (See the color insert for more details.)

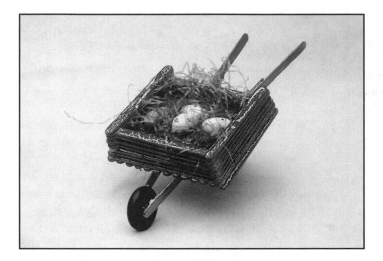

Hopping down the bunny trail in style.

Level: Easy

Time involved: One to two hours

Materials:

 54 wooden Popsicle sticks

 Glue gun

 Wooden wheel

 White crackle-finish base coat

 Green crackle-finish spray paint

 10 wooden robin's eggs

 Pastel-colored craft paints

 Foam plate

Paintbrushes

Clear acrylic finish spray

Paper grass

Holiday Hints

You can turn this cute Easter-egg cart into a candy dish by adding chocolate foil-covered eggs to it instead of wooden eggs. You might also want to consider making this cart as a Halloween project and adding small wooden pumpkins to it instead of eggs. A red cart with miniature Christmas balls glued inside would also make a unique Christmas-tree ornament.

1. Lay out 11 sticks in a row and glue 11 more sticks on top of and perpendicular to these. Glue four sticks around the perimeter of the top row of sticks (see illustration). Glue sticks on top of these sticks in the same manner to form a box that is four sticks high. (All the sticks are glued flat down, not on their sides.)

2. Build one end wall and two side walls three sticks higher, and slope the sides to the end wall that is four sticks high (see illustration).

3. Glue three sticks together as shown to form a handle. Repeat this process to form the second handle. Glue the ends of the handles onto the wooden wheel. Glue the handles in place on the bottom of the cart as shown. Cut a Popsicle stick into two 2-inch pieces, and glue these onto the bottom of the cart to form a stand.

4. Spray the base coat of the crackle paint onto the finished cart. Allow this to dry and then spray the top coat on the cart. Allow this to dry.

5. Paint the wooden robin's eggs pastel colors and allow them to dry. Spray them with clear acrylic finish spray and allow them to dry again.

6. You might want to add some colored-paper grass to the cart and insert the eggs into the grass.

Steps to assembling an Easter egg cart.

(© Melissa LeBon)

Festive Facts

The egg has long been a symbol of Easter, dating back to the custom of giving colored, hard-boiled eggs or chocolate eggs as gifts during pagan festivals. Before the era of Christianity, Egyptians dyed Easter eggs in spring colors to symbolize renewed life. Eggs were sacred to many ancient religions and played a role in the rituals of the spring ceremonies. The symbols of the Norse goddess Ostara were the egg and the hare, which represented fertility.

Lacy Eggs

Gather your family together to help you make these beautiful Easter eggs that you can use year after year. You might want to spray paint an egg carton with an Easter color to keep them safe in between use.

Level: Moderately easy

Time involved: Two to three hours, including drying time

207

Materials:

> Dozen eggs
>
> Bowl
>
> Straight pin
>
> Nail
>
> Toothpick
>
> Dark green, maroon, navy, and yellow glossy craft paints
>
> Paintbrushes
>
> Foam tray
>
> Assorted pieces of lace (Use the type of lace that has distinct designs that can be cut out.)
>
> Scissors
>
> Tacky glue
>
> Clear acrylic finish spray

Making a lacy Easter egg.

(© Melissa LeBon)

1. Hold an egg over a bowl. Using a straight pin, poke a hole in both ends of the egg. Use the nail to enlarge the hole by slightly twisting it into the started holes. Make the hole about $1/4$-inch wide. Stir the egg inside with a toothpick, and shake the egg to remove the mixture. Rinse the egg inside and out and allow to dry.

2. Paint the egg with a high-gloss craft paint of your choice and allow to dry.

3. Cut out designs from the lace pieces. Glue these in a pattern on the egg. Be sure to cover both holes with a piece of cut-out lace. Allow to dry.

4. Spray the egg with clear acrylic finish spray and allow to dry.

5. Repeat these steps using different colors and lace patterns until all of the eggs are decorated.

Holiday Hints

You might want to try substituting paper doilies for the lace used in making lacey eggs. You could also make these eggs with glued-on sequins or acrylic jewels. Display the finished products by hanging them on a tree branch that is sprayed white and placed in a pot of dirt covered with Spanish moss. To hang an egg, insert a small piece of a toothpick with embroidery thread tied around the middle of it into the hole before covering it. Pull up on the thread until the toothpick is sideways against the inside of the hole and holds the thread in place.

Peter Cottontail's Picks

There's a lot more to Easter fun than just dyeing eggs. If you're still on the Easter bunny's list, you might want to try out these fun crafts with your own little bunnies.

Funny Bunny

Help your kids to make their own bunny ears and then spend some time hopping down the bunny trail with them playing follow-the-leader. This would be a perfect opportunity to get them to eat some bunny food—especially something healthy such as carrots and celery with a veggie dip!

Level: Easy

Time involved: Half to one hour

Materials:

Tape measure

White and pink foam sheets

Scissors

Glue gun

Easter bunny for a day.

1. Measure your child's head and cut a 2-inch-wide band out of the white foam sheet to fit. You may have to cut out two pieces and glue them together if you need a band larger than 18 inches.

2. Cut two white ovals (for bunny ears) out of foam sheets that are 10 inches long and about 3 inches in the middle. Cut two smaller ovals out of the pink foam sheet.

3. Glue the pink ovals on to the white ovals. Glue the ears onto the band and hop away.

Egg-Ceptional Eggs

There are lots of techniques and natural dyes for making unique, personalized, colored Easter eggs. If you're ready for a change of pace, try some of these eggs to dye for.

➤ **Using natural dyes:** The technique for dyeing eggs with natural dyes is to add the ingredients to $^3/_4$ cup boiling water and then add $^1/_2$ teaspoon vinegar. Always wash the eggs first with soapy water to remove any oily coating. Simmer the egg for about 20 minutes in the dye. Natural dyes include instant coffee, spinach, orange peels, lemon peels, blueberries, cranberries, red beets, and ground turmeric. If you want your eggs a darker color, refrigerate them in the dye overnight.

➤ **Making designs:** Cover the egg with rubber bands, crayon markings, or pieces of masking tape before dyeing them. The area that is covered will not take the dye and will form a design on the egg. Re-dip the eggs in another color if desired.

➤ **Using tissue or crepe paper dye:** Soak tissue or crepe paper in hot water. Place pieces of the paper on the egg for a few minutes and remove them. The dye from the paper will remain on the egg.

➤ **Creating sponge effects:** Use food coloring and small sponges to create a splattered effect on your eggs. Be sure to wear gloves for this project.

➤ **Making an egg farm:** Use construction paper, feathers, pom-poms, pipe cleaners, and rub-on faces to make farm animals out of dyed eggs. Form a strip of paper into a circle that fits snugly around the bottom of the egg. Make a face on the egg using rub-on transfer faces that can be found in a craft store. Add feathers, construction paper features, pipe cleaners, and pom-poms as desired.

Holiday Hints

You might want to save the shells from broken Easter eggs to make mosaics. Draw an Easter scene or design on a piece of poster board. Crack the eggshells into small pieces and lay them on top of a thick layer of glue, filling in the picture or design. Allow the glue to dry several hours before moving the picture.

Easter-Egg Fun

Now that you've got all these beautiful dyed Easter eggs, what will you do with them? Here are some ideas to have some fun with them before they become egg salad:

➤ **Easter-egg hunt:** Help the Easter bunny by hiding Easter eggs outside (if the weather cooperates) or in a room in your house for the kids to find on Easter morning. Mark several eggs with a marker that will win special prizes (such as a small toy or candy). Be sure to hide some that little kids can easily find and lead them to that area. You might want to count the number of eggs you've hidden so you'll know when they've all been found.

➤ **Conking eggs:** At our house, we have a tradition of conking Easter eggs to see whose egg is the strongest. Use your dyed Easter eggs to try out this fun game with your kids: Have one child put an Easter egg in his or her fist with a small amount of the tip of the egg showing. The second child should take his or her egg and tap the tip of the first person's egg until one of the eggs breaks. Then do the same with the other ends of the egg, letting the person whose egg was hit do the conking this time. The person who has an unbroken egg wins the other person's egg. If each person has one side unbroken, conk the unbroken sides to determine a winner.

➤ **You're on a roll:** Participate in an egg-rolling contest with your family. Have each person roll the eggs down a hill with a spoon until they break. The last person with an unbroken egg is the winner.

Holiday Hassles

You can avoid the hassle of hurt feelings or unfair advantages when you have kids of different ages participating in a game. Try making arrangements for the little kids to compete with the bigger ones by modifying the game to each age level. For example, if you have kids participating in an egg hunt who are far apart in age, you might want to write their names on the eggs and have them look for their own eggs. Instruct the participants to re-hide any eggs they find that don't have their name on them. Or you might want to have separate rooms or areas outside for different age groups to hunt for eggs.

Jesus Is Risen!

Tell your kids the story of the resurrection of Jesus Christ, and then make these window decorations with them to celebrate this victory over death.

Level: Moderately easy

Time involved: One to two hours and overnight to dry

Materials:

Resurrection pattern

Copy paper

Pen

Styrene blanks (These are plastic sheets that are placed over a design and traced with paint, peel, and stick paints. These can be found in a craft store.)

Assorted colors of paint, peel, and stick-on transparent paint including black leading paint

A sample design for a risen-Lord window decoration.

(© Melissa LeBon)

Festive Facts

For Christians, Easter Sunday commemorates the resurrection of Jesus Christ from death. The events of Holy Week lead up to the Resurrection and the Ascension of Jesus into heaven. Palm Sunday recalls Jesus' passage into Jerusalem one week before his execution. Holy Monday commemorates the expulsion of the money handlers from the temple by Jesus, which some scholars believe triggered his arrest. Maundy Thursday depicts the last supper that Jesus spent with his disciples, and Good Friday recalls his death on the cross. Holy Saturday is a period of waiting and is the final day of Holy Week leading up to Jesus' resurrection on Easter Sunday.

Holiday Hints

You can make other Easter sun catchers using paint, peel, and stick-on transparent paint. These paints come in easy-to-use squeeze bottles. You might want to download some Easter designs from the Internet or use an Easter coloring book for ideas. Or you can always let your imagination take over and create your own designs. A simple colored Easter egg would be an excellent beginner's project.

1. Trace the sample Resurrection pattern onto copy paper and place it under the styrene blank. Trace the pattern with leading paint onto the styrene blank and allow this to dry for one to two hours.

2. To fill in the design, squeeze the paint directly from the bottle, moving the bottle side to side and filling in the area to the same level as the leading. Allow this to dry for 24 hours or longer in humid climates.

3. Gently peel off the design from the styrene blank and stick it on a window or smooth surface.

Easter Edibles

Don't let this Easter season pass you by without making some special treats for your friends and family. Get them involved in the process and spend some rewarding hours together, bonding in the kitchen.

Let Them Eat Cake!

This Easter-bunny cake is easy to make and looks great on the table for dessert. You can make this cake from your favorite cake recipe, use a box mix, or try this easy German white-cake recipe that has an old-fashioned taste. Either way, the kids will have fun measuring the ingredients, beating the cake mix, and decorating their cake.

Level: Moderately easy

Time involved: One to two hours

Ingredients:

German White Cake recipe:

 1 cup (2 sticks) margarine

 2 cups granulated sugar

 $2^1/_2$ cups flour

 2 teaspoons baking powder

 5 eggs

¹/₂ cup milk

Nonstick baking spray

Frosting, coconut, candies, and icing for decorating

Equipment:

Electric mixer

Two 9-inch round baking pans

Toothpick or cake tester

Cooling racks

Large platter or cardboard covered with tinfoil

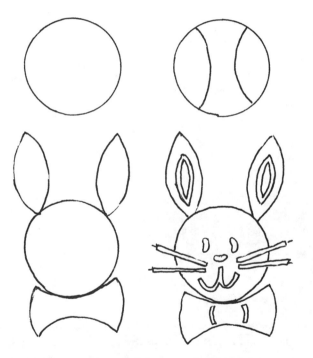

Steps to cutting and assembling your Easter-bunny cake.

(© Melissa LeBon)

1. Mix the first four ingredients together with an electric mixer until they form crumbs.
2. Add the eggs and milk, and beat on high speed for 10 minutes.
3. Spray two round, 9-inch baking pans with nonstick spray and divide the batter evenly, pouring it into each pan.

4. Bake at 350°F for 10 minutes and then 325°F for approximately 10 minutes, or until a toothpick comes out clean. The cake should spring back to the touch.

5. Cool the cake in the pan for five minutes and remove to cooling racks to cool completely.

6. When the cake is cool to touch, use one layer for the head and the second layer for the ears and a bow tie as shown in the illustration.

7. Lay the cake out on a large platter or cover cardboard with tinfoil to accommodate the cake.

8. Use your favorite frosting to ice the cake, and sprinkle coconut on the cake for a "fur" effect.

9. Let the kids be creative with candy and tubes of icing to create eyes, nose, whiskers, and so on, and to line the ears and bow tie.

Excellent Eggs

Easter wouldn't be Easter without the taste of homemade Easter eggs. These are candies that even the Easter bunny can't top. Lisa Gray of Pottsville, Pennsylvania, melts her chocolate in a microwave oven when making these candies to simplify the process.

Level: Moderately easy

Time involved: One to two hours

Holiday Hints

If you enjoyed making homemade Easter eggs, you might want to try your hand at solid chocolate eggs and bunnies. Melt a pound of chocolate in the top of a double boiler until it begins to bubble. Pour the melted chocolate into Easter molds and allow them to set up in the refrigerator before moving them. You could use different colors of chocolate for your creations or follow the techniques for decorating chocolates listed in the project Stolen Hearts in Chapter 8, "Be My Valentine."

Ingredients:

Butter Cream Egg recipe:

 1 stick ($^1/_2$ cup) butter

 One 8-ounce package cream cheese

 2 pounds powdered sugar

 $^1/_2$ teaspoon vanilla extract

Peanut Butter Egg recipe:

 12 ounces peanut butter

 4 ounces cream cheese

 1-pound box powdered sugar

 1 teaspoon vanilla extract

 $^1/_4$ teaspoon salt

Coconut Cream Egg recipe:

 $^1/_2$ stick ($^1/_4$ cup) butter

 8 ounces cream cheese

 2 pounds powdered sugar

 1 teaspoon vanilla extract

 $^1/_2$ cup flake coconut

To coat the eggs:

 1 pound melting chocolate

 $^1/_2$ teaspoon vegetable oil

Equipment:

 Mixer or food processor

 Cookie sheets

 Waxed paper

 Microwave-safe bowl

 Colander with holes (not slits) in the bottom

 Wooden skewers

1. Using an electric mixer or food processor, mix the butter or peanut butter and cream cheese until blended. Add the remaining ingredients for the type of egg you're making, and blend approximately three minutes or until thoroughly mixed.

2. Refrigerate the mixture overnight. Using your hands, shape pieces of the mixture into small eggs. Place the eggs on a cookie sheet covered with waxed paper. Refrigerate for several hours until hardened.

3. After the eggs have hardened, place the chocolate pieces in a microwave safe bowl. Add $1/2$ teaspoon vegetable oil to the chocolate. Cook on medium heat for one minute. Remove the bowl from the microwave and stir. Return the bowl to the microwave oven and cook another minute or until the chocolate is thoroughly melted.

4. Turn the colander upside down on a piece of waxed paper. Remove the eggs from the refrigerator and place one on a wooden skewer. Dip the egg into the chocolate mixture until it is thoroughly coated. Stick the end of the skewer into one of the holes of the colander until it hardens (about two minutes). Once it hardens, remove the egg from the stick and return it to the cookie sheet. You can reuse the skewers for the rest of the eggs. Repeat this step until all the eggs are coated. If your chocolate begins to re-harden, you could cook it in the microwave oven again for a few seconds until it is melted. Place the coated eggs in the refrigerator for a couple hours until hardened. Store the eggs in the refrigerator in a plastic container between layers of waxed paper until you're ready to eat them.

The Least You Need to Know

➤ You can get a jump on your Easter decorations by trying out the fun crafts in this chapter.

➤ Take advantage of the spring weather to plan some outdoor activities and games.

➤ Pull the kids away from the video games by planning some old-fashioned Easter fun.

➤ Work together with your family in the kitchen to create delicious Easter treats.

Parent Perfect

In This Chapter

➤ Special crafts for the special mothers in your life

➤ Handcrafted gifts to celebrate Father's Day

➤ Fun projects to do with the kids for Mother's Day and Father's Day

➤ The perfect treat for a Mother's Day or Father's Day celebration

Mother's Day and Father's Day have been officially celebrated in the United States since the early 1900s. In 1872, Julia Ward Howe (author of the "Battle Hymn of the Republic") suggested that a special day be set aside for Mother's Day in America. Unfortunately, no one took her seriously. Anna Jarvis of West Virginia is considered to be the true founder of Mother's Day in America—she spent considerable time and energy campaigning for an official Mother's Day celebration. By 1909 almost every state had a planned Mother's Day holiday. In 1914 President Woodrow Wilson made Mother's Day an official celebration in the United States to be held on the second Sunday in May.

The Mother's Day celebration may have spurred the creation of a special day set aside for fathers. Sonora Smart Dodd of Spokane, Washington, was listening to a Mother's Day Sermon at her church in 1909. Her mother had died in childbirth, and her father was the sole parent taking care of 6 children for 21 years. Sonora campaigned to have

an official day established to recognize fathers. It was decided to create Father's Day to be celebrated on June 5, her father's birthday. However, time constraints moved the first celebration to June 18. In 1972, the U.S. Congress officially recognized the celebration of Father's Day to be held on the third Sunday of June.

Whether you have a mother, father, grandparent, aunt, or uncle to remember, you can individualize their gifts by creating them with your own two hands. Get the kids involved in these activities to make the experience even more meaningful.

Marvelous Mothers

Lots of mothers are present in our lives. You may have a grandmother, a mother, a daughter or friend who's a mother, or an aunt who's like a mother to you. Whatever the case, you can't go wrong with these special crafts that do double duty as gifts on this special occasion.

Festive Facts

The celebration of Mother's Day can be traced to ancient mythology. The Greeks and Romans had powerful goddesses who they believed to be the mothers of all gods. Celebrations were held to honor these special women. The eventual rise of Christianity brought about the concept of holding a celebration to honor the "Mother Church." On the fourth Sunday in Lent, people brought gifts to the churches where they were baptized. In the 1600s, England instituted a special day of honor for mothers called "Mothering Day," which also occurred on the fourth Sunday in Lent.

Frolicking Fish

Light up your mom's life by making her this interesting gel candle in a fish bowl. Gel candles are easier to make than you might think. After you make the fish bowl candle, try pouring gel wax into other unique containers such as mason jars, cups, and glasses. Be sure to run hot water in the container first so it doesn't crack from the heat. (See the color insert for more details.)

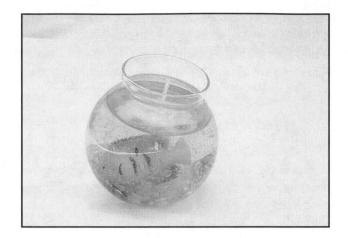

A unique, decorative candle for Mom.

Level: Moderately easy

Time involved: Two to three hours

Materials:

Newspaper or plastic

Small round glass fishbowl (I used one that I found at a craft store that was approximately 4 inches wide.)

Candle wick (The stiff wicks with a metal tab on the bottom work best.)

Glue gun

Pencil

Masking tape

Decorative marbles

Spoon

Gel wax (I used about $^1/_3$ of a 23-ounce container.)

Knife

Medium saucepan

Blue gel wax dye

Candy thermometer

Tweezers

Decorative fish that can be added to gel candles (These can be found in the candle-making section of a craft store.)

221

Holiday Hassles

You should be careful when choosing wicks for candle-making or even when buying candles. Some wicks have a metal core that contains lead. Burning these candles can create dangerous lead-based fumes that can be especially harmful to young children. To be sure that your wick is safe, try pressing it against a piece of paper. If it makes a mark on the paper, chances are that there is lead inside. The manufacturers of gel wax recommend that you use a bleached, nonwire core wick in gel candles.

1. Spread newspapers or plastic on your work area to protect it. Run hot water in the fish bowl to prevent it from cracking from the heat of the gel wax. Dry the bowl thoroughly. Prepare the fish bowl by gluing the metal tab of the wick to the bottom of it. If the wick is not stiff, tape the other end of the wick to a pencil and lay it across the top of the bowl.

2. Place a layer of decorative marbles in the bottom of the bowl, being careful not to disturb the wick.

3. Spoon out about $^1/_3$ of the gel wax into the saucepan. You might have to use a knife to cut around the edges of the gel to facilitate an easy removal. Melt the wax on low heat for 5 to 10 minutes or until it turns liquid. Add a couple drops of the blue dye to the gel until it turns a light blue color. Place the thermometer in the gel when melting it, and do not exceed 260°F.

4. Carefully pour the wax into the prepared glass, keeping the wick straight up and down in the center. Allow the wax to cool for about 10 minutes. Using the tweezers, insert the fish into the gel on the side of the bowl, away from the wick. Allow the candle to cool thoroughly (several hours) before handling.

Holiday Hints

If you enjoyed making a fish-bowl gel candle, you might want to try your hand at making this candle that resembles a jar of preserves. Use a small Mason jar and attach the wick to the bottom. Tie the end of the wick to a pencil and place it on top of the jar. Melt the gel according to the manufacturer's directions, and add orange dye and a fruity dye fragrance to the gel. Pour a small amount of the gel into the prepared jar and add several chunks of yellow candle wax to the jar. (You can get these in bags in craft stores.) Pour some more gel wax and add wax chunks again. Repeat this process until you reach the top of the candle. The wax chunks will melt a little from the heat of the gel wax, helping them blend into the gel. The candle should resemble a jar of marmalade. If desired, you could make a decorative label for the front of the jar that says "Orange Marmalade."

Mosaic Stepping Stone

Your mom will think of you every time she steps into her garden on this lovely stepping-stone. If desired, you can add a personal touch to this stone by making a heart out of the decorative pieces and spelling out "Mom." (See the color insert for more details.)

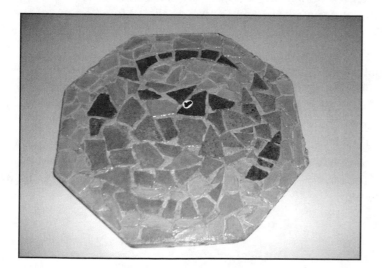

Stepping into the garden with Mom.

Level: Moderately difficult

Time involved: Three to four hours, plus two days to dry

Materials:

> Box of stepping-stone cement mix (You can find this in craft stores prepackaged in the size you'll need for the mold.)
>
> Water
>
> Bucket
>
> Garden digging tool or trowel to mix the cement
>
> Stepping-stone mold
>
> Decorative glass chips or marbles
>
> Popsicle stick (optional)
>
> Sponge
>
> *Mosaic sealant*
>
> Paintbrush

1. Mix the cement and water in a bucket according to the manufacturer's directions. Use the trowel or digging tool to turn the cement over and work in the powder.

2. Pour the cement into the stepping-stone mold and level off the top using the trowel or digging tool.

3. Place the decorative glass or marbles on top of the cement in a planned or random pattern. If desired, form a heart and the words "Best Mom" on top of the cement. You could also use the Popsicle stick to write a name or saying (such as "Mom's Garden") in the cement.

4. Be sure to work quickly and have your design completed before the cement begins to set. (You have approximately one hour to complete your design.) Wipe the design lightly with a wet sponge to remove any excess cement. Once you've completed your stone, do not move the mold until it has completely set (overnight), or you'll develop cracks in the stone.

5. Once the stone is completely hardened, you can remove it from the mold by applying pressure to the back of the mold. Paint the stone with mosaic sealant and allow it to dry overnight.

Seasonal Sense

Mosaic sealant comes in a small can, and you can find it in craft stores in the mosaic section. This sealant works well on cement and glass, but I wouldn't advise using it on plaster molds (clear acrylic finish spray works better on plaster). You can paint the sealant onto the project, and you should allow it to dry overnight. You'll need paint remover to clean your brush afterward.

Handy Candy Container

Mom will love this cute candy dish filled with her favorite wrapped sweets. You could also make a smaller version of this pot and fill it with potpourri or a scented candle.

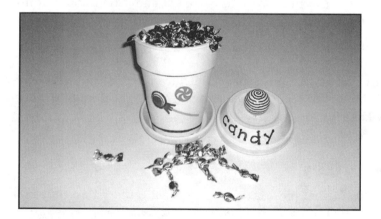

Sweets for a sweet mom.

Level: Moderately easy

Time involved: Three to four hours, including drying time

Materials:

 Newspaper or plastic

 4-inch clay pot

 Two 4-inch clay saucers

Antique-white craft paint

Paintbrush

Round wooden knob

Red, blue, and brown craft paints

Glue gun

Clear acrylic finish spray

Piece of felt for the bottom

Scissors

Tacky glue

1. Place newspapers or plastic on your work area to protect it. Paint the clay pot and the saucers inside and out with the antique-white paint. Paint the wooden knob antique white. Allow these to dry.

2. Paint a blue spiral design on the wooden knob. Glue the knob to the bottom of the clay saucer to form a lid with a handle. Following the lettering directions in Chapter 2, "The ABCs of Crafting," paint the word "Candy" on the rim of this lid. Paint a blue lollipop and red and white peppermint candy on the front of the candy dish. Paint a blue line on the bottom of the candy dish for an accent.

3. Glue the bottom of the second saucer onto the bottom of the pot.

4. Spray the pot with clear acrylic finish spray and allow it to dry. Cut a piece of felt the size of the bottom of the finished candy dish and glue it onto the bottom saucer using tacky glue.

Father's Day Favorites

Don't neglect the "fathers" in your life. Make them a special Father's Day gift to show them you appreciate all of their love and support over the years.

Gone Fishin'

If your father's into fishing, you might want to make him this personalized fishing tackle box. He'll think of you every time he reaches for a new hook.

Level: Moderately easy

Time involved: Two to three hours, including drying time

Materials:

 Foam stamps with a nautical theme (fish, plants, shells, anchors, and so on)

 Craft paints

 Foam plate

 Paintbrushes

 White copy paper

 Scissors

 Decoupage finish

 Plastic fishing tackle box (Choose one with a smooth surface.)

 Sticker letters

Adding a personal touch to a practical gift.

(© *Melissa LeBon*)

1. Paint one of the nautical stamps with colorful craft paints. Press the prepared stamp onto the copy paper. Repeat this process with other stamps and colors. Allow the stamps to dry.

2. Cut out the images, and brush the decoupage finish on the back of them. Place the stamps in a pattern around the tackle box and smooth them in place with your fingers. Allow this to dry completely.

3. Spell out your father's name and the words "Tackle Box" on the front of the box using the sticker letters.

4. Brush decoupage finish over the tackle box and allow it to dry. Repeat with a second coat.

Seasonal Sense

You can find **decoupage finish** in the decoupage section of craft stores. To use this medium, simply cut out your designs from paper or fabric. Brush a light coat of decoupage finish on the back of the cut-out design. Place this on your project and smooth it in place with your fingers. When this is completely dry, brush the decoupage finish over the entire project and repeat with a second coat.

Cook's Cover-Up

Does your father or husband flip the best burgers in town? You might want to create a special apron for him for Father's Day that he'll be proud to wear at your next barbecue.

Making a design on a canvas apron.

(© Melissa LeBon)

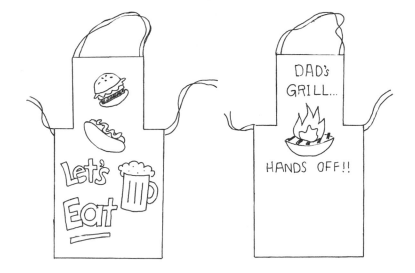

Level: Moderately easy

Time involved: Two to three hours, plus overnight to dry

Holiday Hints

You can follow several techniques when using fabric paints in squeeze bottles. You can paint right from the bottle so that the applicator tip touches the surface of the fabric. Allow the paint to seep into the fabric by squeezing the bottle and dragging the tip along the design. You can also brush on fabric paint mixed with extender or water to fill in larger areas. To add shading to a design, paint a darker color over a lighter color where the light would hit the object. Make dots or teardrops on your project by squeezing the bottle quickly, barely touching the fabric, and then lifting up the bottle. Make a dot and drag the bottle to the side to make a teardrop. Don't make a long continuous line when using fabric paints because it will tend to crack when the fabric moves.

Materials:

> Canvas or denim apron (You can find these in craft or discount department stores.)
>
> Iron and ironing board
>
> Iron-on transfer with a food theme (optional)
>
> Scissors (optional)
>
> Pencil or crayon to draw a design (optional)
>
> Straight pins
>
> Piece of cardboard
>
> Fabric paints in squeeze bottles
>
> Paintbrushes (optional)

1. Wash and dry the apron without using fabric softener. Press it to remove any wrinkles.

2. If using a transfer, turn on the iron to a cotton setting. Cut out the transfer, leaving a 1-inch border. Pin the design to the apron, ink-side down. Press with the iron for about 10 seconds. Don't move the iron or the design will blur. Lift

one corner to see if it is transferred; if not, repeat the ironing process. Remove the transfer from the apron. Pin the apron to the piece of cardboard and fill in the areas with fabric paint in squeeze bottles.

3. If creating your own design, draw the outline on the apron with a pencil or crayon and color it in with the appropriate colors of fabric paint. You could also follow the design in the illustration. You might want to dilute the fabric paint with a little water and use a paintbrush to paint larger areas of the design.

4. If desired, leave room on the bib of the apron to write a saying such as "World's Greatest Cook" or "Chef (father or husband's name)."

5. Allow the apron to dry overnight. After 72 hours the apron can be washed when necessary by using warm water in a gentle cycle.

Family Fun

The whole family can enjoy "messing around" together with these kid-approved crafts. Make something for Mom or Dad, or just spend some quality time together being creative.

Flutterflies

Celebrate the arrival of spring by helping your kids make this flying stained-glass butterfly. This would be a perfect decoration for Mom and Dad's garden or deck.

Making a stained-glass flutterfly.

(© Melissa LeBon)

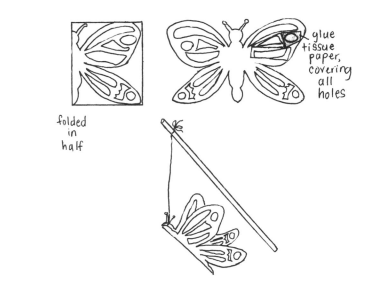

Level: Easy

Time involved: One to two hours

Materials:

> Construction paper
>
> Pencil
>
> Scissors
>
> Tissue paper
>
> White glue
>
> Clear contact paper
>
> Hole punch
>
> String or yarn
>
> Dowel

1. Fold a piece of construction paper in half. (Choose a bright color for your butterfly.) Draw an outline of a butterfly on the paper as shown. Be sure the body of the butterfly is in the fold. Cut out several holes in the wings with scissors for the stained-glass effect.

2. Cut out the shape and trace it onto another piece of construction paper. You should have two identical butterfly shapes.

3. Glue pieces of tissue paper onto one side of a butterfly cut-out, covering the holes. Glue the second butterfly on top of this. (The tissue paper should be sandwiched between the two construction-paper butterflies.)

4. Lay the butterfly onto the sticky side of a piece of clear contact paper. Place a second piece of clear contact paper on the other side so that both sides of the butterfly are covered. Trim around the outside of the butterfly. Make a hole in the top of the butterfly with a hole punch or sharp scissors to attach the string.

5. Bend the butterfly in half and attach it to a string. Attach the string to a wooden dowel.

Holiday Hints

If your kids enjoyed making a flutterfly, you could try making a bird using the same technique. You could also string the stained-glass creations from a wire hanger creating a mobile for a kid's bedroom.

Foam Frames

You can make a magnetic picture frame for Mom or Dad using foam sheets. Either buy pre-cut foam frames with magnets attached (check out your local craft store), or design your own frame out of foam sheets.

A pretty frame for a kid's photo.

Level: Easy

Time involved: One to two hours

Materials:

Two 5 × 5 inch purple foam sheets (or your choice of colors)

Pencil

Two different-sized drinking glasses (to make circles)

Scissors

Magnet

Glue gun

Blue, green, red, and purple jewelry wire

Wire cutters

Bag of foam animals with a spring theme (chicks, ducks, and so on)

Photo

1. Place the smaller glass in the middle of the foam sheet and trace around it to form a space for the photo. Draw the shape of a flower on the foam sheet

keeping the circle in the center. Cut the flower out of the foam sheet. Cut the circle out of the center of the flower. The flower with a circle cut out of it will form the picture frame.

2. Use a larger-based glass to draw another circle on the second piece purple foam sheet. Cut out this circle to make a backing for your frame. Glue a magnet onto one side of the circle.

3. Form a heart and flower out of the jewelry wire and glue them each onto a side of the front of the frame.

4. Pick out three foam animals and glue them to the top and bottom of the frame. Cut a photo in a circular shape, using the smaller glass to make the circle. Glue this picture onto the purple circle on the side without the magnet.

5. Position the flower frame over the circle with the photo, and glue it together around the edges of the circle.

Holiday Hints

Grandmothers, mothers, or aunts would love a handcrafted gift from their favorite tykes. You might want to help your kids make a handprint frame for these special people. Just have the kids trace their handprints onto special textured paper (scrapbook paper works well) and cut them out. Glue the handprints around the perimeter of a cardboard frame and place a picture of the kids in the frame.

Crafty Kitchen Creations

There's nothing like the homemade taste of a special treat from your kitchen. These recipes are easy to make and create hours of family fun. They also make a great gift for Mother's or Father's Day!

Chocolate-Covered Delights

Chocolate-covered strawberries are a delicious and perfect treat for a special occasion. You can add variety to your creations by using dark and white chocolate to dip the berries.

Holiday Hassles

When cooking chocolate in a double boiler, be sure to keep it at medium heat or lower. If the mixture begins to boil, turn it down. If the chocolate is boiling too long, it won't have the right consistency to cover the strawberries. It could also scorch and have a burnt taste. Don't leave the strawberries in the chocolate for more than a second or two, or they'll become soggy.

Level: Moderately easy

Time involved: One to two hours

Ingredients:

 Large dipping strawberries

 $1/2$ pound dark dipping chocolate

 $1/2$ pound white dipping chocolate

Equipment:

 Double boiler

 Cookie sheet

 Waxed paper

1. Wash the strawberries and allow them to dry. Do not remove the stems.
2. Place a $1/2$ inch of water in the double boiler and bring it to a boil. Put the dark chocolate in the top boiler pan. Cook over medium heat until the chocolate is melted.
3. Meanwhile, lay some sheets of waxed paper on the cookie sheet.
4. Once the chocolate is melted, hold a strawberry by the stem and dip into the chocolate for a second. Don't cover the stem with chocolate. Remove the strawberry and place it stem side down on the prepared cookie sheet. Repeat this process with half the strawberries.

5. Repeat steps 2 through 4 using white chocolate in the pan. Store the strawberries in a plastic container until ready to use. Serve on a cut glass or china plate covered with a lace doily.

You might want to include a bottle of champagne or sparkling cider with this gift and write a poem or special toast to share with your parents when you serve it.

Taffy

Round up the kids and get them involved in a taffy pulling session to create this sweet concoction for Mom or Dad.

Level: Moderately easy

Time involved: One to two hours

Ingredients:

> 2 cups sugar
>
> $^2/_3$ cup light corn syrup
>
> $^2/_3$ cup water
>
> $^1/_2$ teaspoon vanilla extract
>
> 3 tablespoons butter or margarine
>
> Butter to grease cookie sheets

Equipment:

> Heavy saucepan
>
> Candy thermometer
>
> Cookie sheets
>
> Spatula
>
> Kitchen shears

1. Mix the sugar, corn syrup, and water in a heavy saucepan. Add the butter or margarine and insert a candy thermometer into the mixture. Heat, stirring constantly, over moderately high heat until the sugar dissolves. Cook uncovered without stirring to 270°F or until a drop placed in cold water forms firm, pliable strands.

2. Pour the mixture all at once onto a cookie sheet greased with butter. Do not scrape the pan. Cool one to two minutes, and then sprinkle with the vanilla.

Using a buttered spatula, fold the edges in toward the center to distribute the heat evenly.

3. When the candy is cool enough to handle, pull and stretch it with buttered hands until it is light and no longer shiny. When it is too stiff to pull anymore, stretch the taffy into a rope about $^{1}/_{2}$ inch in diameter, and with kitchen shears greased with butter, cut across the grain into 1-inch pieces. Separate the pieces and dry thoroughly, and then wrap and store them in an airtight container.

Making delicious taffy with the kids.

(© Melissa LeBon)

The Least You Need to Know

➤ Mother's Day is the perfect time to share handcrafted gifts with the mothers on your list.

➤ You can honor your father on Father's Day by making him a special gift from your heart.

➤ Let the kids give you a gift of their time and talents by working on Mother's and Father's Day crafts together.

➤ Spend an afternoon in the kitchen with your kids making tasty treats for special occasions.

Part 5

Super Summers and Fall Favorites

The summertime embodies a number of holidays that are linked to a patriotic theme. Memorial Day kicks off the summer season, followed by the Fourth of July, and then Labor Day. If you need ideas to keep yourself and the kids busy during summer vacation, you'll want to check out the fun crafts and activities in Chapter 14, "Patriotic Pride."

Labor Day officially closes the summer season, and Halloween and Thanksgiving are right around the corner. You'll find clever ideas to celebrate these important fall holidays in this part. The Halloween chapter details unique craft projects, homemade costumes, fun activities for kids, and spooky foods to serve at a party. Because the Thanksgiving holiday is centered on a family banquet, you'll find ideas in this chapter for fall decorations and crafts, table centerpieces and place cards, and delicious foods that will be sure to please your guests.

Read this part to complete a year's worth of holiday ideas. Then, if you're so inclined, you could go back to the beginning to check out the crafts you might have missed the first time around!

Patriotic Pride

In This Chapter

➤ Creative time outdoors with the kids

➤ Projects that display your patriotic pride

➤ Unique projects to craft with family and friends

➤ Delicious treats for your holiday celebrations

Official holidays mark the beginning, the middle, and the end of the summer season in the United States. The first of these holidays, Memorial Day, commemorates the memory of our soldiers who died in battle. Fourth of July celebrates the birth of our nation, and Labor Day honors working Americans. These three holidays have a common thread—the reaffirmation of the patriotic pride that pervades the American spirit. We celebrate federal holidays by hanging the American flag and counting the many blessings that accompany living in a free nation. It's a great time to kick back at a summer barbecue or vacation spot and spend some welcome time off with family and friends.

If you have vacation time, you might want to check out the crafts in this chapter that would receive Uncle Sam's seal of approval. Gather your loved ones together for a fun craft session and display your patriotic colors with pride.

Memorable Memorial Day

Memorial Day, celebrated the last Monday in May, signals the beginning of the summer vacation season. Kids are excited to get a break from busy school schedules (and so are their parents). It's a great time to relax and spend some time outdoors renewing creative energies.

For a change, try making some of these "memorable" crafts outdoors on a picnic table or deck.

Frozen Flowers

The nice thing about a break in the weather that occurs around Memorial Day is the beginning of the growing season. You can celebrate the gift of flowers in your life by making these unique floral arrangements that are "frozen" in time.

Level: Moderately easy

Time involved: Two to three hours

Materials:

> Newspaper or plastic
>
> Latex gloves and protective clothing
>
> Glazing dip
>
> Disposable cup
>
> One dozen dried roses or summer flowers with stems
>
> Glass vase (Use one with a wide opening and wide base for best results.)
>
> Decorative glass pieces or marbles (optional)
>
> Floral-arranging gel
>
> Saucepan of hot water

1. Cover your work area with newspapers or plastic. Put on protective clothing and gloves. Pour the glazing dip into the disposable cup to the depth of the size of the roses. Hold the flower by the stem and dip the head completely into the glazing dip. Raise the flower over the cup and allow the excess dip to run off. Hold the flower upside down for several minutes until it is no longer dripping. Place the flower in the vase and allow it to dry. Repeat this step with the remaining flowers.

2. Once the flowers are dry, remove them from the vase. If there are any dried drips on the flowers, you can cut them off with scissors.

3. Prepare the vase by adding the decorative glass chips or marbles to the bottom if desired. Place the unopened bottle of floral-arranging gel into a pan of hot water until the gel liquefies. Carefully pour the gel into the vase. Arrange your roses in the gel and allow it to solidify.

Festive Facts

It's not certain where the image of Uncle Sam originated. One theory is that Uncle Sam represented Samual Wilson. During the war of 1812, Wilson, owner of a meat-packing plant, sent provisions to U.S. soldiers in large barrels. These barrels were stamped with the letters "U.S.," which some jokingly suggested stood for "Uncle Sam" Wilson. Through this link to the army, Uncle Sam became a symbol of the federal government. Thomas Nast, a prominent cartoonist, drew some of the earliest cartoons of Uncle Sam, but they didn't resemble Sam Wilson at all. One of the most famous portrayals of Uncle Sam was the "I Want You" WW I Army recruiting poster painted by James Montgomery Flagg in 1916.

Ice-Cream Fantasy

Kids and adults alike can agree that a favorite sign of the summer season is hearing the ice-cream truck come down the street and the day the ice-cream stands open. You can make your own rendition of this crowd-pleaser out of a few simple ingredients.

Level: Easy

Time involved: One to two hours

Materials:

 Newspaper or plastic

 Gold acrylic paint

 Disposable cup

 Paintbrush

 3-inch-wide × 4-inch-high clay pot

Holiday Hassles

Be sure to protect your work area with newspapers and wear protective clothing when working with floral-arranging gel and dipping glaze. Work in a well-ventilated area and avoid inhaling the fumes. The mediums are flammable, so store the bottles in a cool area away from flames or sparks. As with all crafting supplies, keep them out of the reach of children or pets.

3-inch clay saucer

Glue gun

3-inch ball candle

A candle that looks good enough to eat!

1. Cover your work area with newspapers or plastic. Pour a small amount of gold paint in the disposable cup. Paint a gold line along the rim of the pot. Paint a second gold line around the bottom of the rim. Paint a pattern of triangles on the bottom of the pot (see illustration).

2. Paint the saucer gold. Using the glue gun, glue the bottom of the saucer to the top of the pot.

3. Place the ball candle in the saucer. The saucer will catch any drips that may occur when the candle is burning.

Creating the ice-cream-cone effect.

(© Melissa LeBon)

Festive Facts

Memorial Day is an official holiday celebrated on the last Monday in May in most of the United States. It is a time set aside to honor the nation's service personnel killed during wartime. This holiday, marked by parades, memorial ceremonies, and the decoration of gravesites, was first observed on May 30, 1868. It was then that, upon the order of John Alexander Logan, flowers were placed on the graves of the Union and Confederate soldiers at Arlington National Cemetery. The South originally refused to honor the date until after World War I when the holiday changed from honoring just those who died in the Civil War to honoring those who died in any war.

Country Candleholders

Light up your picnic table with this quaint set of country-style candleholders.

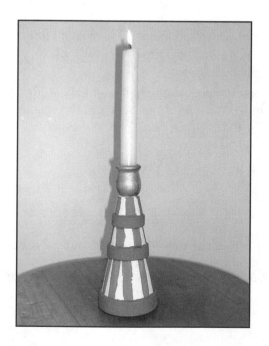

A candleholder designed from clay flowerpots.

Holiday Hints

If you liked the look of the country candleholders, try making them with a different holiday theme. For example, you could make a summer theme by using ivy or flower stencils, a Christmas theme using red and green colors and snow texture paint, a Hanukkah design using blue and gold colors, or a Kwanzaa motif using red, black, and green colors.

Level: Easy

Time involved: One to two hours

Materials:

 Newspaper

 Two 3-inch clay flowerpots

 Two 2-inch clay flowerpots

 Two 1½-inch clay flowerpots

 Red, white, blue, and gold craft paints

 Paintbrushes

 Two wooden candleholders (You can find these packaged in bags in the wood section of craft stores.)

 Glue gun

 Clear acrylic finish spray

 Two red, white, or blue candles

1. Cover your work area with newspapers. Paint the rims of all of the pots blue. Paint the remainder of each pot white and allow these to dry. (You do not have to paint the inside of these pots.) Paint red stripes vertically on each pot. Paint the wooden candleholders gold and allow to dry.

2. Using the glue gun, glue the 2-inch pots to the bottom of the 4-inch pots. Then glue the 1½-inch clay pots to the bottom of the 2-inch pots. Glue the wooden candleholder to the bottom of the 1½-inch pot. Spray the candlesticks with clear acrylic finish spray and allow to dry.

3. Place a red, white, or blue candle in each holder.

Fabulous Fourth

The Fourth of July celebrates the birth of the United States. It's a time for enjoying fireworks, family picnics and vacations, and the freedom to do whatever makes us happy. Share a few moments of this time with your family or friends working on these patriotic projects.

Festive Facts

The Battle of Baltimore, fought in 1814 as part of the War of 1812, inspired the writing of "The Star Spangled Banner." President James Madison sent Francis Scott Key, a prominent lawyer, to obtain the release from the British of his old friend, Dr. Beanes. It was during this time that the battle of Baltimore was fought. Key was standing down-river from the battle and put the events into a poem. Despite several attempts, the British were unable to take the city, and they departed from Baltimore. Key wrote the poem to be sung to the old English tune "To Anacreon in Heaven." "The Star Spangled Banner" grew in popularity, and in 1931, Congress declared it the National Anthem.

Four-Star Service

Impress your family and friends by serving refreshments on this serving tray with a flag motif. You might want to make one of these for a hostess gift for that upcoming Fourth-of-July barbecue.

Serving refreshments on a red, white, and blue tray.

Level: Moderately easy

Time involved: Three to four hours, plus overnight to dry

Materials:

> Newspaper or plastic
>
> Unfinished wooden serving tray (You can find this in the wood section of craft stores.)
>
> Red craft paint
>
> Paintbrushes
>
> Red, white, and blue bandana or material
>
> Pen
>
> Scissors
>
> Decoupage finish
>
> Varnish
>
> Thin white ribbon or trim
>
> Glue gun

1. Cover your work area with newspapers or plastic. Paint the entire wooden tray red. Add a second coat if necessary. Allow this to dry.

2. Place the bandana or material on a flat surface. Lay the tray on top of the material, and trace around the tray with a pen. (If necessary, iron the bandana or material before using it.) Cut the tray shape out of the bandana or material.

3. Place a light coat of decoupage finish on the wrong side of the material. Place this on the inside of the wooden tray and smooth in place with your fingers. When this is completely dry, brush a light coat of decoupage finish over the entire project. Repeat with a second coat. Allow this to dry.

4. Paint the wooden tray with a coat of varnish on the sides and inside of the tray, covering over the fabric. Allow this to dry and then repeat on the bottom of the tray. Allow the tray to dry overnight.

5. Cut the ribbon or trim to form a border inside the tray around the fabric design. Using a glue gun, glue the ribbon onto the tray. If desired, you could glue a border of ribbon around the painted outsides of the tray.

Holiday Hints

You could customize a hostess tray by cutting several designs out of fabric and using de-coupage finish to attach them to the tray. You might want to consider adapting this tray to other holidays by using the appropriate holiday theme. For example, you could use material with bunnies and eggs for Easter, pumpkins and ghosts for Halloween, or four-leaf clovers for St. Patrick's Day.

Labor of Love

Labor Day, celebrated the first Monday in September, is an official holiday designated to honor the American working class. Free industry and a dedicated labor force helped to make America the great nation that it is today. Labor Day also signals the end of summer vacation and a return to school for the kids. Help savor this final summer holiday by spending some time with the kids designing eye-catching craft projects.

Seasonal Sense

You may celebrate **Labor Day** by having a picnic with your friends and family, but are you aware of the reasons behind this celebration? (No, I'm not talking about Labor Day Sales!) Labor Day, celebrated on the first Monday in September, is a creation of the labor movement dedicated to the achievements of American workers. There is some dispute among the experts as to who founded Labor Day. Some say it was the idea of Peter J. McGuire, general secretary of the Brotherhood of Carpenters and Joiners, and co-founder of the AFL. Others feel it was proposed by Matthew Maguire, a machinist working in New York City. Maguire served as secretary of the Central Labor Union in New York. This union adopted a Labor Day proposal and appointed a committee to plan the first Labor Day celebration: A demonstration and picnic in New York City were held on September 5, 1882. The first Monday in September was selected as the official Labor Day holiday in 1884.

Aquatic Art

If you're into tropical fish and plants, then this project is perfect for you. The aquatic garden is easy to assemble, and it makes a beautiful decoration for a den or an office.

A lovely home for a beautiful fish.

Level: Moderately easy

Time involved: One to two hours

Materials:

> One 10¾-inch vase (Crafts stores sell these vases, and some will include the saucer for free. I found all the necessary ingredients for this project at a garden shop.)
>
> One 4-inch plastic saucer
>
> One pack of decorative rocks or marbles
>
> One water-loving plant (such as a peace lily)
>
> Scissors
>
> One gallon bottled water
>
> One Beta fish (or Japanese fighting fish)
>
> One yard of red, white, and blue ribbon

1. Rinse off the vase, saucer, and rocks or marbles with water and set them aside.
2. Remove the plant from the pot and thoroughly rinse all the roots. You may have to soak them to get them clean. Trim the ends of the roots so that they are about four inches long.

3. Using scissors, cut a 2-inch hole in the bottom of the plastic saucer. Work the roots through the hole. Place a 2-inch layer of rocks or marbles in the bottom of the vase. Fill the vase with bottled water to about 3 inches below the neck of the vase.

4. Place the plastic bag containing the fish in the vase for about an hour to acclimate it to the temperature of the water. The water should be around room temperature. Carefully float the fish out of the bag and fill the vase to about 1 inch from the top with more bottled water. There should be about a 1-inch space between the bottom of the saucer and the water level for the fish to breathe. Do not use tap water as it contains chlorine that is harmful to the fish.

5. Work the roots from the saucer into the vase and allow the saucer to rest on the lip of the vase. Add decorative rocks to the saucer to hold it in place.

6. Tie a red, white, and blue bow around the top of the vase.

Place the vase in indirect sunlight and keep it in a warm spot (room temperature), out of drafts. Carefully lift the saucer from the vase to feed the fish.

Holiday Hassles

Beta fish or Japanese fighting fish are aggressive fish that like to live alone. If you put two together in a bowl, they'll fight with each other. You can feed your fish prepared fish pellets from a pet shop, and give it shrimp brine and dried blood worms for a treat. Change about 25 percent of the fish's water each week by adding bottled water that is the same temperature as the water the fish is residing in. If necessary, trim the roots of the plant if they become too long.

Antique Designs

If you're cooped up on a rainy Labor Day weekend, you might want to try making these antique vases or candleholders to brighten up your dinner table.

Level: Easy

Time involved: Two to three hours

Materials:

Newspaper or plastic

Glue gun

Small objects with a raised surface such as pasta shapes, cereal, beads, cord, buttons, and bottle caps

Glass bottles

White glue

Aluminum foil

Black tempera paint

Liquid detergent

Disposable cup

Paintbrush

1. Cover your work area with newspapers or plastic. Using a glue gun, glue the raised objects onto the bottle, creating an interesting design. Be sure that you cover the entire surface fairly well. Allow to dry.

2. Cover a small area of the bottle with white glue. Using small pieces of aluminum foil, cover the glued area and press the foil into all the crevices. Don't worry if the foil splits or gets a hole in it; it will be covered by the black paint. Continue to add the foil until the entire bottle is covered.

3. Make a solution of two parts black tempera and one part liquid detergent. Paint this mixture onto the bottle, a small area at a time, making sure to get it into all the cracks. Use a small piece of crumpled newspaper to buff the black paint off of the high areas of your bottle. The black paint should remain in the cracks, with the raised areas free of paint, giving the bottle an antique look.

Add flowers or a candle to the bottle, and place it on your picnic table to light up your Labor Day feast.

Steps to making an antique vase or candleholder.

(© Melissa LeBon)

Food, Glorious Food!

Backyard barbecues are the name of the game for summer holiday weekends. If you're throwing a holiday bash, you'll want to check out these ideas for the perfect picnic foods.

Festive Facts

Grilled chicken-salad sandwiches make a delicious summer picnic lunch. The next time you make chicken on the grill, try adding an extra breast or two to make chicken salad. Marinate the chicken first in a vinaigrette salad dressing for two hours before grilling. The grilled chicken is great on a Caesar salad for dinner, and the extra pieces can be chopped up for chicken salad for your picnic lunch the next day. Add $1/2$ cup chopped celery, $1/4$ cup chopped onion, $1/4$ cup chopped red pepper, and about $1/3$ cup mayonnaise to the chicken, and mix well. Season with salt and pepper to taste.

Fruit Fantasy

When it's too hot to eat anything else, fruit is a great choice to boost your energy. Try making this decorative and delicious watermelon basket for your next summer event.

Level: Moderately difficult

Time involved: One to two hours

Ingredients:

> Whole seedless watermelon (Choose one that sits straight on its underbelly. A ripe watermelon should have a whitish-yellow underbelly where it was laying on the ground.)
>
> Cantaloupe
>
> Honeydew
>
> 8-ounce package cream cheese
>
> 7-ounce jar marshmallow whip

Equipment:

> Pencil
>
> Sharp knife
>
> Large bowl

Melon-ball utensil

Large spoon or scoop

Paring knife

Electric mixer or food processor

top view

Cutting out a watermelon fruit basket.

(© Melissa LeBon)

1. Wash the outside of the watermelon. Draw the design of the basket on the top-side (green side) of the watermelon with a pencil. You should have two triangular shapes, one on each side of the melon, with a 2-inch strip for the handle in the middle (see illustration).

2. Cut the two triangles out, being careful not to knick the edges of the handle. Pry the two triangles out of the watermelon with your hands and place them in a bowl.

3. Using the melon-ball utensil, begin scraping out the watermelon using a quick twist of the utensil to form a ball. If you use a seeded watermelon, you'll have to remove the seeds from the balls with your fingers. (I always use a seedless watermelon for this reason.) Make as many watermelon balls as you can, and then

scrape the remainder of the watermelon fruit out of the skin with a spoon. Discard or eat the watermelon scraps. Make balls out of any watermelon attached to the two triangles that you cut out. Discard the skin.

4. Using a paring knife, cut a notched edge into the edge of the basket as shown. Make one cut on an angle to the left, and a second cut on an angle to the right to form a notch, and repeat around the perimeter of the basket. (This step is not as hard to do as it seems.) You can continue to notch the handle if desired, but it looks fine un-notched, and you'll minimize your chances of cutting through the handle by mistake if you leave the edges smooth.

5. Once you've notched your basket, place the watermelon balls in the basket.

6. Cut the cantaloupe in half and remove the seeds with a spoon. Use the melon-ball utensil to make cantaloupe balls. Repeat this step with the honeydew, so you have three different melon balls. Place the balls in the watermelon basket and mix them together. If desired, you could add cut-up strawberries and blueberries on top for decoration.

7. Using a mixer or food processor, mix the cream cheese and marshmallow whip in a bowl. Place the mixture in a small bowl to use as a dip for the fruit.

Holiday Hints

You can make a beautiful pineapple dessert by laying a pineapple on its side on a cutting board and cutting it in half, lengthwise. (Keep the leaves on top intact and cut through them.) Carefully cut out the pineapple and core from the pineapple skin and place on the cutting board. Discard the core and cut the pineapple into chunks. Meanwhile, drain a 15-ounce can crushed pineapple and mix it with an 8-ounce package cream cheese in a mixer or food processor. Fill half the hollowed pineapple with the mixture. Place the pineapple chunks on toothpicks and stick them in the skin of the filled pineapple. Place the pineapple on a serving tray and add some other cut-up fruits (bananas, strawberries, kiwi).

Artichoke Dip

Artichoke dip is so simple to make and yet it gets rave reviews from company. All you need is a food processor and three ingredients to make this mouthwatering dip.

Level: Easy

Time involved: Half to one hour

Ingredients:

> Can of whole artichoke hearts (You can find this in the canned-vegetable section of supermarket.)
>
> 10-ounce brick white mild or medium cheddar cheese (You could use a 10-ounce package shredded cheddar cheese instead.)
>
> $1/_2$ cup mayonnaise
>
> Nonstick cooking spray
>
> Crackers

Equipment:

> Food processor
>
> Mixing bowl
>
> Small ovenproof baking dish

1. Preheat the oven to 350°F. Open the can of artichoke hearts and drain them, discarding the liquid. Place the artichoke hearts in a food processor and surge the power until the hearts are cut into chunks (not mushy). Place in a mixing bowl.

2. Cut the brick of cheese into chunks and shred in the food processor. Remove to the mixing bowl. (If using shredded cheese add now.) Add $1/_2$ cup mayonnaise to the mixture and stir thoroughly.

3. Spray the baking dish with nonstick cooking spray. Add the artichoke mixture and pat it down with a spoon. Bake the mixture for approximately 20 minutes or until melted and golden brown. Serve with crackers.

Holiday Hassles

Low-fat butter and mayonnaise have come a long way since their discovery. Unfortunately, although their taste has improved, they don't always hold up well in recipes. I tried using nonfat mayonnaise in the artichoke dip, and it was a disaster. The dip had a dry, as opposed to a creamy, texture and it didn't brown well. Along the same lines, substituting low-fat butter or margarine in recipes that call for real butter or margarine doesn't usually work, especially when the dishes are baked (such as cakes, cookies, and breads).

The Least You Need to Know

➤ You can show your patriotic pride by making homemade Memorial Day, Fourth of July, and Labor Day crafts.

➤ Learn the origins of America's official holidays, and celebrate them by spending time outdoors with your loved ones.

➤ Make your summer barbecues special by concocting simple party foods and treats for your guests.

Halloween How-To's

In This Chapter

➤ Making crafts that will turn your home into a spooky haven

➤ Creating the perfect costume for a Halloween parade or party

➤ Having some Halloween fun with your own little "monsters"

➤ Cooking the perfect food for a Halloween celebration

Halloween is a unique folk holiday that is celebrated in the United States and Canada on October 31. The word Halloween itself has its origins in the traditions of the Catholic Church. All Saints Day, or All Hallows Day, is a holy day, created by Pope Boniface IV to honor all saints. He felt that there were too many saints at this point in time to pay tribute to them individually. He chose November 1 as the day of celebration, possibly to offset any pagan rituals also occurring at this time of the year. The day preceding this holy day was known as "All Hallows' Eve," which was eventually translated into "Halloween."

Many of the traditions of Halloween can be traced to the Celtic society of 800 B.C.E. In Celtic Ireland, October 31 was the official end of the summer and was termed Samhain (*sow-en*), or the Celtic New Year. The Celts thought that the wall between the current existence and the next world was thinnest at this time of the year. They believed that the spirits of all those who had died during the year would come back to

find living bodies or animals to possess. Not wanting to be possessed, the Celts extinguished their hearth fires to make their homes cold and unwelcome to the spirits. They dressed in ghoulish costumes and paraded around the town to frighten away the ghosts. A huge bonfire was lit, and the Celts used embers from this fire to re-light their hearth fires for the next day. These embers were carried in special ember holders (usually gourds or pumpkins) that were carved with frightful faces to scare away the spirits.

Nowadays, Halloween is a whimsical holiday enjoyed by both young and old alike. Whether you have kids hitting the neighborhood candy circuit or are the one in charge of the doorbell on trick-or-treat night, you'll want to check out these ghastly ideas for Halloween décor and fun. Don't be afraid to let the kid in you take over and make this the best Halloween ever!

Signs of the Season

There's no mistaking the look of Halloween. Ghosts float from trees, *jack-o-lanterns* grace doorsteps, and witches fly through the air on their broomsticks. Don't let this season fly by without trying out some of these eye-catching "spooktacular" crafts.

Seasonal Sense

It is believed that the tradition of making **jack-o-lanterns** originated from an Irish folktale. According to the legend, a notorious Irishman named Jack tricked the devil into climbing a tree. He then carved a cross on the tree, trapping the devil in its branches. When Jack died, he was denied access into heaven because of his evil life. The devil also rejected him from hell and instead gave him an ember placed inside a hollowed-out turnip to light his way in the dark. In America, pumpkins were substituted for the turnips as a traditional jack-o-lantern because they were more plentiful.

Ghastly Ghost

This ghost is environmentally friendly because it enables you to recycle your old newspapers into a Halloween decoration. Stand him up near your front door or hang him from a tree for a haunting effect.

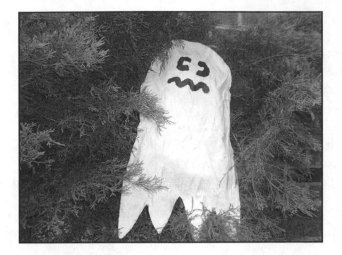

A spooky welcome to your home.

Level: Moderately easy

Time involved: Two to three hours, plus overnight to dry

Materials:

> Newspapers
>
> Black marker
>
> Scissors
>
> Stapler and staples
>
> Disposable bowl or cup
>
> White glue
>
> Water
>
> Thick paintbrush
>
> Pack of white tissue paper
>
> White and black craft paints
>
> Sharp scissors (optional)
>
> String (optional)

1. Cover your work area with newspapers. On a flat surface, lay out six single pages of newspaper. Using a magic marker, draw an outline of a ghost on the newspapers. The head should be rounded and the bottom should be raggedy (see the accompanying figure). Cut out the ghost outline. You should have six newspaper ghost shapes.

2. Using a stapler, staple the six newspaper ghosts together leaving about a 6-inch opening on one side. Crumple up other newspapers and stuff the ghost with these papers between the third and fourth layer of the newspaper ghost. (You should have three layers of newspaper ghosts on either side of the stuffing.) Be sure to stuff small pieces of newspaper in the raggedy edges at the bottom. Staple shut the 6-inch opening.

3. Mix about 1 cup white glue in a bowl with $1/4$ cup water. Rip up white tissue paper into strips. Paint an area of the newspaper ghost with the glue mixture and smooth on a piece of tissue paper. Repeat this process until several layers of tissue paper cover the newsprint. Allow this side to dry. Repeat this process on the other side until the entire newspaper ghost is covered with tissue paper and no newsprint can be seen through the tissue paper. Be sure to mold some of the tissue paper around the edges to cover up the staples. Allow this to dry for several hours.

4. Paint one side of the ghost white and allow this to dry. Paint the other side white and allow it to dry. Make eyes and a mouth on the front of the ghost using black craft paint. Allow your ghost to dry overnight.

5. If desired, poke a hole in the top of the ghost with a pair of sharp scissors. (Parents should do this step.) Thread the string through the hole and hang your ghost from a tree branch.

Holiday Hints

You can make a ghost stuffed with candy to serve at a Halloween party. Place wrapped candies in the ghost along with light newspaper stuffing. Substitute the white tissue paper glued onto the outside with newspaper strips. Allow this to dry and paint the ghost with white craft paint. Use a marker or black paint to make eyes and a mouth on your ghost. Hang the ghost from a rafter or beam in your home or a tree in your backyard, and allow blindfolded guests to take turns hitting it with a plastic bat to break it open and let the candies loose.

The Cat's Meow

What would Halloween be without a black cat to cross your path?

Put this little imp on a shelf or mantel for a unique Halloween decoration. (See the color insert for more details.)

A sultry black cat to display on Halloween.

Level: Easy

Time involved: One to two hours

Materials:

Newspaper or plastic

Two 3-inch wooden circle disks (These can be found in the wood section of a craft store.)

Four rounded-peg clothespins

One round wooden knob

Two wooden animal ears (You can find assorted wood pieces [Woodsies], for making animals in bags in the wood section of a craft store.)

One wooden spoon

Black, red, and white craft paints

Paintbrushes

Glue gun

Clear acrylic finish spray

Plastic eyes

Fine-tipped paintbrush

14-inch piece of cord or ribbon

Magnet (optional)

1. Cover your work area with newspapers or plastic. Paint all the wooden pieces black (on all sides) and allow them to dry.

2. Slide two peg clothespins onto one of the wooden circles. Glue these in place with a glue gun. Repeat this step with the other wooden circle. Glue the two wooden circles together with the clothespins, forming two legs and the circles forming the cat's body.

3. Glue the round knob onto the top of one of the circles to form a head. Glue the ears onto the top of the head. Glue the wooden spoon onto the top back of the cat to form a tail that is sticking straight up. Spray the cat with clear acrylic finish spray and allow it to dry.

4. Glue the two plastic eyes onto the head. Using the fine-tipped paintbrush, paint a red triangular-shaped nose on the cat beneath the plastic eyes. Then paint white whiskers onto the face of the cat using this paintbrush.

5. Tie the piece of cord around the cat's neck for a collar. If desired, glue a large strip of magnet onto the back of the cat and place him on your refrigerator.

Festive Facts

A black cat has been a symbol of Halloween dating back to the ancient Celtic festival of Samhain. It was believed that on October 31, friends and relatives would return and inhabit the bodies of animals, black cats in particular. The black cat is still a symbol of Halloween. Some people consider them to be intuitive animals that can sense the presence of spirits. They are depicted as witch's familiars (animals possessed by ancient spirits) and are thought to have special powers. Unfortunately, black cats can be in danger on Halloween. If you own a black cat, it's a good idea to keep him indoors on trick or treat night.

Wicked Welcome

Scare away the goblins on trick-or-treat night by hanging this bewitching decoration on your front door. (See the color insert for more details.)

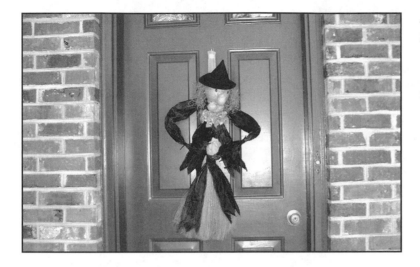

A welcoming witch for your door.

Level: Moderately difficult

Time involved: Two to three hours

Materials:

> Wire coat hanger
>
> Wire cutters
>
> Decorative straw broom
>
> Black and tan paper ribbon (3-inch width)
>
> Scissors
>
> White glue
>
> One 4-inch round Styrofoam ball
>
> Three 2-inch oval Styrofoam balls (egg size)
>
> Low-heat glue gun
>
> Plastic eyes
>
> Spanish moss

1 yard of decorative Halloween ribbon

Black foam sheet

Miniature plastic or real pumpkin or gourd

1. Open up the coat hanger and cut off the hooked end. Wrap the middle of the wire around the upper one third of the broom handle to form the arms.

2. Cut two pieces of black paper ribbon to 36-inch lengths. Make the ends of these lengths of ribbon jagged to form fingers. Wrap the middle of the ribbon around the middle of the wire and extend the ribbon down the wire arms, covering the front and back of each piece of wire. Run a line of glue down each side of the paper ribbon to keep the two pieces of ribbon together with the wire arms in between the ribbon.

Holiday Hints

If you can't find black and tan paper ribbon to make your witch, you could substitute black and tan tissue paper, crepe paper, or streamers for the ribbon. If using tissue or crepe paper, cut it into 3-inch-wide strips. You also might want to experiment with using different colors for the face, such as green or gray.

3. Cut two more pieces of black paper ribbon 36 inches long. Wrap the middle of these ribbons around the intersection of the arms and broomstick. Bring two of the ends of ribbon down the front to form a skirt on top of the straw of the broom. Wrap the other two ends around the middle of the broomstick to form the bodice, and glue them in place (see illustration).

4. Using the white glue, cover the round Styrofoam ball and the three oval balls with tan paper ribbon, smoothing the ribbon with your fingers as you go along. Some wrinkles will form on the surfaces, which are a desired effect. Using a glue gun, glue one oval onto the center of the ball to form a nose, and two ovals onto the bottom center of the ball to form a chin. Glue the plastic eyes onto the ball.

5. Glue Spanish moss onto the top of the head to form hair. Make a bow out of the ribbon, and glue it onto the witch's neck.

6. Make a witch's hat out of the black foam sheet by cutting a circle out of the foam that is 6 inches in diameter. Then cut a second circle out of the middle of this circle that is 4 inches in diameter. This will form the rim of the hat. Make a $12 \times 9 \times 9$ inch triangle out of black foam sheet and form it into a cone, making the point of the hat along the longer length of the triangle. Using a low-heat glue gun or foam glue, glue the cone together and trim the ends to form the top of the hat. Glue the cone onto the foam rim to form a witch's hat. Glue the hat onto the head of the witch.

7. Insert the ends of the wire hands into the sides of a small pumpkin, or glue a small plastic pumpkin onto each end of the wire to bring the arms together holding a pumpkin.

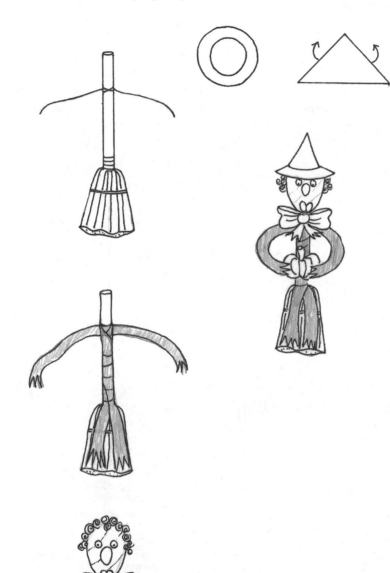

Steps to creating a welcoming witch for your door.

(© Melissa LeBon)

Ghostly Garb

The best thing about Halloween is using your imagination to conjure up the perfect Halloween costume. If you're running out of costume ideas for your Halloween party or neighborhood parade, you'll want to check out the unique disguises in this section.

Beautiful Butterfly

Let your kids flutter from treat to treat dressed in this cute butterfly costume. You can make this charming bug disguise in no time using a few simple ingredients.

Designing the perfect butterfly costume.

(© Melissa LeBon)

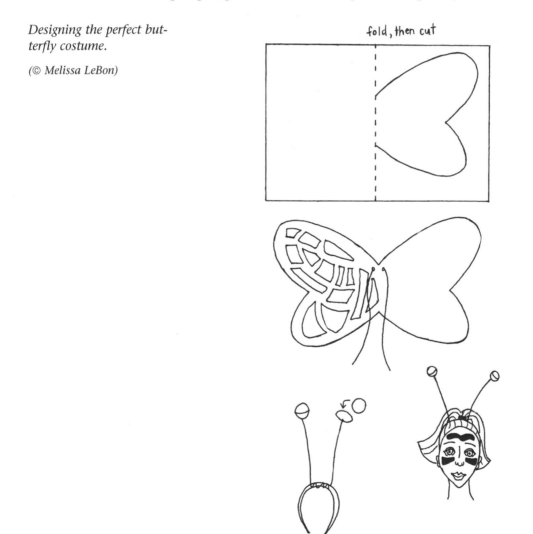

fold, then cut

Holiday Hassles

The following are some pitfalls to avoid when making a homemade costume:

➤ Using flammable materials in the costume

➤ Making a headpiece that obstructs the wearer's vision

➤ Making the costume too heavy or tiring to wear or carry around

➤ Making a dark costume for trick-or-treating without adding fluorescent tape or paint

➤ Using paint instead of make-up on skin

Level: Moderately easy

Time involved: One to two hours

Materials:

Newspaper or plastic

One large piece of cardboard or poster board (approximately 25 × 17 inches)

Thick black marker

Scissors

White glue

Water

Disposable cup

One 2-inch wide paintbrush

Multicolored tissue paper

Heavy cord

18-gauge jewelry wire

Wire cutters

Two small Styrofoam balls

Glue gun

Plastic headband

Any color of matching leotard and tights or sweat suit

Hyperallergenic make-up

1. Cover your work area with newspapers. Place the poster board on a table with the longer end running horizontally. Fold it in half vertically and, using the marker, draw half of a wing on the folded side as shown. Cut out the wings and open them up.

2. Place $\frac{1}{2}$ cup white glue in the disposable cup and dilute it with 3 tablespoons water. Mix this with a paintbrush.

3. Cut or tear different colors of tissue paper into strips, shapes, pieces, or a combination of these. Paint one wing with glue and begin covering it with pieces of tissue paper. You can use a specific pattern or place them randomly. Repeat this process until you have a second layer of tissue paper on the wing. Paint a layer of the glue mixture on top of the paper layers. Cover the other half of the wings in the same manner. Allow this to dry.

4. Turn the wings over and repeat steps 2 and 3 on the other side of them. Allow this to dry.

5. Poke two side-by-side holes in the upper centerfold of the pair of wings. Thread a 36-inch piece of cord through both holes. Leave enough cord on both sides to wrap over the shoulders, thread under the arms, and tie behind the back.

6. Cut a piece of jewelry wire 24 inches long. Stick the point into the top of the ball and begin wrapping it around the ball in a circular pattern. Use a glue gun to hold the wire in place where necessary. Bring the remaining wire down into a tail to form the antenna. Repeat this step with a second piece of wire and another Styrofoam ball. Wire these antennae onto the headband and glue them in place.

7. Dress your child in a matching leotard and tights or sweat suit. Use make-up to make the face of the butterfly using the illustrated pattern or your own creative design.

8. Place the headband on your child's head and attach the wings.

Holiday Hints

If the butterfly costume was a hit, try making a ladybug costume using the same method. Just cut circles out of cardboard for wings, and glue red construction paper and black dots on the cardboard circles. Connect them at the top and sides with pieces of cord. Make the antenna out of red or black headband using red or black jewelry wire. Have your child wear a black sweat suit underneath and use black and red make-up for the face.

Make-Up Magic

Using make-up for a disguise is a safe alternative to wearing a plastic mask. There's nothing to obstruct a child's vision, and you can use your imagination to create a special look to complement the costume. The following are some illustrated ideas for creating special looks with make-up.

Level: Easy

Time involved: Half to one hour

Materials:

> Make-up kit
>
> Make-up brushes or sponges
>
> Cold cream (to remove the make-up)
>
> Apply make-up to the face using the accompanying illustrated sample, or pick a design of your own choice.

You might want to make a partial mask out of papier-mâché (see the "Molded Masks" section later in this chapter) and fill in the open spaces with make-up. For example, you could make a bunny nose and cheeks and fill in the forehead and chin with a matching color of make-up.

Some examples of using make-up as a mask.

(© Melissa LeBon)

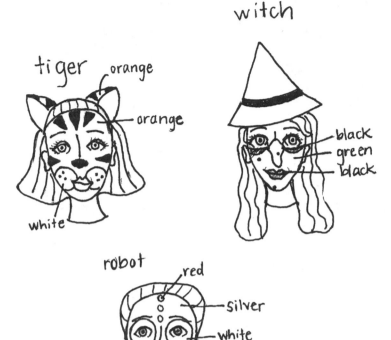

Kicks for Kids

Halloween is a great time to have some frightful fun with the kids. These Halloween activities are easy to do and don't take a lot of time or materials. Enjoy some good old-fashioned entertainment.

Ghastly Groans

Scare the wigs off your trick-or-treaters by making a spooky cassette tape to play on Halloween night. You'll be surprised how many creepy sounds you'll hear around the house that would be perfect for a Halloween tape.

Level: Easy

Time involved: One to two hours

Materials:

> Tape player
>
> Blank cassette tape
>
> Spooky sounds

1. Set up the cassette player to record sounds.
2. See how many spooky sounds you and the kids can record inside or outside the house.

Some suggestions for taped sounds include a creaky door, screams, dogs barking, hitting a pot with a spoon, organ chords, sirens, running footsteps, and a cackling laugh.

Foam-Sheet Fun

A piece of poster board and some Halloween foam are the main ingredients in this clever Halloween decoration. This wreath is the creative work of Jordan Gray of Pottsville, Pennsylvania.

Level: Easy

Time involved: One to two hours

Materials:

> Poster board
>
> Protractor
>
> Pen or pencil
>
> Scissors
>
> Low-heat glue gun or foam glue
>
> Foam pumpkins
>
> Orange, yellow, red, white, beige, brown, black, and blue foam sheets
>
> Fine-tipped black marker
>
> Small piece of raffia
>
> Button
>
> Green pipe cleaners

Holiday Hints

As long as you have the tape recorder out, you might want to take turns telling a spooky story and recording it. Let the storyteller designate someone to make sounds to enrich the story as needed. If you can't think of a ghost story to record with your kids, give the storyteller a book to read aloud and take turns making the sounds to accompany the story.

A colorful Halloween decoration for a wall or a door.

1. Using the protractor, draw a 9-inch circle on a piece of poster board. Make a second circle in the middle of this circle 1 inch smaller than the first circle. Cut out the middle circle to form a circular frame that is 1-inch wide.

2. Glue six pumpkin shapes, equally spaced, onto the circular frame, leaving a 3-inch space on the bottom of the frame for the scarecrow face.

3. Make a $2^1/_2$-inch circle out of the beige foam sheet. Cut triangular eyes out of the black foam sheet and a triangular nose out of the red foam sheet, and glue them onto the circle. Make a mouth with the black marker.

4. Make hair out of brown foam sheet, and glue it onto each side of the scarecrow's face. Make a hat out of black foam sheet and add a blue band. Tie the raffia into a small bow and glue it onto the hat. Glue a button onto the center of the bow. Glue the hat on top of the head, covering the top of the hair. Glue the scarecrow onto the bottom of the wreath.

5. Cut five candy-corn shapes out of orange foam sheet, which are approximately 3×2 inches. Cut out and glue a yellow bottom piece and white tip on the corn, using yellow and white foam sheets.

6. Glue the candy corn in a random pattern overlapping the pumpkin shapes. Glue a small twisted piece of green pipe cleaner on top of the pumpkins for a stem. Make a small loop out of a piece of pipe cleaner, and glue it onto the top back of the wreath for hanging purposes.

Molded Masks

Papier-mâché is a perfect molding medium (although a bit messy) for making a handmade Halloween mask. You'll need to get started on this project early, as it requires overnight to dry. If you don't have time for papier-mâché, try making masks out of paper plates and craft paints instead.

A unique Halloween disguise.

Level: Moderately easy

Time involved: Two to three hours, plus overnight to dry

Materials:

 Newspaper

 9-inch balloon

 Mixing bowl

 Flour

 Water

 Mixing spoon

 Sharp scissors

 Craft paints

 Paintbrushes

 8-inch piece of elastic

Holiday Hassles

Papier-mâché masks are somewhat cumbersome and could present a safety hazard if worn for trick-or-treat night. A full papier-mâché mask should only be worn indoors since it tends to obstruct a child's vision. However, these masks are bright and decorative and can also be used as a head for a stuffed scarecrow, a ghost, or a witch.

273

1. Cover your work area with newspapers. Blow up the balloon and make a knot in it.

2. In the mixing bowl, make a paste out of ³/₄ cup flour and a little less than ¹/₂ cup water. When mixed, the paste should be thick enough to thoroughly coat a piece of paper dipped in it without the paste dripping off the paper. If the paste is too runny (slimy), add more flour; if it's too stiff, add more water.

3. Tear the newspapers into 1-inch-wide strips. Dip the strips into the paste, and run your fingers down them to make sure they are coated. Paste the strips onto the balloon in a vertical direction from the knotted end to the top and back down again. Repeat this process several times until the balloon has several layers of paper covering it. Then paste strips around the balloon horizontally until you have about three more layers of newspapers on the balloon. Be sure the knot is not covered up by newspapers. (You will remove the balloon through this opening.)

4. Allow the ball to dry overnight or longer if necessary. Pop the balloon and pull it through the hole.

5. Starting at the hole, carefully cut the ball in half. You will have two masks. Cut two holes for eyes in each mask. (Parents should do this step.)

6. Paint facial features on the mask using craft paints and allow to dry.

7. Poke a hole in each side of the mask and thread a piece of elastic through the holes to keep the mask in place on the head.

Holiday Hints

You can create a lovely, lighted walkway for your trick-or-treaters by making globes out of small pumpkins. Simply cut the tops off the pumpkins and scrape them out. Use Halloween cookie cutters to trace Halloween shapes on the outside of the pumpkins. Carefully cut out the shapes, add a candle, and voilà! A glowing Halloween trail.

Frighteningly Fun Food

Halloween sustenance should consist of more than just candy bars. Try making some of these treats to help tame the sugar high.

Pumpkin Pleasers

Make the most of your Halloween pumpkins by saving the seeds to make this delicious snack.

Level: Moderately easy

Time involved: Half to one hour

Ingredients:

 Pumpkin seeds

 Cooking-oil spray

 Salt

Equipment:

 Baking sheet

1. Preheat oven to 325°F.
2. Remove the pumpkin seeds from the pulp and rinse them thoroughly. Allow to dry.
3. Spray the cookie sheet with nonstick cooking spray. Place the seeds in a single layer on the baking sheet.
4. Spray the seeds with the cooking spray and dust with salt.
5. Bake for approximately 10 to 12 minutes or until golden brown. Watch the seeds carefully so they don't burn.

Hot-Diggity Dogs

Make the headline "Man bites dog!" this Halloween. Serve up these dinner treats for a Halloween bash or cozy family dinner.

Level: Easy

Time involved: Half to one hour

Ingredients:

 One package hotdogs (eight-count regular sized)

 One package sliced cheese

 One can crescent rolls

 One can black sliced olives

Equipment:

 Baking sheet

1. Preheat oven to 375°F. Slice the hotdogs lengthwise. Cut thin slices of cheese and place the cheese in the sliced hot dog.
2. Wrap the hot dogs in the crescent rolls using a diagonal motion as you would if making crescent rolls.

3. Place two olives on the end of the crescent rolls to form eyes.

4. Place on baking sheet and bake for 10 to 12 minutes or until lightly browned.

Holiday Hints

Throw a Halloween party for your kids and serve hot-diggity dogs with a witches'-brew punch made out of a can of fruit punch, a $^1/_2$ gallon rainbow sherbet, a liter of ginger ale, and gummi worms frozen in ice cubes. If your kids are older and into being "grossed out," you could also make a bloody hand for the punch by pouring water colored with red food coloring into a disposable glove, closing the opening with a rubber band, and freezing it. Remove the glove and add the hand to the punch. If desired, place a plastic spider ring on one finger.

Creepy Crawlers

Use your imagination when shopping for the ingredients for these Creepy Crawlers. You can use any kind of candy or toppings with the marshmallows. The bigger the variety, the creepier the crawler.

Level: Easy

Time involved: Half to one hour

Ingredients:

> One bag large marshmallows
>
> One bag miniature colored marshmallows
>
> Toothpicks
>
> Red and black licorice (sticks and shoestring)
>
> Raisins
>
> Assorted Halloween candies (corn, pumpkins, gummi candies)
>
> Tubes of icing
>
> Assorted cake toppings

1. Make an animal body out of the large and small marshmallows using toothpicks.

2. Use the licorice for legs, antennae, tails, and so on. Add raisins and candies as desired.

3. Decorate and make facial features on the animal using the icing and cake toppings. You can use the icing as a glue to stick the toppings onto the animal.

4. Be sure to remove the toothpicks before allowing the children to eat their creations.

The Least You Need to Know

➤ You can learn how to craft spooky Halloween symbols that will highlight your home for the holiday.

➤ You'll be the hit of the parade by making your own homemade costume.

➤ Halloween is a perfect time to get reacquainted with your family and work together on fun Halloween crafts.

➤ Menu-planning will be a snap if you check out the quick and delicious Halloween treats in this chapter.

Cranberry Sauce

Talking Turkey

In This Chapter

➤ Traditional handmade Thanksgiving decorations

➤ Crafts to commemorate the Native Americans who helped to settle Plymouth Colony

➤ A Thanksgiving Day feast that will make everyone thankful for you!

What is *your* fondest memory of a Thanksgiving celebration? For many, Thanksgiving conjures up thoughts of succulent roasted turkey, herb stuffing, buttery potatoes, and Mom's homemade pies. But Thanksgiving is more than just a day for feasting on rich, traditional foods. For most, Thanksgiving Day is spent with friends and relatives gathered around a dinner table to give thanks for all the blessings of the past year.

The Thanksgiving tradition itself has its roots in England in the 1600s. At this time in history, a group of men and women known as Puritans were seeking religious freedom. They desired their own land where they could live as Englishmen and practice their faith in peace. They joined with fellow pilgrims whom they called "the Strangers," and together they made a contract to sail to America on the *Mayflower*. One hundred two Pilgrims were aboard the ship, and about half were children. After a long and difficult voyage, the ship landed on December 11, 1620, just off the coast of Cape Cod.

Festive Facts

It's not certain whether turkey was served at the first Thanksgiving feast, but we do know that the menu included wildfowl, sea bass and cod, cornmeal, fruits and vegetables, and five deer provided by the Native Americans. There probably wasn't pumpkin pie, as the settlers had run out of flour, but boiled pumpkin and wild berries may have topped off the meal.

The Pilgrims' first winter was an extremely harsh one. Only about 50 of the original travelers survived. Half of these were children and only four were women. They managed to survive the harsh winters with the aid of Native American friends who helped them farm and hunt for food. In 1676, with their community fully established, the governing council of Charlestown, Massachusetts, proclaimed June 26 to be an official day of Thanksgiving.

Nowadays, people celebrate Thanksgiving on the fourth Thursday in November. If you're the person in charge of creating a special Thanksgiving for your family, you'll want to check out the craft and food ideas in this chapter that will make your celebration another reason to be thankful.

Giving Thanks

Many symbols of Thanksgiving are centered on the bounty of the harvest. You won't regret taking the time to dress up your home with these creative symbols of the season.

Whimsical Wreath

Nothing creates a welcoming atmosphere more completely than a lovely seasonal wreath hung on your front door. This wreath is relatively easy to make and will make the vibrant fall colors come alive in your home. (See the color insert for more details.)

A lovely wreath to welcome your guests.

Level: Moderately easy

Time involved: Two to three hours

Materials:

> Large bunch of brown eucalyptus
>
> Large grapevine wreath
>
> Wire
>
> Wire cutters
>
> Bunch of silk fall-colored flowers
>
> Glue gun
>
> Three yards of thick ribbon in a matching color
>
> 24 small pine cones

1. Place the eucalyptus branches around the grapevine wreath, covering the top of the wreath, and wire them into place.
2. Make a row of about 12 fall flowers on the bottom of the wreath, leaving space in between some of them to place pine cones. Wire or glue these in place.
3. Make a bow out of the ribbon, following the directions in Chapter 5, "Hanukkah Happiness." Wire the ribbon onto the top of the wreath. Then wire three or four flowers onto each side of the bow.
4. Glue the pine cones in a random pattern onto the wreath. Be sure to glue some in between the flowers, and at the beginning and end of the stretch of flowers. The sides of the wreath should show some eucalyptus.

Display your wreath on a door or above a mantle to welcome your guests to your home.

Turkey Tags

These cute turkey nametags will dress up your Thanksgiving table and save some confusion over seating your guests.

A lovely invitation to the Thanksgiving feast.

Level: Easy

Time involved: One to two hours

Materials:

Seven 2-inch oval wooden pieces (*Woodsies*)

Brown, red, green, yellow, blue, and orange craft paints

Paintbrushes

Foam plate

Flat 3-inch wooden circle (These can be found in bags in the wood section of a craft store.)

Two 1¹/₂-inch oval wooden pieces

Small triangular wooden piece for beak

Glue gun

Plastic eyes

Black calligraphy marker

Clear acrylic finish spray

1. Paint six of the 2-inch wooden ovals each a different color: red, yellow, green, blue, orange, and brown. Paint the remaining 2-inch wooden oval and the circle brown. Paint the two 1½-inch oval pieces orange and the triangular piece red. Paint a second coat if necessary. Allow these to dry.

2. Glue the six wooden ovals (feathers) onto the back of the top half of the circle. Glue the brown oval piece in the middle of the circle to form a head. Glue the triangle nose onto the head. Then glue the two smaller oval pieces flat onto the bottom of the body to form feet that will make the turkey stand up.

3. Glue two plastic eyes on the head. Write the name of the guest on the bottom of the circle using a calligraphy marker.

4. Spray the project with clear acrylic finish spray and allow it to dry for several hours.

Festive Facts

The weather during the *Mayflower* voyage affected the eventual location of the Pilgrim colony. Back in England, the Puritans heard about the thriving colony of Jamestown, Virginia. They applied and received a charter to found a plantation near this colony, at the mouth of the Hudson River. However, violent storms blew the *Mayflower* off course and instead, they landed far north of their destination, just off the coast of Cape Cod. Realizing that their original agreement as a group was legal only in Virginia, the Pilgrims drafted the Mayflower Compact before debarking from the ship. This agreement fashioned laws for the good of the new colony and established a lasting form of government. The Pilgrims chose to settle in a sheltered harbor that eventually became known as Plymouth Colony.

Native American Crafts

The Native Americans were important members of the Pilgrim settlements in America. Without their help, survival in the wilderness would have been difficult, if not impossible. Commemorate the memory of these generous souls by trying out these special crafts.

Seasonal Sense

Woodsies are a trademarked name for craft wood that is cut into assorted shapes and sizes and packaged in bags. You can find them in the wood section of craft stores, and they usually include suggestions for using them. For example, there is a bag of Woodsies that is designed for making animals, which includes ovals, circles, sticks, ears, noses, and so on. There are also craft books you can buy to get ideas for using these wooden pieces in special projects. Setting out several bags of Woodsies, some paint markers, and tacky glue could provide hours of entertainment at a kids' sleepover.

Dream Catchers

Native Americans designed these charms to filter out the bad dreams and provide a restful night's sleep for the owner. Let your kids hang these in a bedroom window to ward off scary nightmares. (See the color insert for more details.)

A decorative dream filter.

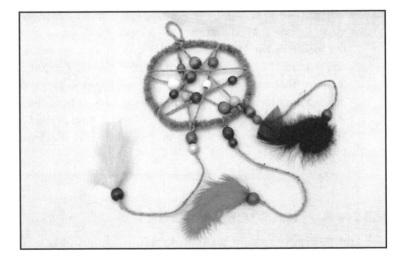

Level: Moderately easy

Time involved: One to two hours

Materials:

> Heavy-gauge jewelry wire
>
> Wire cutters
>
> Three chenille pipe cleaners
>
> Brown twine
>
> Scissors
>
> Masking tape
>
> Bag of assorted colorful wooden beads
>
> Three medium-sized feathers
>
> White glue

1. Form the wire into a circle that is approximately 5 inches in diameter. Begin where the wire is twisted together and start wrapping the chenille pipe cleaners around the wire. Thread the pipe cleaners in and out of the circle, covering the wire with tight loops of pipe cleaner.

2. Cut a piece of twine approximately 5 feet long. Double-knot one end of the twine onto the top of the circle. Cover the other end of the twine with a piece of masking tape, and roll and cut this into a triangular point to make threading the beads easier.

3. Thread two wooden beads onto the twine and push them into the middle of the dream catcher. Loop the twine around the bottom side of the dream catcher and bring it up to form a V inside the dream catcher. Thread two more beads onto the twine and push them to the center of the dream catcher. Loop the twine around the outside again and bring it across the V to the other side. Thread two more beads onto the twine and push them to the center of the dream catcher. Repeat this process several more times until you have a star shape inside the dream catcher. You'll see the star forming as you go from side to side with the twine.

4. Cut the masking tape off the end of the twine, and knot it in place on the dream catcher. Form a small loop out of the excess twine and knot it in place at the top for hanging purposes.

5. Cut three 12-inch pieces of twine. Cover one of the ends of each piece with masking tape and cut them into a point for threading the beads. Tie the other ends of the three strands, equally spaced, onto the bottom of the dream catcher. Thread a large bead and a small bead onto each strand, and push them to the top. Thread a large bead onto the bottom of the twine. Cut off the ends of the

twine that are covered with masking tape, and make a knot in each one below the bead.

6. Take a medium-sized feather and dip the end in white glue. Stick the feather into the bead at the bottom of the strand. Repeat this step with the other two strands.

Hang your dream catcher in a bedroom window or over your bed, and dream away!

Totem Poles

Native American tribes carved *totem poles* to record their family histories and legends. Your family might enjoy creating this totem pole that depicts your own legends and accomplishments.

Steps to making a colorful totem pole.

(© Melissa LeBon)

Level: Easy

Time involved: Two to three hours

Materials:

12-inch piece of heavy wire

Several colors of sculpting clay (Fimo or Sculpy clay)

Baking sheet

Foam sheets (optional)

Scissors (optional)

Glue gun (optional)

Assorted colors of craft paints

Paintbrushes

Foam plate

Clear acrylic finish spray

1. Have a family discussion to decide what would best represent your family heritage.

2. Bend the wire in half and make a circular base at the bottom to create a form for your totem pole. Take a color of clay and knead it between your fingers to soften it. Form the clay into a cylindrical form that is approximately $1\frac{1}{2}$ inches high and 1 inch around. Form this clay into the first family representation, and slide it onto the bottom of the wire form.

3. Repeat step 2 until you have four cylindrical shapes that are relevant to your family history.

4. Place the clay totem onto a baking sheet and bake it in a 275°F oven for approximately 20 minutes or until hardened. Allow this to cool.

5. Cut wings out of the foam sheet to add to the totem if desired. Glue these onto the totem with a glue gun.

6. Pour small dollops of assorted colors of paint onto the foam plate. Paint the totem with the appropriate colors and allow this to dry. Spray the totem pole with clear acrylic finish spray and allow it to dry. Set the totem pole in a place of honor in your home.

Seasonal Sense

Totem poles were a creation of the Tlingit Native Americans of the Pacific Northwest and lower Alaska. They were carved out of natural cedar wood and they expressed the history and accomplishments of the family. These bigger-than-life carvings depicted animals such as the bald eagle, grizzly bear, seal, porpoise, and wolf, which had symbolic meaning for the tribe. A totem would be raised for a multitude of reasons including honoring a deceased elder, recording an encounter with a spiritual being, or achieving a lifetime goal.

Kiddy Krafts

The Thanksgiving holiday is a wonderful time to teach kids to be grateful for all their blessings. You could spend some time with them working together on these projects to help them appreciate the gift of family, friends, and community.

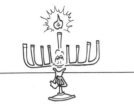

Holiday Hints

If you haven't already done this, Thanksgiving would be a great time to volunteer your family to work at a local soup kitchen or for a feed-a-friend program. It's an eye opener for kids to see how fortunate they really are to have a stable home life.

Holiday Hints

People must face many hassles during the year. You could have your kids create a "What I'm Not Thankful For" poster, using pictures of things such as pollution, cigarettes, violence, and so on, and contrast it with the "What I'm Thankful For" poster.

Counting Your Blessings

Give special meaning to your Thanksgiving celebration by helping your kids create this poster that expresses what they are thankful for in their lives.

Level: Easy

Time involved: One to two hours

Materials:

Magazines

Scissors

Markers

Poster board

White glue

Thanksgiving stickers

1. Sit down with your kids and help them look through magazines to find pictures that express what they are thankful for. Cut out the pictures.

2. Prepare the poster board by writing the words "What I Am Thankful For" on top of the poster board. Glue the pictures onto the poster board in an attractive pattern. Use the markers to label each picture and to fill in the spaces with color.

3. Decorate the poster board with Thanksgiving stickers. This can be an ongoing project that you can add to over the holiday season as more pictures are found.

Handprint Turkey

It's easy to make simple turkeys out of handprints. You might want to make a family of turkeys using the hands of everyone in your family. These cute turkeys would make nice place cards for the dinner table.

Level: Easy

Time involved: One to two hours

Materials:

> Poster board
>
> Markers or crayons
>
> White glue
>
> Feathers
>
> Plastic eyes
>
> Scissors
>
> Magnet (optional)

1. Let the kids trace the hands of each member of the family on to the poster board. Color the handprint turkeys with a light brown marker or crayon.

2. Spread glue on the tails (fingers) of the turkeys. Glue a feather onto each finger (not on the thumb).

3. Glue an eye onto the heads (thumbs) of the turkeys. Draw red beaks protruding from the heads. Draw two orange legs on the bottom of each turkey.

4. Cut out the turkeys. Write the names of the family members on the front of the turkey using a black marker.

5. If desired, glue a magnet onto the back of the turkeys and arrange them on the refrigerator.

If using these as place cards, cut out a small piece of poster board and fold it in half to create a stand. Glue the turkey onto the front of the poster board and place it on the table. You could let family members take turns at writing on the turkey cards to tell each person why they're thankful for him or her.

Holiday Hints

You might want to make a wreath out of kids' handprints or cover a picture frame with them. You could change the holiday theme of this project by making the paper hand-prints out of seasonal colors and cutting holiday symbols out to place in between the handprints. For example, you could make black-and-orange handprints with cut-out pumpkins in between. You also might want to write messages on the handprints such as: "Things I'm Thankful For" for Thanksgiving, or "The Reasons I Love You" for Valentine's Day.

Food, Glorious Food

You can't forget the food when planning your Thanksgiving celebration. Whether you do a traditional turkey dinner or like to experiment with menus, you won't go wrong by checking out these recipes.

Crunchy Cranberries

Don't just shake cranberry sauce out of a can this year; make your own fresh cran-berry relish for your Thanksgiving Day meal. This delicious recipe is a favorite of Dr. Carol Taylor of Georgetown, Washington, D.C., and has been a staple of the Taylor family menu for years.

Level: Easy

Time involved: Half to one hour

Ingredients:

> 1 bag fresh cranberries
>
> 1 orange
>
> $^3/_4$ cup sugar
>
> $^1/_2$ cup walnuts (optional)

Equipment:

> Food processor
>
> Bowl
>
> Mixing spoon

1. Wash the cranberries and allow them to dry. Grind up the cranberries in a food processor, a small amount at a time, and remove them to the mixing bowl. Do not overprocess the cranberries to the point where they are mushy.

2. Wash the orange and cut it into quarters. Remove any seeds. Grind the orange (peel and all) in the food processor. Add this to the mixing bowl.

3. Add sugar and walnuts, if desired, to the mixture and stir until well blended.

4. Refrigerate the cranberry relish overnight for the best taste and color.

Mom's Pumpkin Pie

No one makes pumpkin pie like Mom does. Well, now you can, if you follow this easy recipe supplied by my mom, Mildred Taylor, of Pine Grove, Pennsylvania.

Level: Moderately easy

Time involved: One to two hours

Ingredients:

> 2 eggs
>
> $1^3/_4$ cups pumpkin (Mom uses her own neck pumpkins, peeled, cut, and boiled, but you can substitute canned pumpkin—the 29-ounce size.)
>
> $^3/_4$ cup sugar (use $^1/_2$ white sugar and $^1/_2$ brown sugar)
>
> $^1/_2$ teaspoon salt
>
> 1 teaspoon cinnamon
>
> $^1/_2$ teaspoon ginger
>
> $^1/_2$ teaspoon cloves
>
> $1^2/_3$ cup evaporated milk
>
> 1 tablespoon molasses
>
> Ready-made pie crust

Equipment:

> Electric mixer
>
> 9-inch pie pan

1. Preheat the oven to 425°F. Place two eggs in the mixer and beat slightly. Add the pumpkin and mix well. Add the dry ingredients and blend together until well mixed. Blend in the evaporated milk and molasses.

2. Make a crust in the pie pan following the manufacturer's directions for a prepared crust. Pour the pumpkin mixture into the pan.

3. Bake for 15 minutes and then turn the heat to 350°F. Bake at this temperature for 45 minutes. The pumpkin pie is done when the tip of a knife inserted in the center comes out clean and the pumpkin mixture is solidified.

Holiday Hints

You can avoid having a burnt crust when baking pies in the oven for long periods of time by covering the crust with aluminum foil after it turns a golden brown color. You can also buy metal piecrust shields online, in mail-order catalogs, or in a discount store, which you can simply place over the crust to keep it from getting too dark. The shields that I've used are made by Betty Crocker.

Savory Stuffing

You can make your stuffing from scratch without a lot of hassle if you use prepared seasoned bread-stuffing cubes. You'll get rave reviews from your family for this special stuffing recipe sent to me by Dr. Robert Barnet of Reno, Nevada.

Level: Moderately easy

Time involved: One to two hours

Ingredients:

> Two 16-ounce bags seasoned bread cubes
>
> 1 cup corn meal

2 cups bread crumbs

$^1/_2$ cup chopped walnuts

$^1/_2$ cup white raisins

1 teaspoon chopped dry or fresh sage

1 teaspoon chopped dry or fresh thyme

1 teaspoon salt

$^1/_2$ teaspoon pepper

1 cup celery (especially tips and leaves) cut into $^1/_2$-inch lengths

1 medium-sized onion, chopped

4 garlic cloves, chopped

10 to 12 small mushrooms sliced (These can be added fresh or sautéed in olive oil first.)

1 cooking apple, cored and sliced into thick pieces

1 egg

1 stick butter, melted

1 or 2 cups chicken broth

Equipment:

Large mixing bowl

Mixing spoon

Cooking spray

13 × 9 inch baking dish (optional)

Mix the ingredients together in the mixing bowl in the order listed. Use enough chicken broth to make the mixture soft and moist, but not sticky (according to your preference). Stuff the turkey with the mixture or place it in a baking dish sprayed with cooking oil. Add some drippings from the turkey and bake this at 350°F for 30 minutes.

The Least You Need to Know

➤ You can prepare your home for Thanksgiving by handcrafting festive decorations.

➤ Enhance your Thanksgiving feast by making the unique table decorations and centerpieces in this chapter.

➤ Thanksgiving is the perfect time to teach your kids to be grateful for all their blessings.

➤ Be the one your family and friends are thankful for by cooking them a delicious Thanksgiving feast.

Resources and Supplies

Books

Carlson, Laurie. *Ecoart*. Charlotte, VT: Williamson Publishing, 1993.

———. *Kids Create*. Charlotte, VT: Williamson Publishing, 1990.

Chapman, Gillian, and Pam Robson. *Art from Paper*. New York: Thompson Learning, 1995.

———. *Art from Rocks and Shells*. New York: Thompson Learning, 1995.

Chinery, Michael. *Enjoying Nature with Your Family*. New York: Crown Publishers, Inc., 1977.

Cook, Deanna F. *Kids' Multicultural Cookbook*. Charlotte, VT: Williamson Publishing Co., 1995.

Kiehn, Gwen, and Terry Krautwurst. *Nature Crafts for Kids*. New York: Sterling Publishing, 1992.

LeBon, Marilee. *The Complete Idiot's Guide to Making Great Gifts*. Indianapolis: Alpha Books, 2001.

———. *Have Fun with Your Kids The Lazy Way*. Indianapolis: Alpha Books, 1999.

Lockwood, Georgene. *The Complete Idiot's Guide to Crafts with Kids*. Indianapolis: Alpha Books, 1998.

Meras, Phyllis. *Vacation Crafts*. Boston: Houghton Mifflin Company, 1978.

Owen, Cheryl. *Paper Crafts*. London: Salamander Books Ltd., 1991.

Owen, Cheryl, and Anna Murray. *The Grolier Kids Crafts Craft Book*. Danbury, CT: Grolier Educational, 1992.

Pulleyn, Micha, and Sarah Bracken. *Kids in the Kitchen*. New York: Sterling Publishing, 1994.

Ross, Kathy. *Every Day Is Earth Day*. Brookfield, CT: Milbrook Press, 1995.

Sattler, Helen Roney, and Lee Lothrop. *Recipes for Arts and Crafts Materials*. New York: Shephard Books, 1973.

Smith, Christine. *How to Draw Wild Animals*. Milwaukee: Gareth Stevens Publishing, 1996.

Magazines

Arts and Crafts
700 East State Street
Iola, WI 54900
715-445-2214

Crafts
PO Box 56010
Boulder, CO 80323
1-800-727-2387

Crafts 'N Things
Pack-O-Fun
PO Box 420235
Palm Coast, FL 32142
1-800-444-0441

Jewelry Crafts Magazine
5000 Eagle Rock Blvd., #105
Los Angeles, CA 90041
1-800-784-5709

Stamping Arts and Crafts
30595 Eight Mile
Livonia, MI 48152
1-800-458-8237

Online Resources

Check out these Internet sites for information on holiday traditions and craft ideas.

www.about.com	www.family.go.com
www.childfun.com	www.geocities.com
www.craftideas.com	www.holidays.net
www.craftown.com	www.homeandcrafts.com
www.decorating4less.com	www.kidsdomain.com
www.enchantedlearning.com	www.swagga.com
www.dltk-kids.com	www.teelfamily.com
www.family.com	www.theholidayspot.com
www.familyplay.com	

The following Internet sites offer quality craft supplies for sale:

www.craftbarn.com	www.misterart.com
www.dickblick.com	www.bearcountrycandleandsoapsupply.com
www.just4ewe.com	

Supply Catalogs

Collage
240 Valley Drive
Brisbane, CA 94005
1-800-926-5524
www.collagecatalog.com
Fine papers and paper products

Craft Catalog
PO Box 1069
Reynoldsburg, OH 43068
1-800-777-1442
www.craftcatalog.com
Art and craft supplies

Dick Blick Art Materials
PO Box 1267
Galesburg, IL 61402
1-800-828-4548
www.dickblick.com
Art supplies

Home Craft
PO Box 24890
San Jose, CA 95154
1-800-301-7377
www.homecraftexpress.com
Art supplies

Utrecht
6 Corporate Drive
Cranbury, NJ 08512
1-800-223-9132
www.utrechtart.com
Art supplies

Plaid Enterprises, Inc.
PO Box 2835
Norcross, GA 30091
1-800-842-4197
www.plaidonline.com
Art supplies

Glossary

acrylic paints Craft paints that clean up easily with soap and water and produce vivid, permanent colors.

Afikomen A piece of matzoh in a holder, which gets hidden by the leader of a Seder celebration. The child who finds it gets a small gift or treat.

basket filler Torn, shredded, or folded material that fills the bottom of a gift basket (crepe paper, tissue paper, raffia, Spanish moss, and so on).

beeswax sheets Sheets of wax made from the honeycombs of bees, which can be molded into decorative candles.

Beritzah Hebrew word meaning a baked or roasted egg. Beritzah is placed on a Seder plate during the Seder dinner.

calligraphy tool An ink pen or marker used to create intricate letters.

candle dye A dye that can be added (by drops) to melted candle wax to color it.

candle molds Plastic molds of various shapes used to form candles.

candle wicking A wand of woven or twisted fiber contained in a candle or lamp.

card stock Special papers used for making stationery or greeting cards.

Charoset A Hebrew word meaning a mixture of chopped apples, walnuts, cinnamon, and wine. Charoset is placed on the Seder plate during the Seder dinner.

clear acrylic finish spray A clear protective spray-on finish for craft projects.

clear glue Transparent glue that can be used to replace white glue in projects.

crackle paint Spray paint that gives objects a weathered or antique look.

craft paints Water-based paints that provide vivid, lasting colors (same as acrylic paints).

craft sticks Sticks that resemble Popsicle sticks, but have notches in the sides to facilitate building projects. The sticks can be inserted into each other or snapped apart at the notched sections.

crepe paper Decorative paper, similar to tissue paper, which is used in various craft projects.

crimper A tool for making shredded, uniquely shaped bits of paper that can be used in craft projects.

decorative edge scissors Scissors that make a decorative line on the object being cut.

decoupage A creative art that involves pasting and varnishing paper cut-outs onto decorative objects.

decoupage finish A product that resembles white glue, which can be brushed onto a decoupage project to replace varnish as a finisher.

dowels Rounded wooden sticks that come in different widths and lengths.

dream catchers A Native American charm thought to filter out bad dreams.

dreidel A spinning top used in Hanukkah celebrations.

Elijah's Cup A ceremonial cup that is filled with wine or juice and placed on the table at the Seder dinner to symbolize the prophet Elijah's visit.

embroidery thread Floss used in decorative sewing.

eucalyptus A form of evergreen tree found chiefly in Australia that yields potent oil. Its dried branches are used in floral arrangements.

Exacto knife A sharp-bladed knife used in precision cutting.

excelsior moss A natural fiber filler for baskets or boxes.

fabric glue An adhesive used for gluing objects to material or holding material pieces together.

fabric paint Machine-washable paint used on fabric.

felt Fabric made of a composite material that has no raw edges.

flocking kits Kits that contain adhesive and fibers in squeeze bottles, for making a flocked effect on projects.

foil accents kits Kits that contain adhesive and rolls of foil, for making foil accents on projects. You can purchase rolls of foil or foil designs.

floral arranging gel A medium that can be melted and that gels when cooled to serve as a permanent arranging medium for flowers.

florist pick A wooden stick used to anchor flowers in arrangements.

foam block (florist) A block of porous material (foam) used in flower arrangements.

foam sheet cutouts Shapes that are pre-cut from foam sheets.

foam sheets Flexible foam material used in craft projects to replace construction paper.

fusible webbing A product that can be ironed onto fabrics to hold them together in place of stitching.

garden stone A painted stone (usually slate) that decorates a garden.

gel candle wax A transparent gel that can be melted and poured into molds to produce gel candles.

glass-etching solution Acid used to etch stencils into glass.

glass-etching stencils Stencils taped to glass that form the design created by etching acid.

glass pieces (decorative) Pieces of glass that are clear or translucent with smooth edges, which are used in mosaics, candle making, and other projects.

glazing dip A solution in which flowers can be dipped to give them a permanent ceramic effect.

glue gun A tool that dispenses melted glue.

glue sticks Hardened sticks of glue that are clear, colored, or glitter, which are used in a glue gun. Colored or glitter glue sticks are used to make designs on projects.

glycerin block Material that can be cut, melted, and poured into molds to make soap forms.

grout A powdered material that can be mixed with water and applied to a mosaic to fill in the spaces between the decorative pieces.

Hanukkah A sacred Jewish holiday that commemorates the rededication of the temple of Jerusalem under the Maccabees in 164 B.C.E.

Imani An African-American term for having faith in the creator, parents, family, community, and the goodness of the struggle for excellence.

iron-on transfers Designs on paper that can be ironed onto a fabric project and filled in with fabric paints.

jewelry wire Wire that comes in different gauges and colors that can be used in jewelry-making or other wire projects.

Karamu The Kwanzaa feast.

Karpas A Hebrew word meaning the parsley placed on the Seder plate during the Seder dinner. Karpas represents the bitterness of enslavement.

Kinara A ceremonial candleholder that holds seven candles for the African-American celebration of Kwanzaa.

Kujichagulia An African-American term for being proud of who you are and what you do in life.

Kuumba An African-American term for being able to express yourself in a creative fashion through music, art, dance, and so on.

Kwanzaa (Swahili for "first") An African-American celebration, developed by Dr. Maulana Karenga, to promote unity and pride in the African-American community.

leprechaun A legendary Irish fairy, often unfriendly, who lives alone and makes shoes for a living.

liquid lead Thick, black liquid that can be squeezed from a bottle onto a stained-glass project to simulate molded lead.

liquid scent A pleasant-smelling extract used in making candles and soaps.

magnet sheet Sheet of magnetic material that can be cut to size and used for refrigerator magnets or other magnetic crafts.

maror A Hebrew word meaning the bitter herb (usually horseradish) placed on the Seder plate to represent the bitterness of slavery.

material remnants Ends of bolts of material that are packaged and sold at a reduced rate in fabric stores.

matzoh A cracker that represents the Jewish people's inability to allow the yeast in their bread to rise in their haste to leave Egypt.

matzoh meal A kosher substitute for flour in recipes.

menorah A ceremonial candleholder used during Hanukkah celebrations.

Mkeka A woven mat, one of the seven basic symbols of Kwanzaa.

mosaic adhesive The glue that holds mosaic pieces in place.

mosaic sealant A sealer that protects and fortifies a mosaic project.

mosaics Works of art that are designed from grout and pieces of materials such as glass, stone, or tile.

Nia An African-American term for trying to be the best you can be and being responsible for your own actions.

paint, peel, and stick-on paints Translucent, squeezable paints used to make designs on a plastic template (styrene blank), which can be peeled off when dry and stuck onto glass surfaces.

painter markers Markers that are filled with acrylic paint and can be used in place of painting with a paintbrush.

papier-mâché A French word that describes a material consisting of paper pulp mixed with glue or paste, which can be molded into various shapes when wet and becomes hard when dry.

paraffin Blocks of wax used in candle-making, cooking, and other craft projects.

Passover A sacred holiday that commemorates the liberation of the Jewish people from enslavement.

Pesach The Hebrew word for Passover.

polyester fill A cotton-like substance made from polyester that is used as filling for pillows and other stuffed projects.

pom-poms Cottony balls of various colors and sizes that are used in craft projects.

pony beads Round, plastic beads that come in assorted colors and can be used in many different craft projects.

poster paints Vivid, water-based, nonpermanent paints that are easy for children to handle.

quilted panel Pre-quilted material panel that contains a mural or special design.

raffia A fibrous ribbon used in craft projects, which is made from a plant.

rainstick A musical instrument used from ancient times to present day to appease the rain gods.

rub-on face transfers People and animal faces that can be rubbed onto a project with a Popsicle stick.

rub-on transfers Designs that can be transferred onto a project by rubbing them with a wooden tool.

salt dough A sculpting dough made out of flour, water, and salt that hardens when baked.

scrapbook pack Tablets or packs of paper used in scrapbook-making that contain print designs, backgrounds, cut-outs, and patterns for enhancing a scrapbook or photo album.

sculpting clay A pliable material that can be molded into sculptures and baked to harden.

Seder dinner A traditional dinner gathering held in the home at Passover.

Seder plate A centerpiece dish containing symbolic foods, placed on the Seder table during the Seder dinner.

Shamash The raised helper candle in the middle of a menorah that is used to light the other candles.

shrink shapes A craft medium that enables you to paint a design on plastic, cut it out, and bake it in an oven to shrink it.

snow-texture paint A white, texture paint that comes in a jar and can be painted onto a project to resemble snow.

soap chips Bags of colored soap pieces that are added to soap molds for a decorative touch.

soap molds The forms that hold the melted glycerin until it hardens into soap.

Spanish moss A natural plant that is used in flower arrangements and other craft projects.

sponge painting Painting a project using sponge shapes dipped in paint.

sponge stamps Shapes made out of sponges that can be used to form designs with paint.

sponges, textured Sponges that have a variety of textures and can be painted and pressed onto projects to create different designs.

spouncer A stencil paintbrush that resembles a piece of wood with a sponge molded onto the end.

stained-glass paint A transparent, colored paint that resembles stained glass and can be painted or sprayed onto a project.

stamps/stamp pads Tools with a raised design on a rubber surface that can be painted or pressed onto a stamp pad and then stamped onto a project.

Star of David A six-pointed star known in Hebrew as Magen David, or Shield of David.

statice A dried branch of tiny white flowers, similar to baby's breath, that is used in arrangements or other craft projects.

stencil paint A special, powdery paint used with stencils.

stencil paintbrushes Special paintbrushes used for stenciling that are shorter and blunter than regular brushes.

stencils Designs cut out of plastic that can be filled in with stencil paint to create pictures on projects.

stone-finish paint Spray paint that creates a stone or cement-like finish on projects.

styrene blanks Clear, plastic boards used to make designs for paint, peel, and stick-on transparent paint.

tacky glue Clear glue used in craft projects that is thicker than white glue and stays in place when applied.

tempera paints (nontoxic) Poster paints that are nonpoisonous and can be used when working with children.

textile medium A liquid helper that transforms acrylic paints into washable fabric paint.

textured paper Fancy papers used for making cards, origami, or scrapbook packs.

tile-cutting tool A tool that resembles a pair of pliers that can be used to cut tiles to fit into mosaic works.

transfer paper A paper similar to carbon paper that is used to transfer designs onto projects.

trivet A decorative object used to protect a surface from heat or spills.

Ujamaa An African-American term for taking pride in the cultural expressions of African Americans (such as music, art forms, or dance).

Ujima An African-American term for working together as a team to support the goals of the family and/or community.

Umoja An African-American term for sticking together as a family.

Unity cup A ceremonial communal cup that is filled with a drink and used in a Kwanzaa celebration.

varnish A finishing product that gives a glossy or matte finish to a product.

white glue Traditional school glue that is used in craft projects.

wired ribbon Wire-edged ribbon that keeps its form when shaped into a bow.

wooden bead heads Round, wooden beads with painted-on facial features.

wooden heads (clothespins) Rounded, wooden pieces with or without painted-on facial features that fit over the end of a clothespin.

wood stain A clear, brown paint that darkens a wooden object without covering up the grains in the wood.

Woodsies A trademarked product that consists of bags of wood pieces that are used to make wooden objects such as animals.

Zawadi An African-American term for the gifts given at Kwanzaa.

Zeroa The Hebrew word for a shank bone. Zeroa is placed on the Seder plate during the Seder dinner to symbolize the sacrificial lamb offering the Jews made to God.

Index

THE COMPLETE IDIOT'S GUIDE TO

| Arts & Sciences | Business & Personal Finance | Computers & the Internet | Family & Home | Hobbies & Crafts | Language Reference | Health & Fitness | Personal Enrichment | Sports & Recreation | Teens |

IDIOTSGUIDES.COM
Introducing a new
and different Web site

Millions of people love to learn through *The Complete Idiot's Guide*® books. Discover the same pleasure online in **idiotsguides.com**–part of The Learning Network.

Idiotsguides.com is a new and different Web site, where you can:

✳ Explore and download more than 150 fascinating and useful mini-guides–FREE! Print out or send to a friend.

🌐 Share your own knowledge and experience as a mini-guide contributor.

💬 Join discussions with authors and exchange ideas with other lifelong learners.

🏛 Read sample chapters from a vast library of *Complete Idiot's Guide*® books.

✗ Find out how to become an author.

✂ Check out upcoming book promotions and author signings.

🏠 Purchase books through your favorite online retailer.

Learning for Fun. Learning for Life.

IDIOTSGUIDES.COM • LEARNINGNETWORK.COM

Copyright © 2000 Pearson Education